The Real World of the
SURREALISTS

Malcolm Haslam

The Real World of the
SURREALISTS

Weidenfeld and Nicolson London

I am very grateful to Belinda Greaves, who assisted me with the research, for her diligence and perception; to Julia Brown, who supervised the illustrations, for her persistence and imagination; and to Esther Jagger, who combined in her editorship both intelligence and forbearance. I also offer my thanks to Charles and Margaret Plouviez who provided me with the comforts of home for long periods, and to Robert Haslam whose sympathetic attention to undressed gobbets of Surrealist lore was always helpful. M.H.

House Editor Esther Jagger
Picture Editor Julia Brown
Designed by Andrew Shoolbred for
George Weidenfeld and Nicolson Ltd,
11 St John's Hill, London SW11

ISBN 0 297 77399 2

Filmset in Monophoto Ehrhardt
by Keyspools Ltd, Golborne, Lancashire
Colour separation and printed
in the Netherlands
by Druckerij de Lange /Van Leer,
Deventer

Contents

Foreword

Surrealist painting has been the most apparent aspect of a movement which began as an assault on poetry and became a political crusade. The painters tried to establish an art concerned with the unconscious, their aims diverging widely from the programme of contemporary Cubist and abstract artists who were more engrossed in questions of form and colour, and who gave modern art its accepted character. Equally, in literature and ideology the Surrealists adopted attitudes which seemed perverse, creating eddies in the mainstream of twentieth-century opinion. Today, at a distance from the years when Surrealism was born and raised, many of its principles, artistic, political and moral, have begun to appear more significant than the orthodox ideas which emerged during the period between the two World Wars, and which gave the epoch its character.

Surrealism was the first artistic movement which came to terms not only with Freud but also with Lenin. Its avowed ideal was to transform a world where frustration caused suicide and avarice provoked war. The First World War introduced André Breton, Louis Aragon, Paul Eluard, and Philippe Soupault, the founders of Surrealism, to the ghastly inhumanity which lay beneath the well-powdered skin of bourgeois society. The story which this book has to tell begins during that war when those four young poets realized that art could only remain a viable occupation to the extent that it refuted every moral and political principle on which Western civilization was grounded. The revolution of 1917 in Russia suggested that any edifice, however grandiose, might tumble, and in the cause of sabotage and subversion the Surrealists tried to co-operate with the Communists. But while their political allies fought for better material conditions, the Surrealists insisted on showing a more general dissidence; their dissatisfaction was moral and intellectual as well. They seized every opportunity to harass the establishment, to protest against hypocrisy and snobbism. How they nibbled away at the institutions of bourgeois society is told in this book, and how eventually the forces of Fascism overtook both them and their adversaries.

The polemics of the Parisian avant-garde, the squabbles between Trotskyites and Stalinists in the French Communist Party and the feuds within the Surrealists' own ranks, might seem trivial, sometimes sordid. But they are worth describing because Surrealism tried to answer questions which are asked even today, and because deeper appreciation can be felt for the revolutionary content of Surrealist painting only in its revolutionary context. M.H.

Introduction
by Barbara Rose

During the troubled years separating the two World Wars that permanently rent the fabric of European civilization, the traditional values that had governed Western culture since the Renaissance were challenged from many directions. Among the most aggressive assaults was the campaign of subversion waged by the audacious band of young artists and writers who came of age during and just after the First World War.

Born into a world of disintegrating social, cultural and geographical boundaries, the poets and painters who eventually called themselves Surrealists were pledged to inventing a new art that transgressed boundaries. In their search for fresh, uncorrupted meanings they embraced the absurd, the accidental and the illogical – qualities that now appeared to dominate a world no longer governed by the inherited authority of Church and State, nor by any scientific concept that defined the physical universe as stable and unchanging. But their ideas, no matter how radical, were not without precedent. The subversive thought of Nietzsche had already begun to undermine religious, philosophical and aesthetic beliefs, while scientists like Einstein and Freud and social thinkers like Marx and Lenin further overturned established systems of authority, disrupting historical continuity and inspiring the hot-blooded young artists to revolt against rules of any kind.

The Surrealists, of course, did not invent the concept of rebellion in the arts; nor were they the first artists to set out deliberately to *épater les bourgeois* – to shock the middle class whose taste dominated culture. The Italian Futurists, as well as the Dadaists, had already experimented with hybrid art forms, marrying painting with poetry, sculpture with theatre, and architecture with environment. Another profound influence was the revolutionary ideas of the Surrealists' contemporaries, the Russian Constructivists, who raised the possibility of universal *gesamtkunstwerke* – a utopian aspiration towards a synthesis of all the arts. Although they continued to employ the shock tactics of Futurism and Dada, the Surrealists were more positively orientated towards inventing new forms, techniques and images. They set out to create an exciting, unprecedented art that preached liberation – particularly sexual liberation. Many of

their ideas were derived from the French Symbolist poets, who had embraced debauchery and decadence as fresh sources of inspiration. Both Mallarmé's ideas regarding chance as a vital element and Baudelaire's notion of synaesthetic word-image 'correspondences' were assimilated by the Surrealists.

For the Surrealists, the twin revolutions of Marx and Freud were as decisive as Einstein's theory of relativity had been for the Cubists. Both demanded the overthrow of existing systems and attacked repression in its various forms. Psychoanalysis, in the hands of Freud and of Jung, whose theories of collective archetypes definitively influenced Surrealist iconography, introduced the possibility that 'civilized' man was still driven by the same primitive instincts as his savage ancestors, and that beneath the conscious mind lay a rich subconscious world of dream and fantasy. In Freud's method of evoking repressed material through free association, the Surrealists found a means to forget logic and to revel in the freedom of alternative states of consciousness. Adapting the technique of free association to artistic ends, they developed a creative method that André Breton termed 'pure psychic automatism', which in the hands of painters like Miró, Dali, Ernst and Masson resulted in images which seemed to spring spontaneously from a lost archaic consciousness. The Surrealists were fascinated by the powerful content of primitive art, especially in images of love and death, identified by Freud as *eros* and *thanatos*, the two fundamental human drives.

Under the banners of the two radical ideologies invented by the critical modern spirit – Marxism and psychoanalysis – the Surrealists attacked the various categories of repression and alienation. They were probably the last artists naive enough to believe that art can change the world, though they were finally forced to renounce many of their political goals when Stalin betrayed them and Hitler drove them out of Europe. But today, when ideas regarding the meaning of political freedom and social justice are as open to question as the conventional moral and cultural ideas the Surrealists succeeded in overthrowing, their demand for total artistic freedom remains unchallenged as a modern Western ideal.

1 'A Good Laugh'

'War? Gave us a good laugh.'

(André Breton, Manifesto of Surrealism, 1924)

OPPOSITE The Great War. French troops passing General Foch on their way to the front, 1915.

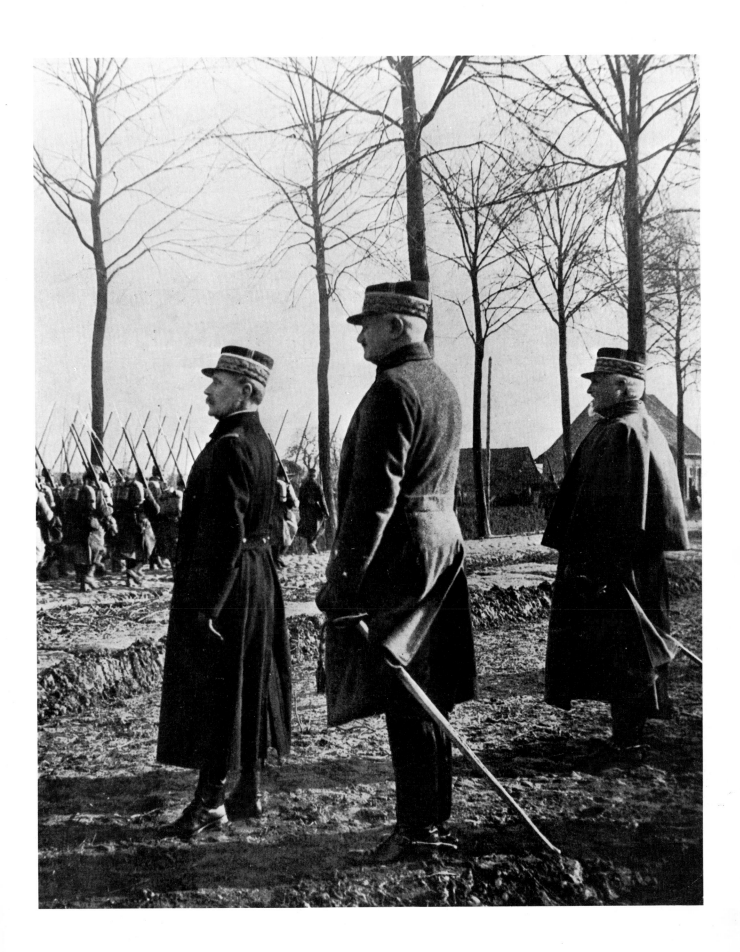

By 1917 the Great War had raged for nearly two and a half years. The French people had suffered horribly. Hundreds of thousands had been killed and more hundreds of thousands wounded. About six per cent of their territory was in the hands of the enemy. Industry and agriculture had been disrupted by the demands of total war. For the men in the trenches there was fatigue, disease, mud and gunfire; for civilians, long hours in factories, bereavement and shortages of coal and bread. The French had been hardened: hardened in their hatred of the enemy and in their determination to conquer, or hardened in their outrage at the senseless destruction and in their contempt for the generals, the politicians, the clergy and the capitalists whom they held responsible. In such an atmosphere was Surrealism conceived, seven years before its first manifesto. The movement started in 1917, that year of war and revolution, when the term was coined by Guillaume Apollinaire and when three young intellectuals, André Breton, Philippe Soupault and Louis Aragon, met each other in Paris and found that they shared the same overriding artistic principle: any art, in future, was only possible if it denied the validity of bourgeois good sense and morals.

The European war which broke out in August 1914 was supposed to be over by Christmas; it quite nearly ended in two months. In September the German army was on the river Marne and Paris was seriously threatened. The French generals Joffre and Galliéni argued ever afterwards which of them saved the capital. The Germans had to withdraw and by the end of the year were entrenched on a front which stretched from Switzerland to the North Sea. The French and British armies dug in facing them. The barbed wire was staked, the machine-gun emplacements were built. The war had become static, and throughout 1915 the French generals squandered thousands of lives in vain attempts to dislodge the invaders. Next year the slaughter was yet more prodigious. Among the forts of Verdun the soldiers of France and Germany killed and were killed with an abandon which was horrific. The battle started in February and the last German assault was launched on 11 July. Verdun had not fallen, but over half a million men had been killed in the battle. Almost as many died on the Somme between July and November. There the Allies gained a few square miles of territory and some villages, and, in December, General Nivelle had recovered the ground at Verdun which had been lost during the German offensive. But there had been no victory. At the beginning of 1917 no end to the slaughter was in sight.

In 1915 Apollinaire had enlisted in the artillery. He was an unlikely soldier, the poet and art critic who stage-managed the Parisian avant-garde. In his

Guillaume Apollinaire, the poet and impresario of the avant-garde, in the uniform of a non-commissioned officer in the artillery.

review *Les Soirées de Paris* he had gathered all the different strands of modern art, but the last number appeared in August 1914. He was wounded in the head by shell splinters in March 1916 and that summer his skull had been trepanned. No longer fit for military service, he worked in the Censor's Office and, in the evening, he might be found at his table in the Café de Flore, Boulevard St Germain, holding court among his friends and disciples. On 31 December some of them gave a lunch in his honour at the Palais d'Orléans in Montparnasse. It ended in rowdy arguments and brawls between the different artistic factions. The African soldiers billeted in the building were astonished, but Apollinaire was delighted: 'My dinner was a sort of magnesium flash', he wrote to a friend, 'exactly what it should have been, explosive and dangerous, brief, but carried to the verge of paroxysm.'

French soldiers near Décauville, January 1916.

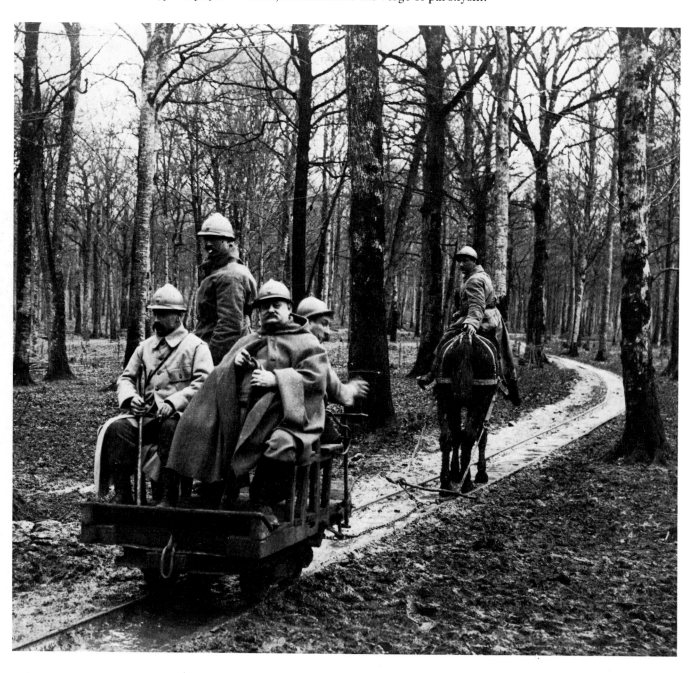

André Breton returned to Paris in the new year. He had studied medicine there for two years before being conscripted in 1915 and posted as an auxiliary to a hospital in Nantes. A year later he had been transferred to St Dizier, about eighty kilometres from Verdun, where he had assisted in the treatment of mental cases at an army neuro-psychiatric centre. Briefly, during Nivelle's offensive on the Meuse, he had been at the front. Now, in Paris, he was to work at the Hôpital de la Pitié under Dr Joseph Babinski, the leading psychiatrist in France at that time. Obsessed with poetry since his schooldays, Breton had written a sonnet which was published in the review *La Phalange* in 1914. He had corresponded with Apollinaire since December 1915 and now he would soon find himself sitting at the Café de Flore. There, too, would be Philippe Soupault, six months younger than Breton, who would be twenty-one in

Victims of war, in a street in Soissons.

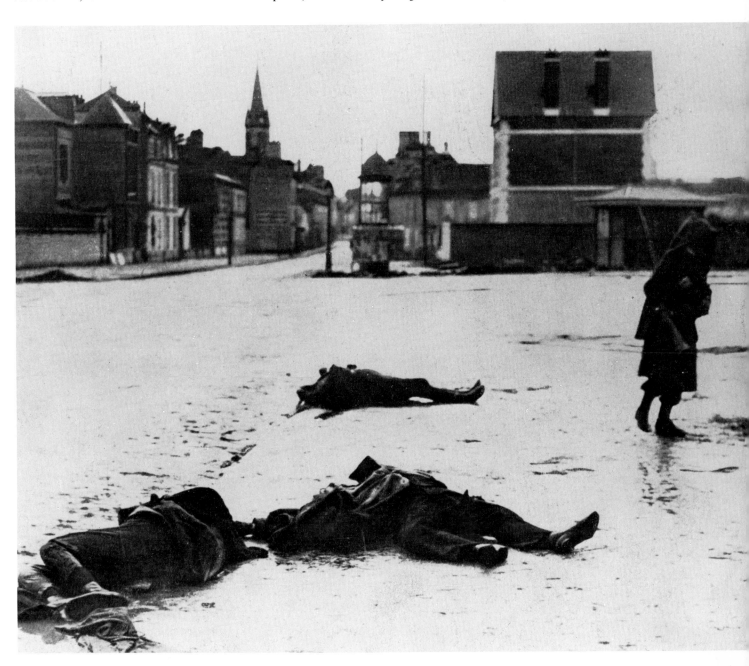

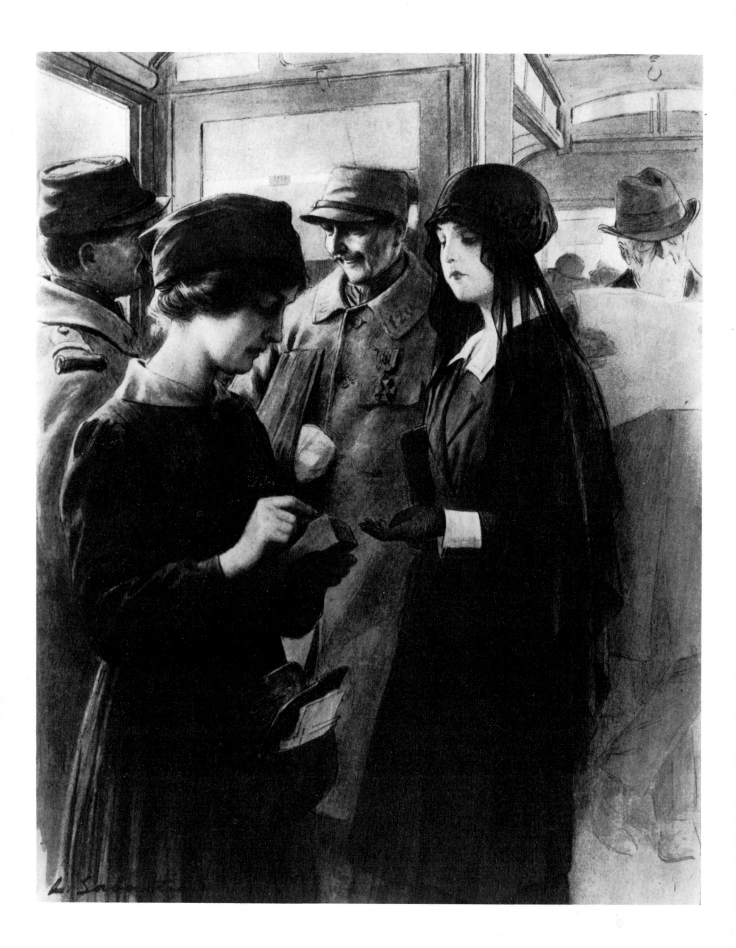

OPPOSITE Women at war. A conductress on a Paris omnibus during the First World War.

BELOW André Breton, a photograph taken about 1913 when he was studying in Paris.

February. Soupault's war had not been glorious. Leaving school in 1915, he had been declared unfit for military service and, without enthusiasm, had begun studying law. Six months later, however, the army had decided he was healthy enough and he had been sent for training to a regiment of *cuirassiers* at Tours. In 1916 his division had been sent to the front, but Soupault had been one of several soldiers who had reacted badly to an experimental typhus serum. Some had died; Soupault had been seriously ill for three months, first at Creil and then in Paris at a military hospital on the Boulevard Raspail, Montparnasse. He had written poems, one of which he dared send to Apollinaire who passed it on to the editor of *Sic*, an avant-garde review which had taken the place of *Les Soirées de Paris*. In March 1917 Soupault's poem would appear in its pages. Louis Aragon was also in Paris, studying medicine at the Val-de-Grâce, the military hospital in Montparnasse. A precocious schoolboy, he had read most of the set books for the *baccalauréat* by the time he was eleven years old. Some sixty novels as well as a quantity of poetry had flowed from his pen before he left the Lycée Carnot at Neuilly. His closest friend at school had been Guy Renaudot d'Arc, although they disagreed on politics. Guy subscribed to the sabre-rattling opinions of *L'Action Française*, the royalist newspaper; Louis was already a man of the Left.

A few days before France declared war, the Socialists' policy of pacifism had been atrophied by the assassination of Jaurès, the leader of the party; it was an event that deeply shocked André Breton. When mobilization was ordered, there was no general strike. By the end of August two Socialist deputies had agreed to hold office in Viviani's government. The *union sacrée* was consummated and one of the highest principles of Socialism forsworn. The same happened in Germany and Britain. As the war went on, however, and the death toll mounted, the conscience of the Left began to rub. In September 1915 representatives from the Socialist parties of France, Germany, Italy, Russia and other, neutral, countries met at Zimmerwald in Switzerland and drew up a manifesto: '... Intellectual and moral desolation, economic disaster, political reaction – such are the blessings of this horrible struggle between the nations.' Merrheim, leader of the French metalworkers' union, was one of the signatories; Lenin was another. That same autumn, also from Switzerland, was heard the voice of the French novelist Romain Rolland. His judgement on the war, *Au-dessus de la Mêlée*, which was published in Geneva, was delivered in idealistic rather than ideological terms, but in it were found guilty the same forces of capitalism and militarism as had been condemned at Zimmerwald. Anatole France and André Gide might deplore Rolland's treason, but younger intellectuals recognized the truth of his words. During 1916 illegal pacifist tracts were circulating in all the large cities of France and by the end of the year about as many Socialists wanted to make peace as wanted to wage war. One of those who underwent the change of heart was the journalist Henri Barbusse who, in August 1914, had informed the editor of *L'Humanité*, the leading Socialist newspaper, that he was joining the army to fight militarism, imperialism and royalism. In August 1916, after he had been wounded at the front, the first part of his novel *Le Feu* appeared in the magazine *L'Oeuvre*. The book is a realistic account of trench warfare, and Barbusse censured not only the generals, but also the politicians and the profiteers who exploited the war.

After the fighting on the Marne in 1914, when the German guns had been quite audible on *les grands boulevards* and taxis had been requisitioned to take

Pablo Picasso in his studio on Boulevard
Clichy.

OPPOSITE Giorgio de Chirico: *The Uncertainty
of the Poet*, 1913 (Sir Roland Penrose
Collection, London).

reinforcements into battle, Paris settled down to the war. Although Métro and
bus services were curtailed, although there were shortages and Zeppelin raids,
the Parisians affected a bold insouciance which the soldiers sometimes found
insufferable. 'I am disgusted with Paris,' Apollinaire wrote to a friend on 26
August 1916; 'So little is being done here towards winning the war that I feel a
kind of despair.' Among the avant-garde artists despair was hidden behind a
façade of black humour. Picasso speculated on the days when his fellow artists
would sit at the café tables, their wooden legs propped on chairs, exchanging
reminiscences of the war. One night the composer Erik Satie, forced to take
refuge in an air-raid shelter, greeted the alarmed occupants: 'Good evening. I
have come to die with you.'

Satie wrote the music and Picasso designed the sets and costumes for
Parade, a ballet which was given its first performance at the Théâtre du
Châtelet on 18 May 1917. Written by Jean Cocteau, it was danced by Serge

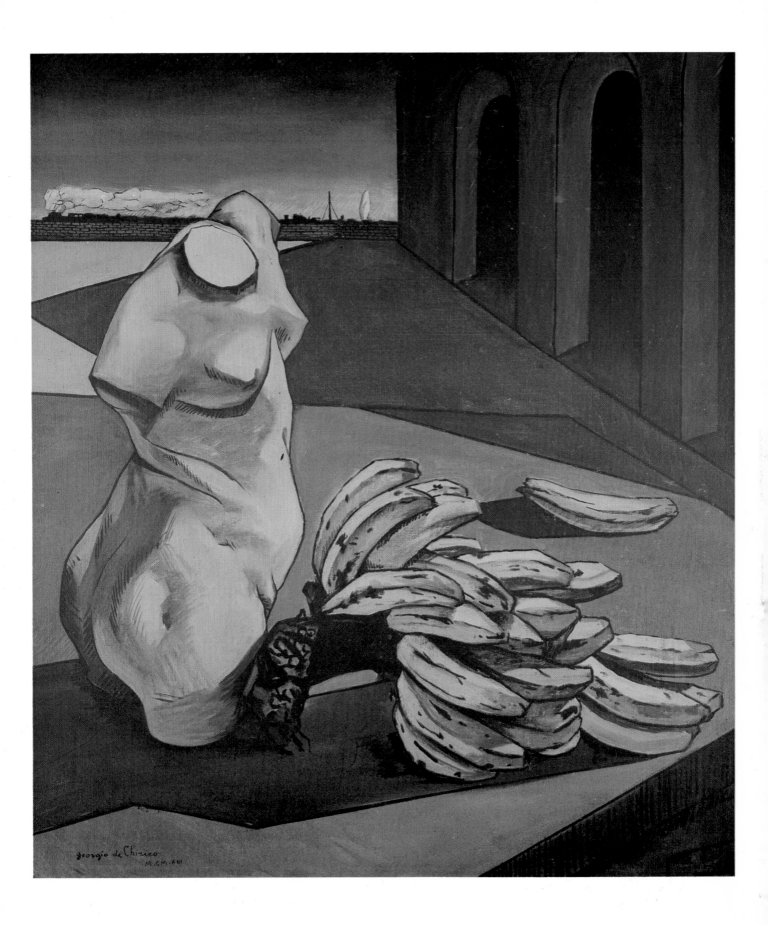

Diaghilev's Ballets Russes company. In its design, music and choreography *Parade* was progressive; the audience found it merely provocative. The décor was Cubist, the music included revolver shots and the noise of typewriters, the dancers did a one-step to ragtime. The bourgeoisie was baffled. '*Boches!*' they shouted. Shrill patriotism was heard everywhere in Paris that spring. In April the offensive which Nivelle, now commander-in-chief, had promised would break through the German lines had been a very limited success with heavy casualties. The eastern front had been seriously weakened by the dislocation of the Russian army after the February Revolution in Petrograd, and the German high command had been able to transfer divisions to France. Rumours had reached Paris of mutinies in the French army. They could only be explained, people said, by the demoralizing effects of Bolshevism. Increasing industrial unrest was certainly due, to an extent, to events in Russia. There were 697 strikes involving 294,000 workers during 1917, against 314 and 41,000 respectively the previous year. When Diaghilev, at pains to show solidarity with the new regime in Russia, unfurled the red flag at the gala opening of his ballet season on 11 May, it had been to the consternation and disgust of '*le Tout Paris*'. Coming a week later, the unintelligible absurdity of *Parade* seemed to be part of a plot to undermine morale by mocking clarity and reason, the traditional values of French culture. In the riot which followed the performance Apollinaire, in his officer's uniform and with his head still bandaged, had to protect the perpetrators of the ballet from enraged patriots. He had watched the final rehearsals in Paris and the paper *L'Excelsior* had published his advance notice on 11 May: 'Definitions of *Parade* are bursting out everywhere, like the lilac branches of this late spring', he wrote, and he suggested that the ballet's unity of design and dance gave rise 'to a kind of "*sur-réalisme*".' He saw in *Parade* the first manifestation of '*l'esprit nouveau*' which 'hopes to change art and manners from top to bottom, to the joy of all'.

One day that summer Apollinaire introduced Breton to Soupault. They were both becoming known to the avante-garde through their poetry which was published in the reviews *Sic* and *Nord-Sud*. Soupault's work was full of the images of modern life; Breton's was more introspective. Both were accepted at meetings of the Lyre et Palette group held at 6 Rue Huyghens, where Apollinaire, Max Jacob, Blaise Cendrars or Pierre Reverdy might read poetry, and where paintings by Juan Gris or Gino Severini might be hanging on the walls and music by Satie or Poulenc might be performed. They attended similar gatherings at the galleries of Léonce Rosenberg and Paul Guillaume, dealers in modern paintings and primitive art. At the home of Jean Royère, the editor of *La Phalange*, Breton was among those who heard Valéry read from *La Jeune Parque*, the first poetry he had written since the 1890s. Both Breton and Soupault used to visit La Maison des Amis des Livres, a bookstore in the Rue de l'Odéon which was run by Adrienne Monnier. A plump, blonde girl in her twenties, she had opened her small shop, which was also a lending library, in 1915. Jacques Prévert described the establishment as 'a fairground booth, a temple, an igloo, the wings of a theatre, a museum of waxworks and dreams, a reading-room and sometimes just a bookshop. ...' Many years later Adrienne recalled the fury with which Breton and Soupault condemned the war. She remembered arguing with Breton about Novalis, Rimbaud and the occult. She read his palm and was struck by a strange head-line which indicated a preoccupation with insanity and all kinds of mental disorder. One day at

Adrienne's, towards the end of 1917, Breton, who had been sent on a course at the Val-de-Grâce, recognized a young man studying at the same hospital; he had particularly noticed this student because he too seemed to disdain the japes from which most of their fellows seldom desisted. Adrienne introduced them to each other; Louis Aragon and André Breton shook hands. Aragon had felt intellectually isolated and his acquaintance with Breton came as a great relief. Soon they shared a study at the Val-de-Grâce which they decorated with pictures by Cézanne, Picasso, Braque, Matisse and Chagall; their officers were quite shocked. As soon as Soupault returned from a holiday, Aragon arranged to meet him. At that time the three future Surrealists cultivated an air of resigned cynicism, waiting passively for the surprises of life and love. Their inspiration was Lafcadio, the hero of André Gide's novel *Les Caves du Vatican*, published in 1914. Lafcadio was detached and blasé, a dandy who wanted his only creation to be a futile, purely disinterested deed.

Adrienne Monnier, about 1917.

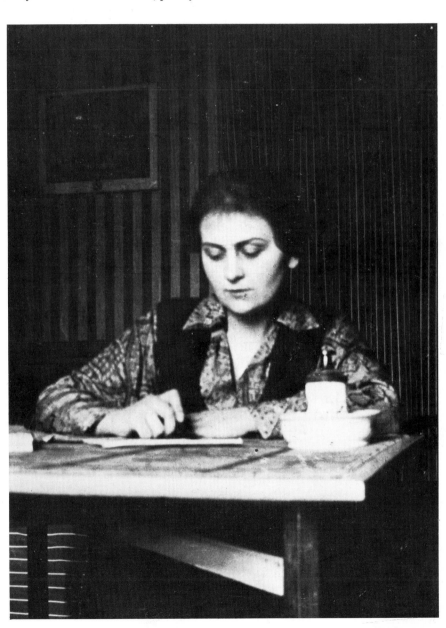

FOLLOWING PAGES Max Ernst: *The Meeting of Friends*, 1922 (Lydia Bau Collection, Hamburg).

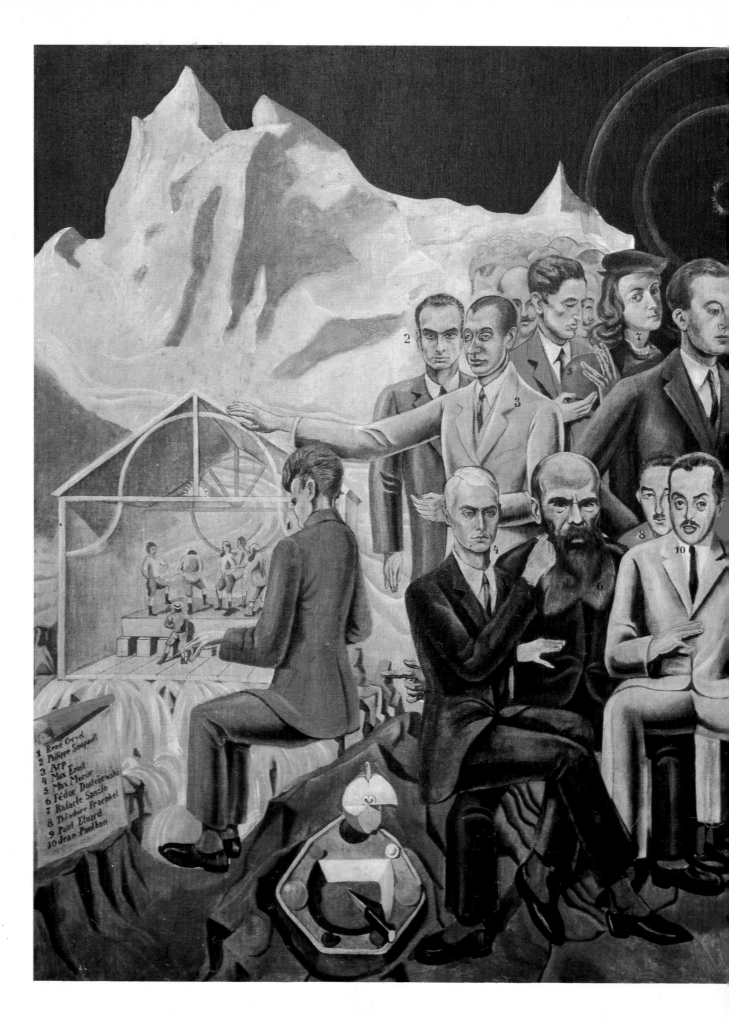

1 René Crevel
2 Philippe Soupault
3 Arp
4 Max Morise
5 Fédor Dostojewski
6 Raffaele Sanzio
7 Théodore Fraenkel
8 Paul Eluard
9
10 Jean Paulhan

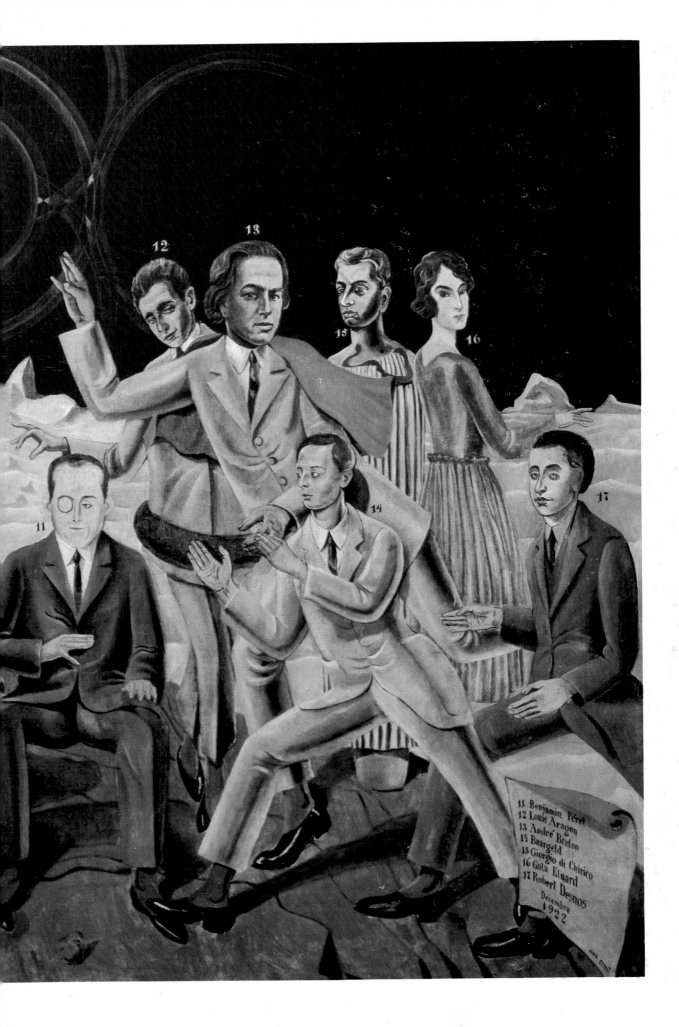

11 Benjamin Péret
12 Louis Aragon
13 André Breton
14 Baargeld
15 Giorgio di Chirico
16 Gala Eluard
17 Robert Desnos
Décembre
1922

A ward in the Second Army psychiatric centre at St Dizier in 1916. André Breton is second from left.

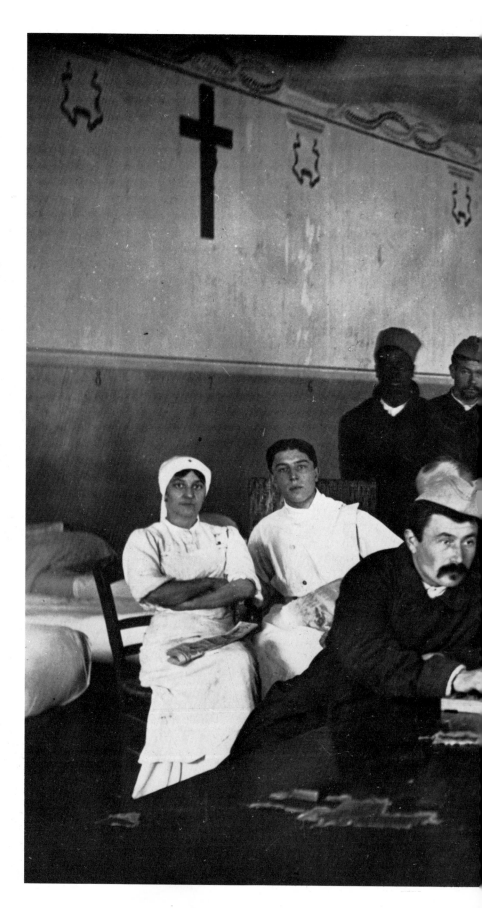

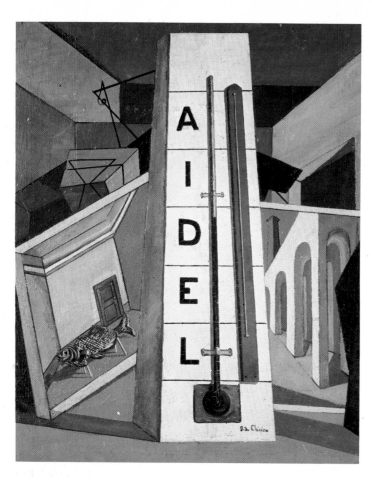

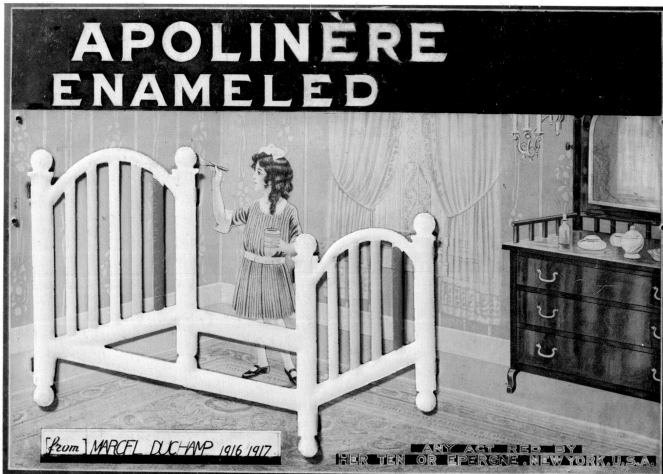

At Nantes, Breton had met an incarnation of Lafcadio, a young soldier wounded in the leg who would spend hours each morning in hospital arranging the few objects on his bedside table with the most careful aesthetic consideration. His name was Jacques Vaché and he had been a student of the Ecole des Beaux-Arts in Paris. In one of his letters to Breton he wrote: 'I concede a little affection for LAFCADIO because he doesn't read and produces only by amusing experiments, like the murder – and then without satanic lyricism.' When he was released from hospital Vaché stayed in Nantes, working at the wharves on the Loire. He wore a series of different uniforms from day to day, and usually had a monocle in his left eye. He adopted different aliases as well as different guises. Life for him was only tolerable if one kept up constantly shifting pretences. Together Vaché and Breton used to go to the cinema, any cinema, and from cinema to cinema, always being sure to miss the beginning or end of a film. The point of this exercise was to create a meaningless succession of vignettes, a montage of non-sequiturs which possessed the charm of random juxtapositions. 'Art is folly', said Vaché, who cared only for the absurd and opium.

Breton retailed his experiences in Nantes to his new friends in Paris. He also told them about developments in psychology. A few months in Vaché's company had induced a crisis in Breton's mind. If life was meaningless, art a delusion, he would search the soul for a significant reality. He had decided to abandon literature and undertake an intense study of psychology. At the neurological hospital in St Dizier, a posting for which he had applied, he had worked under Dr Leroy, a former colleague of Jean-Martin Charcot. In the last decades of the nineteenth century, Charcot had pioneered the treatment of hysteria by hypnosis; he had been nicknamed 'Napoleon of neuroses'. With Dr Leroy as his mentor, Breton at St Dizier had immersed himself in the theory and practice of classical psychology. He had been involved in the treatment of a paranoid case, a soldier who did not believe in the reality of the war: the wounded and dead were faked, the gunfire was a hoax. He had stood on the trench parapet to show that he was right and, remarkably, had not been shot. Breton had wondered if there was a point at which reality and illusion might merge. He had become engrossed in Freud's theories, learning about the trauma, the unconscious, the repression of complexes and the interpretation of dreams. From the work of Emil Kraepelin he had assimilated the theory of word association which seemed to be a completely new poetic stimulus. On 25 September 1916, in a letter to an old schoolfriend, he had written:

> Dementia praecox, paranoia, twilight states,
> O poetry of Germany, Freud and Kraepelin!

Towards the end of 1917 Breton's ideas had been assimilated by Soupault and Aragon. In October a collection of Soupault's poems, *Aquarium*, was published in which the poet had persisted in themes drawn from the city lit by electricity, high-speed travel and modern technology. But in November his poem 'Miroir' was published in *Sic*; it is a hymn to the irrational, water from the well of the unconscious. Breton and Aragon contributed poems of that nature to *Sic* and *Nord-Sud* during 1918. In Apollinaire's *Le Poète Assassiné*, published in 1916, the poet Croniamental's death is demanded by Horace Tograth, the man of science. In his indictment of the poet Tograth declares: 'The prizes that are awarded to them [the poets] rightfully belong to workers,

OPPOSITE ABOVE Giorgio de Chirico:
The Dream of Tobias, c. 1914 (Edward James Foundation).
OPPOSITE BELOW Marcel Duchamp:
Apolinère Enameled, 1916–17 (Philadelphia Museum of Art).

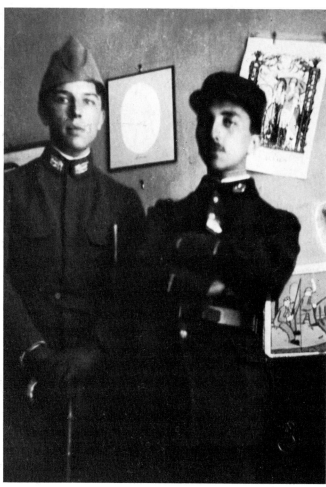

RIGHT André Breton and Théodore Fraenkel
in Paris, about 1917.
BELOW LEFT Louis Aragon, the medical
student.
BELOW RIGHT Made during the First World
War, this drawing by Jacques Vaché reflects his
disdain for the hostilities.

Pablo Picasso: *Jean Cocteau*, 1917 (Private Collection). Picasso made this drawing of Cocteau while they were working together in Rome on rehearsals for the ballet *Parade*.

Pablo Picasso: *Erik Satie*, 1920 (Private Collection). A style of drawing adopted about 1915, and derived from the portraits of Ingres.

inventors, research men. . . .' To Breton and his friends it was not enough to write poetry about science or even inspired by science; the poet should be a scientist himself and his poetry a scientific investigation. As Vaché wrote to Breton: 'We no longer know who Apollinaire is – BECAUSE – we suspect him of producing art too consciously, of stitching up romanticism with telephone wire, and of not knowing that the dynamos THE STARS are still disconnected!' Apollinaire's play *Les Mamelles de Tirésias*, which he called a 'surrealist drama' was performed on 24 June 1917 at the Conservatoire René Maubel, a small theatre in Montmartre. It was criticized for the obscurity of its symbolism. At the end of the first act Vaché, who was with Breton, stood up brandishing a pistol, a gesture of scorn for not only the author's pretensions but also the audience's tumultuous reactions. In the autumn Apollinaire gave a lecture at the Théâtre du Vieux Colombier on '*L'Esprit nouveau* and the poets'. He spoke of the new spirit being 'often content with experiments, with investigation, without being concerned with any lyrical significance', and he referred to poets who 'will lead you, alive and awake, into the nocturnal closed world of the dream'.

The contribution which was being made by Breton and his friends was recognized by Apollinaire. But he attached greater importance to another, more widespread, tendency in modern art. 'The new spirit speaks above all in the name of order and moral responsibility, which are the great classical qualities, the highest demonstration of the French spirit', he said at the Vieux Colombier. In 1915, Picasso had started making drawings in the style of Ingres, prompted by an admiration for the French painter's work and an interest in his subtle distortions of the figure. Picasso's unexpected excursion out of Cubism impressed his French admirers, many of whom, under stress of war, were turning to the logic and serenity of their national culture. Since the audience at the first performance of *Parade* had cried '*Boches!*' patriotic fervour had waxed as the hopes of victory over the Germans had waned. Pacifists and defeatists were pilloried in the press. Every official who did not show ruthless bellicosity towards the enemy was suspected of being in the pay of the Germans. Much of the acrimony was focused on Malvy, the Radical-Socialist Minister of the Interior, who numbered among his friends many whose enthusiasm for the war was lukewarm. Georges Clemenceau told him in the Chamber: 'You have betrayed the interests of France.' In *L'Action Française* Léon Daudet, the editor, accused Malvy of betraying to the enemy plans for a French offensive. At the end of August the minister resigned and the government fell. The new administration, led by Painlevé, seemed to be no better equipped to deal with a rapidly worsening situation. The British army was seriously weakened by the blood-letting at Passchendaele, the Italian army was routed at Caporetto and after the October Revolution in Petrograd the Russian army was practically out of action. Clemenceau was unremitting in his attacks on the then government's incompetence and, although almost friendless in the Chamber, he had one strong bond with Poincaré, the President: they both remembered 1870. On 13 November, Painlevé's government fell and Clemenceau was called upon to form a new administration. 'Home policy? I wage war!' said Clemenceau, 'Foreign policy? I wage war! All the time I wage war!'

Many French artists waged war by rallying to the classical canon of reason, order and clarity, the qualities of the highest French art. It was not coincidental that two of the leaders of this movement, Jean Cocteau and Amédée Ozenfant,

27

RIGHT Sigmund Freud, the psychoanalyst.
BELOW Jean–Martin Charcot giving a lecture at
the *Salpêtrière* in 1887. Dr Babinski is
supporting the patient.

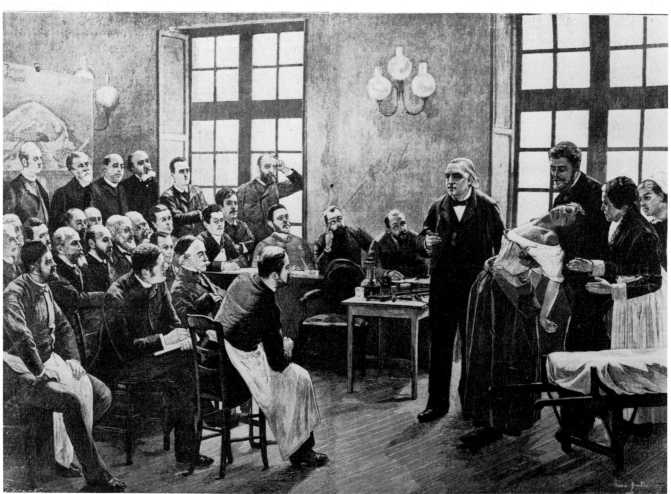

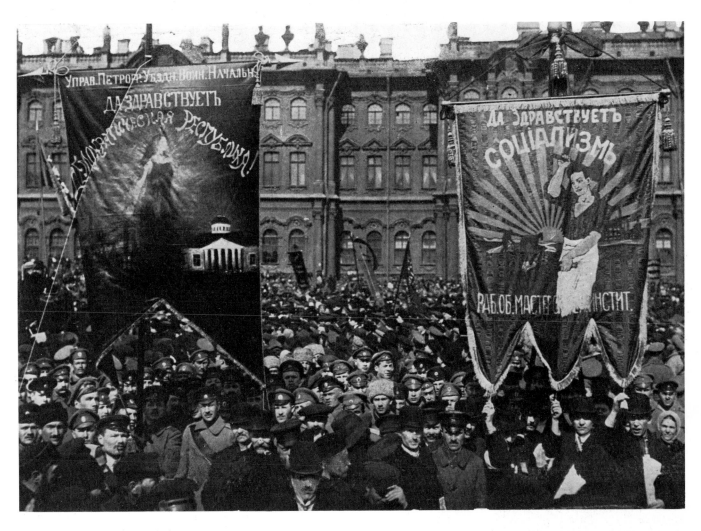

The Russian revolution. A crowd of Bolsheviks demonstrating in front of the Winter Palace.

had been the editors of intellectual reviews with a strong chauvinistic bias, *Le Mot* and *L'Elan* respectively. In the spring of 1918 appeared Cocteau's *Le Coq et l'Arlequin*, a critique of modern music. The frontispiece was a portrait of the author drawn by Picasso in the style of Ingres and in the text Cocteau exhorted composers to abandon Wagnerism and demanded 'purely French music'. His hero was Satie who, as a Communist, was unlikely to join in any kind of patriotic clamour, but who that summer finished *Socrate*, a '*drame symphonique*'. It is a setting to music, which is bare and lucid, of Victor Cousin's translation of the Platonic dialogues. In the preface the composer wrote: 'This method of drawing with a precise and severe line is rather as if Ingres had illustrated these passages from Plato at the request of Victor Cousin.' Ozenfant was applying the same principles of clarity and precision to Cubist painting, referring at the same time to classicism and machinery, both of which are ordered according to numerical laws.

Breton and his friends must have been aghast at the avant-garde's predilection for the classical tradition in French art. Their theories were nourished on nineteenth-century German romanticism and the work of contemporary German or Austrian psychologists. Their allegiance was international; chauvinism seemed to them to have been a greater factor in starting, rather than it was likely to be in ending, the horrors of war. It was the

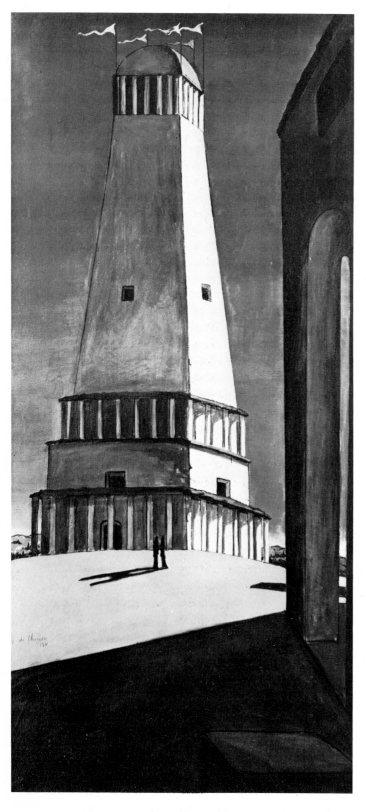

bejewelled shadows and obsessive images in Gustave Moreau's painted world rather than the clear composure and bourgeois probity of Ingres' portraits which had inspired them. Their poetical heritage was Symbolism. Rimbaud's torments and Mallarmés hidden meanings filled their own poetry. In 1919 Breton published *Mont-de-Piété*, a collection of verse impregnated with the influence of Stéphane Mallarmé, whose daughter he had often visited in Nantes. The Symbolist Valéry had given him the introduction and had himself helped to form Breton's ideas about poetry. Apollinaire's intellectual roots were in Symbolism and Breton preferred some of his poems which had been written before 1910 to much of his later work. At Apollinaire's apartment, Breton, Soupault and Aragon saw his collection of paintings which included not only works by Picasso, Braque and other Cubists, but also the strange visions painted by Douanier Rousseau, Chagall's fantasies and, above all, Giorgio de Chirico's evocations of the subconscious. Apollinaire and Paul Guillaume had admired de Chirico's work when the artist was in Paris during the first two years of the war, and had sometimes suggested titles for his paintings. At Guillaume's gallery, as well as de Chirico's, there was primitive art to be seen. Apollinaire had collaborated with the dealer on catalogues for his exhibitions of African and Oceanic art. It was the emotive power of the idols and fetishes from Oceania which appealed to Breton rather than the more aesthetic, formal values of African sculpture. Before he left school Breton had purchased, with money he won as a prize, a fetish object from the South Seas, and from 1910 he could have visited the collection of Oceanic art which was put on show that year at the Trocadéro. He may well have read Emil Durkheim's book, published in 1912, on the mystical power, *mana*, of the totems and other religious images of Australia.

A book was published in Paris in 1917 which illustrates by contrast what significance the future Surrealists attached to the unconscious. *L'Hérédo* is a book of speculative psychology dividing human personality into the ego and the self; the author asserts that when the ego dominates there is strife between the conscious and the unconscious, between conscious perceptions, aspirations and memories and unconscious hereditary influences and psychic automatisms. Only when the self governs the personality is the man well-balanced, capable of insight and moral courage, and it is only the self-possessed man who can be a hero or a creative genius. Furthermore, imagination is a function of the self by which a man can discard his noxious hereditary influences and retain only the images inherited from wise ancestors. Breton's view was the reverse: mental disorders are sources of the images from which poetry should be created. The greater the disorientation of his mind, the more meaningful will be an artist's creations. To add antipathy to antithesis, the author of *L'Hérédo* was the militarist and royalist Léon Daudet, a leading member of Charles Maurras' Action Française movement. Maurras' concept of a hierarchical society was derived, in part, from the science and literature of Classical Greece.

During the first half of 1918 the German high command, aware that defeat was inevitable once the American army was in the field and American industry was supplying the Allies with fresh armaments, ordered an all-out offensive. It was successful at first, but in the summer superior manpower and equipment began to tell. The Germans fell back, and this time not to defensive positions on French territory. Now they were beaten, and rather than have their army routed the generals advised the Kaiser to abdicate and the government to make

OPPOSITE LEFT Giorgio de Chirico: *The Nostalgia of the Infinite*, c. 1913 (Museum of Modern Art, New York). Apollinaire immediately responded to the mystery and sexual symbolism of de Chirico's art. The artist has mis-dated this picture '1911' on the canvas.

OPPOSITE RIGHT Giorgio de Chirico: *The Poet's Dream*, 1914 (Peggy Guggenheim Foundation, Venice).

BELOW Léon Daudet, son of the author Alphonse Daudet. He devoted his considerable literary talents to the cause of the French monarchy, principally in the columns of the newspaper *L'Action Française*. This photograph was taken at the time of his election to the Chamber of Deputies in 1919.

The Armistice agreement was signed on 11 November 1918, and redundant armaments were heaped in the Place de la Concorde, mockingly garlanded.

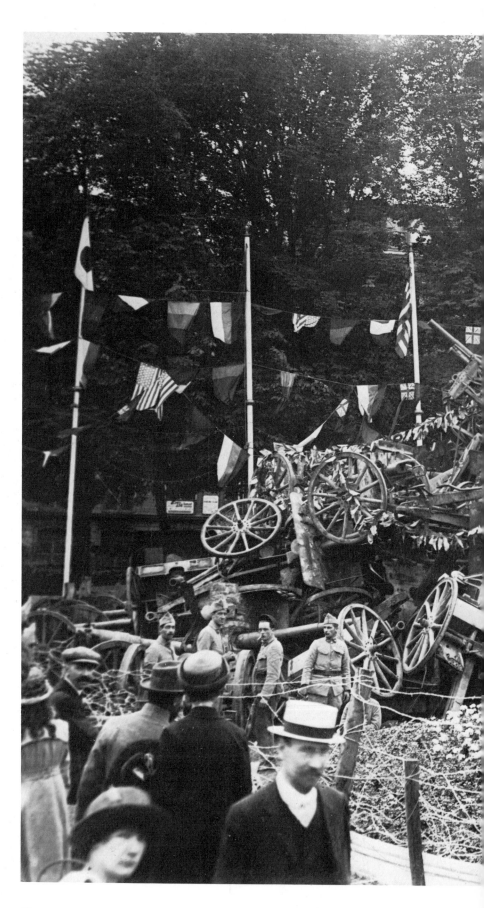

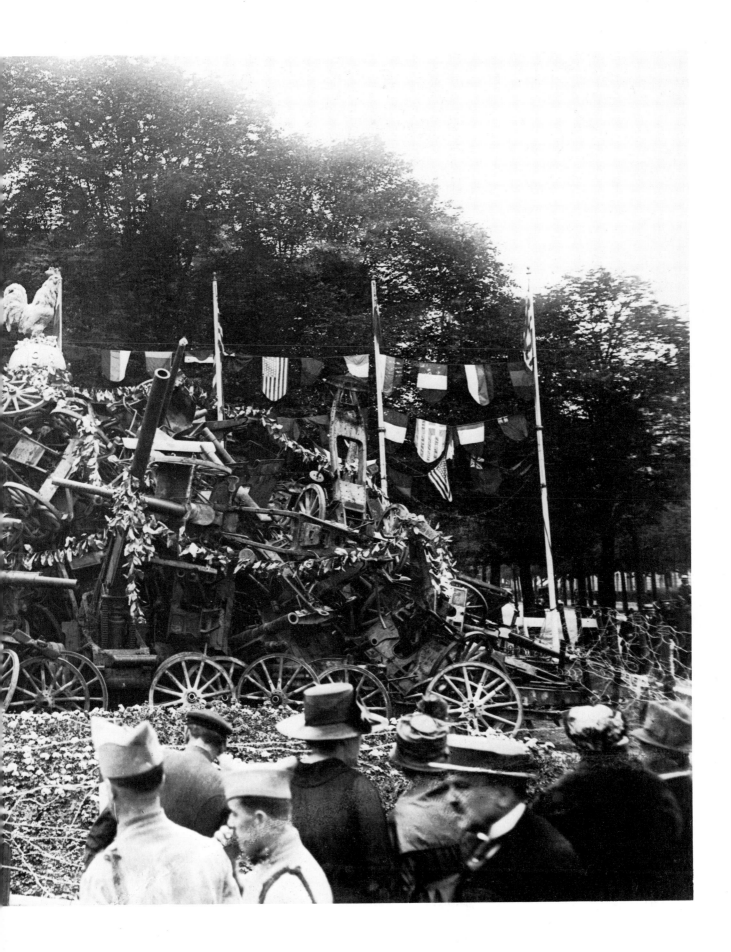

OPPOSITE Jean Cocteau: *Portrait of Guillaume Apollinaire*, *c*. 1917 (Private Collection). Cocteau's acquaintance with Picasso and Satie led him to adopt some of the superficialities of avant-garde art. Apollinaire's head was heavily bandaged at this time after the trepannation he underwent for the removal of shell splinters.

RIGHT Théodore Fraenkel's ironic comment on war-time patriotism, 1916 (Private Collection).

in the folds of the Flag

peace. The Allies demanded unconditional surrender and the Germans, trusting that President Wilson's high-mindedness would make the terms of peace acceptable, capitulated. Two days before the Armistice was signed Apollinaire died at his apartment on the Boulevard St Germain, a victim of the flu epidemic which was ravaging Europe. Not only had he bequeathed to Breton, Soupault and Aragon the name by which their movement would be known, not only had he contributed some of its ideas and fostered others, but also, through him, they had gained a position in the insidious arena of avant-garde polemics. In 1926 Soupault wrote of Apollinaire: 'It is ... thanks to him that poetry was revived. . . . All he had to do was to write a poem and immediately many poems would be born.' And Apollinaire had said of Breton: 'I know no one who can speak as well as you can about what I have done.'

The Armistice was signed. The war had been won and lost. On 11 November a huge crowd gathered outside the War Office in Paris and roared for Clemenceau. He opened a window, looked down on the crowd and shouted: '*Vive la France*!' As soon as he could he escaped to Giverny where he loved to relax, as he had often done through the years, in the garden of his old friend Claude Monet. He told the painter of France's triumph. 'Yes', said Monet, 'now we have time to get on with the monument to Cézanne.' But there appeared in Adrienne Monnier's bookshop that month a new number of a review called *391*; printed on bright pink paper was the legend: 'I have a horror of Cézanne's painting, it bores me stiff.' Francis Picabia, the review's editor, was an old friend of Apollinaire's. He was a painter whose work had developed from post-Impressionist landscapes to diagrams of mechanical eroticism. During the war he had been to New York, Barcelona and Lausanne before reaching Zurich where he made contact with a group of poets and painters who gave their activities the name 'Dada'.

Tonsure de 1919 – Paris
Marcel Duchamp

2 'The Great Enemy Was the Public'

OPPOSITE Marcel Duchamp's return to Paris
after the First World War restored to avant-
garde art the elements of humour and wonder
which might have disappeared on the death of
Guillaume Apollinaire.

Dada started in Zurich during the Great War, in the street where Lenin was living. It was 1916; young artists, some German, some Romanian, some Swiss and an Alsatian, founded the Cabaret Voltaire. They developed a form of entertainment with ingredients from the café concerts of pre-war Munich and the Futurist demonstrations of pre-war Milan. Disgusted with the death and destruction from which they had escaped to neutral Switzerland they showed in their antics a nihilist attitude to art, and to society. The good citizens of Zurich were amazed, amused or appalled. 'Every evening Beauty or the Absurd took charge of our visitors', wrote Tristan Tzara, a Romanian poet who took a leading role from the beginning, 'none was spared – and the wind blew at gale force. Conscience after conscience was knocked sideways – it was like an avalanche . . . wisdom and madness were side by side, and none knew where the frontier lay.' They read poetry, they sang, they danced, and sometimes they just shouted, so exhilarated was their defiance of the world at war. Then they began to organize lectures and exhibitions of paintings and tapestries. The first number of their review, *Dada*, was published in July 1917. Copies reached Paris and Apollinaire showed one to Breton and Soupault.

Tristan Tzara, photographed in Zurich in 1917.

Manic shrieks from Zurich did not seem as destructive as Vaché's annihilation by sardonic indifference. Breton called his friend 'a past master in the art of attaching little or no importance to anything'. But he attached too little importance to life, and suddenly, in January 1919, he was dead. Apparently, he committed suicide by taking an overdose of opium. A friend who was inexperienced in using the drug died with him, having taken an equal dose. Was this Vaché's final gesture of contempt, murder and suicide together? The Surrealists would always believe it was so. Now Tzara assumed greater importance. Besides, at the end of 1918 there had appeared the third number of *Dada* which had contained the *Manifeste Dada 1918* written by Tzara. He asserted the importance of chance and surprise; he warned against the danger of psychoanalysis which puts to sleep man's irrational fantasies. On 22 January, Breton wrote to him: 'Your manifesto has made me really enthusiastic.' Breton, Soupault and Aragon contributed to the next issue of *Dada*, and Tzara's manifesto was printed in their review *Littérature*.

Publication of *Nord-Sud* had ended, and the Futurism in *Sic* now seemed *passé*. There was room for a new literary review. Breton and Soupault, as heirs of Apollinaire, were in an appropriate position from which to launch a magazine that would encompass the gamut of the '*esprit nouveau*'. The name *Littérature*, suggested by Paul Valéry, was an ironic allusion to Verlaine's *Art Poétique* which ends: 'And all the rest is literature.' The choice of this title for

DADA 3

Directeur :
TRISTAN TZARA

Bois de M. Janco.

Je ne veux même pas savoir s'il y a eu des hommes avant moi. (Descartes)

Administration

Mouvement DADA

Zurich

Zeltweg 83

Fr. **1.50**

the review was as anti-art and self-mocking as Dada. But if Breton, Soupault and Aragon wanted to destroy forever what Vaché had derided as '*le pohème*' they conscientiously maintained an intellectual susceptibility. As in life, so in literature; they would be available, always hoping to be surprised. Contributions were sought from writers of many diverse tendencies: established authors including Valéry and Gide, young writers like Pierre Drieu la Rochelle and Raymond Radiguet besides Breton and his associates, popular writers such as Rachilde and Jules Mary.

Gabrielle Buffet-Picabia once recalled: 'The spirit which had blown so hard and ardently degenerated in the post-war climate of Paris into a battle of clans, or even of individuals.' A notorious hatred was Breton's for Jean Cocteau, and *Littérature* never included a contribution from him. Apollinaire had never shown much esteem for the author of *Potomak*. For years he had left the manuscript of Cocteau's novel unattended in the offices of the *Mercure de France*. Three weeks after Apollinaire's death, Breton had been one of a small group to whom Cocteau had read his new poem *Le Cap de Bonne-Espérance*; at the end Breton had only grimaced. 'My opinion – completely disinterested, I swear – is that he is the most hateful being of our time', Breton wrote to Tzara, 'And I repeat, he never did anything against me, and I assure you that hatred is not my strong point.' In 1922 he would refer to Cocteau as 'living on the corpses of his forerunners'. How could Breton, who was searching for the key to man's soul, admire Cocteau, the frivolous plagiarist? How could Breton, who despised nationalism, applaud Cocteau, the anti-German propagandist of *Le Mot* and *Le Coq et l'Arlequin*? How could the left-wing Breton feel affection for Cocteau the socialite, who had many close friends among the *haute-bourgeoisie* including Etienne de Beaumont and Léon Daudet's brother, Lucien? Or the anti-clerical Breton love the friend of Abbé Mugnier, the most fashionable confessor in Paris? Cocteau was excluded from the pages of *Littérature*.

But Breton did not let his distrust of Cocteau inhibit the editors' policy of keeping *Littérature* open to representatives of the various intellectual factions, 'clans'. Among the contributors was Raymond Radiguet, Cocteau's teenage protégé, who was the spokesman for the traditional French literature which his 'second father' admired. Ideas about modern music were aired in articles written by Darius Milhaud and Georges Auric, two of Les Six, the group of composers who regarded Satie as their master and Cocteau as their friend and champion. The work of the poet Blaise Cendrars, too, was printed in *Littérature* despite his collaboration with Cocteau the year before, when together they had founded a new publishing house, Les Editions de la Sirène. Several artists were following Ozenfant's lead, working in a rigorously measured Cubist style. The group showed their paintings and sculptures at Léonce Rosenberg's Galerie de l'Effort Moderne. The artistic opinion of this group was about as far removed as possible from the personal views of the future Surrealists. Nevertheless, for some months the art critic on their review was Maurice Raynal who had written for Apollinaire's *Les Soirées de Paris*. In 1919 he was the author of a pamphlet '*Quelques Intentions du Cubisme*', which was based on a debate held at the Galerie de l'Effort Moderne: he declared that artistic creation should be intuitive but intuition should be subject to '*la science de la mesure*'.

Breton, Soupault and Aragon, of course, used their review to publicize their own theories and insights. Some of Vaché's letters were printed as well as

OPPOSITE The cover of *Dada* no. 3, which contained Tzara's *Manifeste Dada 1918*.

BELOW This photograph of Jacques Vaché, through which he had fired a bullet, was adduced as evidence that he had deliberately ended his life by taking an overdose.

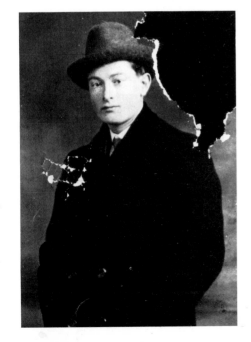

OPPOSITE Jean Cocteau, about 1920. Breton's antipathy to him became legendary in Paris during the early twenties.

unpublished texts by Mallarmé, Rimbaud and Apollinaire. In an early number of *Littérature* appeared the *Poésies* by Isidore Ducasse who in 1869, under the alias of the Comte de Lautréamont, had written *Les Chants de Maldoror*, a prose poem little known until Breton made it one of the major texts of Surrealist thought. In *Les Chants*, Lautréamont describes a totally disorientated universe where the accepted hierarchy of God, man and animals is questioned and subverted. Lautréamont's notion of beauty was that it resided in the irrational convergence of disparate objects, 'the chance meeting on a dissecting-table of a sewing machine and an umbrella.' Soupault and Aragon regularly reviewed literature, drama and films.

RIGHT Pearl White, star of *The Perils of Pauline* and *The Exploits of Elaine*, film serials which were rapturously followed by Breton and his friends.

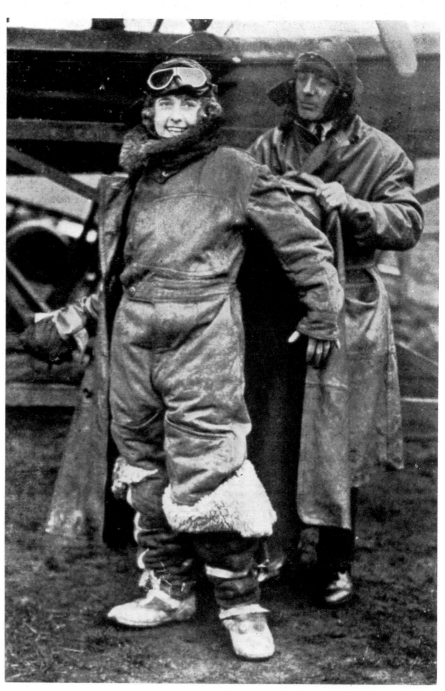

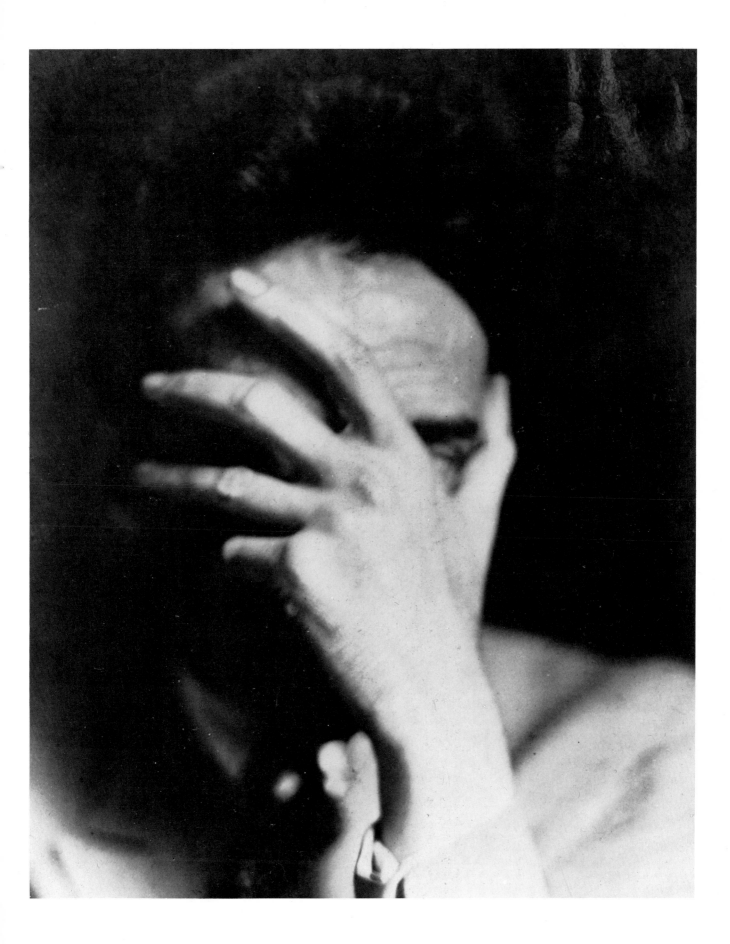

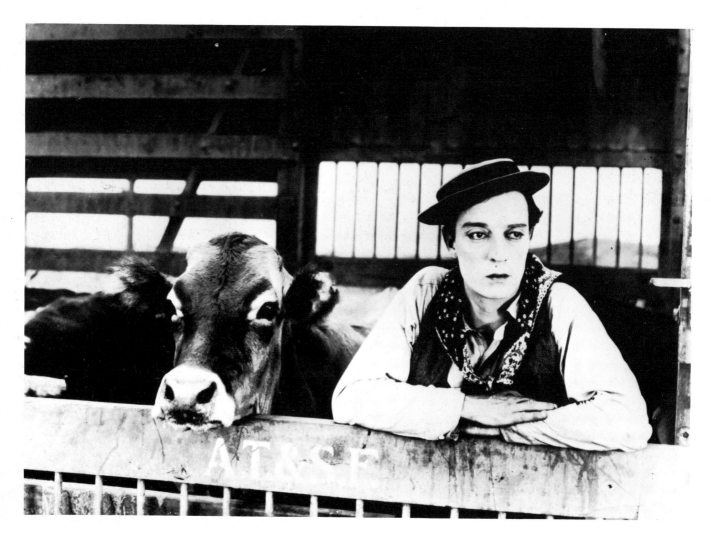

The cinema became one of the Parisians' chief pleasures in the months after the Armistice. Through the presence of American troops in the city during the war a familiarity with jazz, cocktails and the movies had developed which outstayed their departure. Maurice Sachs, who described himself as a young bourgeois at the time, confided to his diary in September 1919 that he preferred the cinema to the theatre, and the next month recorded the fact that there were eleven cinemas in Paris already. The artists and poets of the avant-garde had appreciated the cinema for some years; Apollinaire had sung its praises. What had mainly been admired about the new medium was its potential and its modernity. But the future Surrealists elicited from the cinema the magic and absurdity which Breton and Vaché had discovered. Soupault wrote: 'At the time we were developing surrealism the cinema was an immense revelation to us.' The silent, black and white, flickering images on the screen were, in the opinion of Aragon writing in *Le Film* in 1918, an antidote to the realism and verbiage of the theatre. There was a hypnotic attraction in films where acting gave way to the direct expression of instinct and emotion.

In 1919 Breton, Soupault and Aragon particularly enjoyed the American serial *The Exploits of Elaine*, known in France as *Les Mystères de New York*; Elaine was played by Pearl White. A point of intense debate among them was over the comparative merits of this series and the *Perils of Pauline*, another

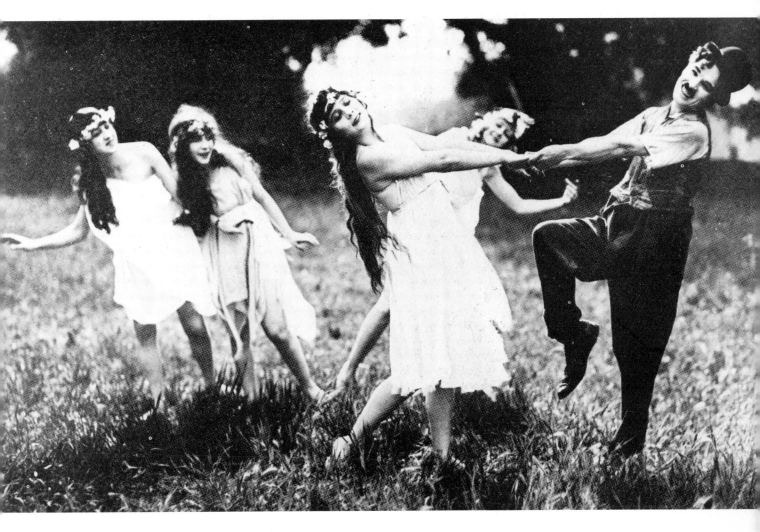

OPPOSITE Buster Keaton, known to his enthusiastic admirers in France as 'Malek'. This still is from *Go West*.

ABOVE Charlie Chaplin in *Sunny Side*, 1920.

serial in which Pearl White starred. The absurdity of Elaine's adventures was matched, in their estimation, by the phantasmagoria of *Judex* and *The Vampires*, films made by Louis Feuillade. In *The Vampires* Musidora evoked all the eroticism of terror; she was a phantom of unconscious desires. There was slapstick, too, with its mental and moral liberation, so simply accomplished in the clowning of Mack Sennett, Harold Lloyd, Buster Keaton and, above all, Charlie Chaplin. Reviewing a Chaplin film in *Littérature* in 1919, Soupault wrote: 'In every town the restaurant dining-rooms are warm. We no longer think, we look at the customers' faces, the door or the light. Do we know whether to leave now or pay? Doesn't the present minute suffice? All we can do is laugh at all that disturbs us.'

In June 1919, Breton and Soupault collaborated on what was the first important Surrealist work. For two weeks, at Breton's apartment in the Place du Panthéon, each tried to write down what was dictated to him by his unconscious. They hoped to produce automatic texts incorporating images which would materialize through a kind of trance. In turn, one of them became the medium retrieving the images from his unconscious while the other recorded what he said. Chance should come into play and texts were created by alternating their roles sentence by sentence. *Les Champs Magnétiques* was the title they gave the results of their experiment. Breton frequently used analogies

45

from the realm of electricity and here 'magnetic' also alludes to psychology. 'Magnetism' was the term signifying the power to draw an ailment from a patient by means of hypnosis, a power which had been in the eighteenth century the property, notably, of Mesmer. In the nineteenth century magnetism was the premise from which Charcot had developed his method of treating hysteria by hypnosis. Behind *Les Champs Magnétiques* lay all the hours Breton had spent studying psychology. The texts were derived not only from Freud's investigations into the imagery of dreams, but also from the research carried out by Théodore Flournoy with the medium Catherine Muller, usually known by her pseudonym, Hélène Smith. For five years, from 1894 to 1899, Flournoy followed her apparently irrational ramblings while she was in a state of trance. Sometimes she was an Indian princess, sometimes Marie Antoinette, and sometimes she talked of her visit to the planet Mars, its customs, people and even its language. What Flournoy discovered was that there was a psychological truth in her pronouncements and that in a fully somnambulistic state her normal range of creativity was enormously widened. In 1900, Flournoy published an account of his findings, *From India to the Planet Mars*, and in 1908 the paintings which Hélène Smith had executed in a state of trance were exhibited in Geneva and Paris. The texts written by Breton and Soupault are full of references to their current enthusiasms: for Lautréamont, 'There is in deepest Africa a lake peopled by male insects who know how to die only at the end of the day'; and for the cinema, 'We were shown round factories producing bargain dreams and stores filled with dark dramas. It was a magnificent cinema. . . .'

'To hell with logic', said President Wilson as he saw his ideals bowing a little lower each day beneath the weight of the victors' realpolitik. The negotiations at Versailles came to an end the same month Breton and Soupault were working on *Les Champs Magnétiques* at the Place du Panthéon. The peace imposed on Germany was humiliating. The vindictive and intransigent stance taken by Clemenceau and Lloyd George in their treatment of the defeated was a true reflection of the opinion held by the greater part of each of their electorates. Hatred had not expired in the last salvo. Patriotic fervour persisted in France and as the elections of November approached the parties of the Right exploited the sentiment. Now it was the Bolshevik menace from which France had to be protected. Millerand, in a speech at the Ba-Ta-Clan dance hall in Paris, called for a Bloc National, a union of the parties which condemned Communism and distrusted internationalism. The danger of revolution was slight, but the militancy of some trade unions agitated the Capitalist establishment. On 1 May there was a riot in Paris; several demonstrators were killed by the police. They were protesting against the rising cost of living, France's military intervention on the Tsarist side in the Russian civil war, and the almost imperceptible rate of demobilization. But powerful financial interests wanted the services kept under arms; huge amounts of French capital had been invested in Russia, money which could only be recovered through the defeat of the Bolsheviks. The Union of Economic Interests, representing, among others, the steel industry and the Regents of the Bank of France, paid for the printing and distribution of a poster which showed the savage Bolshevik holding between his teeth a dagger dripping with blood.

The Socialists were in disarray. The Third International had been set up by the Russian Communists in March and now the question of whether or not to

RIGHT Georges Clemenceau, Woodrow Wilson and David Lloyd-George during the negotiations of the Treaty of Versailles.

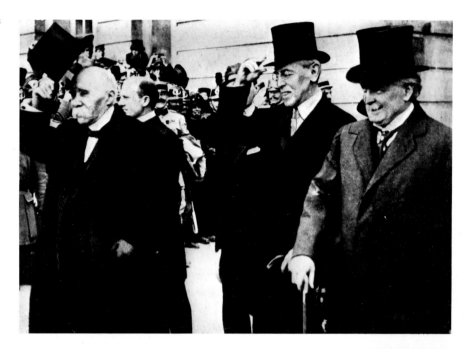

BELOW The Treaty was signed here in the Hall of Mirrors at the Palace of Versailles, where no detail was left unattended to which might have detracted from the dignity of the occasion.

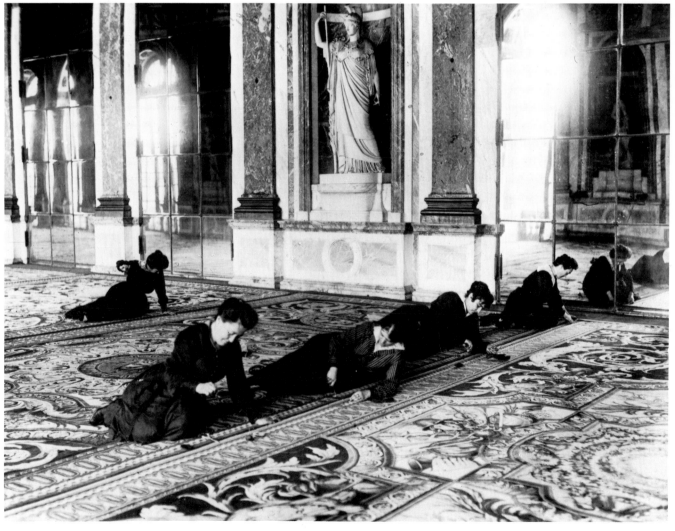

ABOVE Musidora in *Les Vampires.* OPPOSITE The 'anti-Bolshevik poster which appeared all over Paris during the campaign for the 1919 elections.

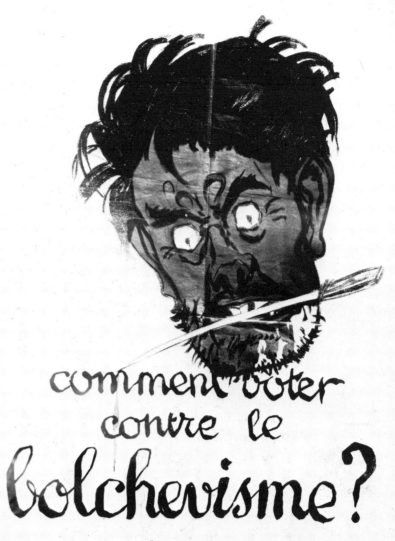

comment voter contre le bolchevisme?

0f.50 EN VENTE DANS TOUTES LES LIBRAIRIES

Edité par le GROUPEMENT ECONOMIQUE des Arrondissements de SCEAUX & SAINT-DENIS

adhere to its policies split the party. La France Libre, a conservative group which had been formed in 1918, was expelled from the party the next year and the votes of the moderates were lost. The elections resulted in a landslide for the Bloc National. Even Léon Daudet was elected to sit in the 'Sky-blue Chamber', so named after the colour of the French army greatcoats. The bourgeoisie felt secure; a shoe shop in Paris offered for sale furry slippers, which were called the 'Little Bolsheviks', for children. The security of the bourgeoisie was not among the priorities for which Breton and his friends might feel any ardour. Catholicism, chauvinism and militarism they detested but was there any political group that represented their aspirations for society? The Socialists were too committed to existing institutions which inhibited the freedom of the human soul. Communism was international but its ethic was

rational. Breton admired the philosophy of Hegel but he deduced from it what Aragon called 'absolute idealism' rather than the dialectical materialism of Marx. Besides, in 1919 several Communist intellectuals in France formed a group called Clarté (clarity) from the name of a book by Henri Barbusse in which he emphasized the mathematical rationalism of the Communist revolution. Among the signatories to the group's first public pronouncements was Anatole France, a writer whose mediocrity and financial success were becoming the cause of almost morbid irritation to the future Surrealists.

An alternative attitude was anarchy. 'No god, no master', ran the inscription on a tombstone which Breton saw when he was still only a boy but remembered all his life. It was while he was a boy, too, accompanying his parents to mass at the church of La Madeleine every Sunday, that he came across the Bernheim-Jeune Gallery and soon became acquainted with its manager, Félix Fénéon. He had been the art critic who had established the reputation of Georges Seurat back in the 1880s. He had numbered the great Symbolists among his close friends, and like them had sympathized with the anarchists who between 1892 and 1894 had terrorized Paris with their bombings. In 1893, Mallarmé had spoken in his defence at the famous 'Trial of Thirty' when the police had tried to eliminate the anarchists root and branch. The poet had described Fénéon as a 'fine spirit, curious about everything that was new'. He had been acquitted. Twenty years later the Bonnot gang had waged war on society in bank raids and gun battles with the police and Breton must have listened eagerly to Fénéon's reminiscences of Ravachol and Emile Henry. It had been Henry who had thrown a bomb into the Café Terminus at the Gare St Lazare, killing one innocent

ABOVE Emile Henry, arrested after throwing a bomb at the Café Terminus in 1893.

BELOW The anarchist-bandit Bonnot went to ground in a house in Choisy-le-Roi, where he was besieged by police and finally killed.

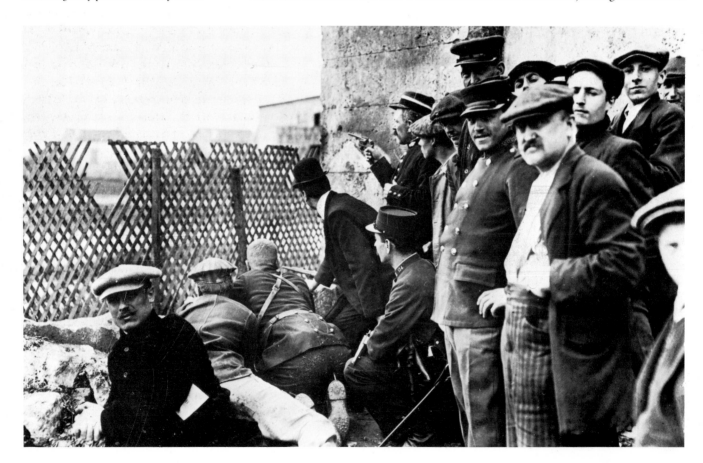

bystander and wounding twenty others. 'There are no innocents', Henry had said; and Breton, who once described the outrage as 'the most beautiful expression of individual revolt', echoed Henry's words when he wrote: 'The simplest surrealist act consists of going out into the street revolver in hand and firing at random into the crowd as often as possible.' Curiously, when Henry had first been apprehended by the police he used the alias 'Breton'. Eventually he had been tried, convicted and executed. His speech at the trial was his testament and contained many seeds of Surrealist thought: '... society ... where all is base, all is cowardly, where everything is a barrier to the development of human passions, to the generous tendencies of the heart, to the free flight of thought'. Breton had been a keen reader of anarchist reviews, such as *Le Libertaire*, *L'Anarchie* and *L'Action d'Art*, during the years before the war. Apollinaire had maintained the tradition of links between art and anarchy, having been friendly with the anarchist Louis de Gonzague Frick.

During 1919 the editors of *Littérature* were adopting an attitude towards the arts which was irreverent and anarchic. In the face of the prevailing revival of classicism, they broke rules and ignored tradition. Years later Aragon would recall that *Littérature* was launched defiantly, 'persistent in obscurity, opposed to Cubist taste, a defence against this revival of grace'. The texts of *Les Champs Magnétiques* were free from any rules of literary composition. There could be nothing traditional, nothing measured about the dictation of the unconscious. Marcel Duchamp returned to Paris that summer. Before the war he had taken an iron bottle-rack and, adding only his signature, had presented it as a work of art ready-made. Accepted aesthetic values had been turned on their head by the ready-made. Finding refuge in New York during the war Duchamp had persisted in artistic sacrilege. In 1917 he had sent an inverted urinal to the 'Independents' show in New York; it had been entitled 'Fountain' and signed 'R.Mutt'. From Buenos Aires where he stayed on his way back to Paris in 1919 he had sent his sister the instructions for the 'Unhappy Ready-Made': a geometry text book was to be hung open by its four corners from the balcony of her apartment in Rue La Condamine. By the action of the weather the axioms and diagrams would crinkle and fade. It was an exaltation of chance over measure, and the pertinence of the comment on the artistic situation in Paris could not have been missed by the future Surrealists.

Duchamp remained only a few months in Paris but he would return again from time to time over the next few years. In the autumn Francis Picabia arrived from Switzerland. In Paris before the war and then in New York Picabia and Duchamp had developed a style of pseudo-mechanical diagrams through which to express erotic functions and the desires and frustrations of sexuality. This investigation of instincts in dispute with convention made their paintings into psychological cryptograms worthy of Freudian analysis. When Picabia showed some of these 'mechanist' works at the Salon d'Automne in 1919 he aroused the indignation of the members who, even though they probably had little idea what the paintings meant, were extremely reluctant to hang them. They had no choice, however, for Picabia himself was a member of long standing and his work was not subject to selection by the jury. Desvallières, who painted religious pictures, looked at the paintings with horror: 'And, in any case, what did you do during the war?', he asked Picabia who replied: 'I was bored to hell.' In January, Tzara arrived from Zurich and moved into Germaine Everling's home where Picabia was staying. His first

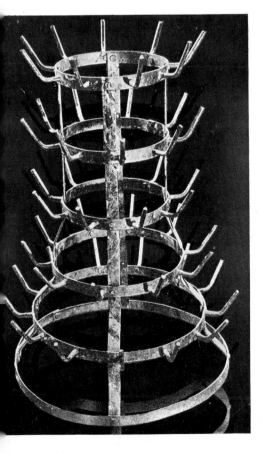

BELOW Marcel Duchamp: *Bottle-Rack*, 1914 (Museum of Modern Art, New York, James Thrall Soby Fund). Ready-made.

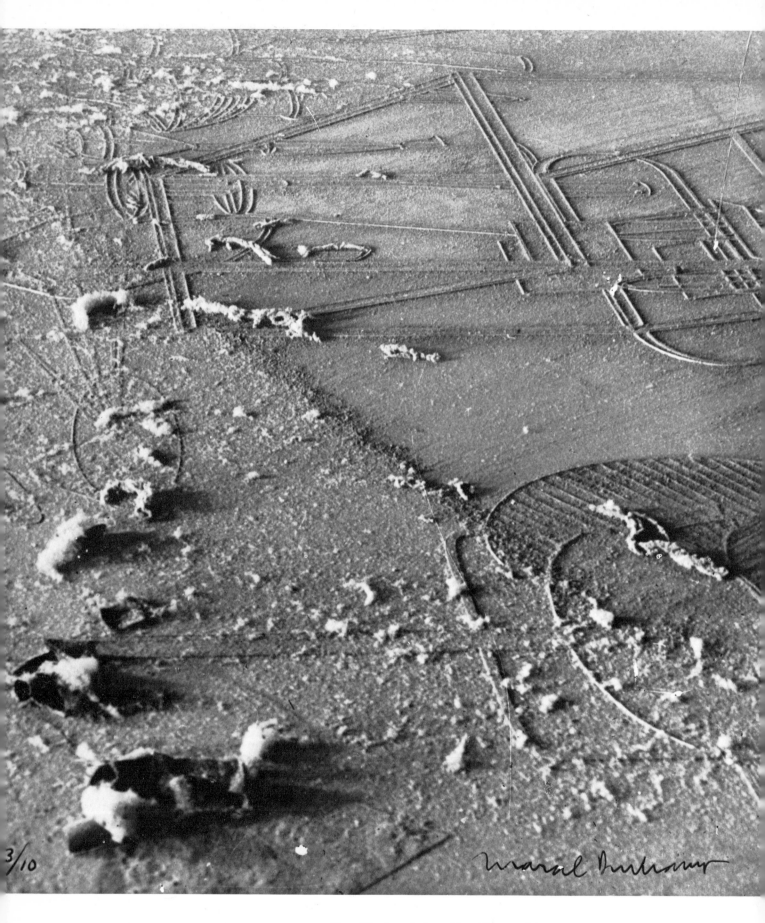

3/10

Marcel Duchamp [signature]

ABOVE Marcel Duchamp's *Large Glass*. Photograph by Man Ray, *Dust Elevation*, 1920.

OPPOSITE Marcel Duchamp: *The Bride Stripped Bare by her Bachelors, Even*, 1915–23 (Philadelphia Museum of Art, Katherine S. Dreier Bequest). Oil and wire on glass.

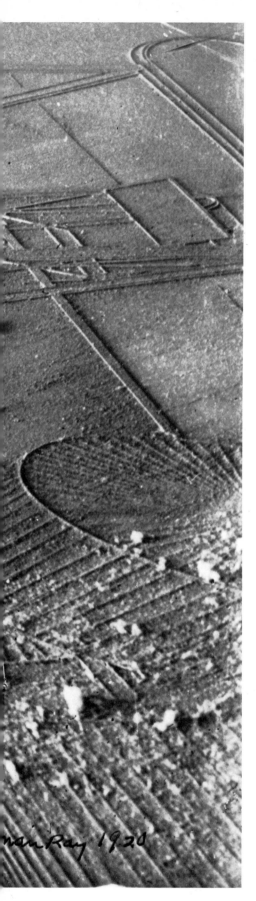

Man Ray 1920

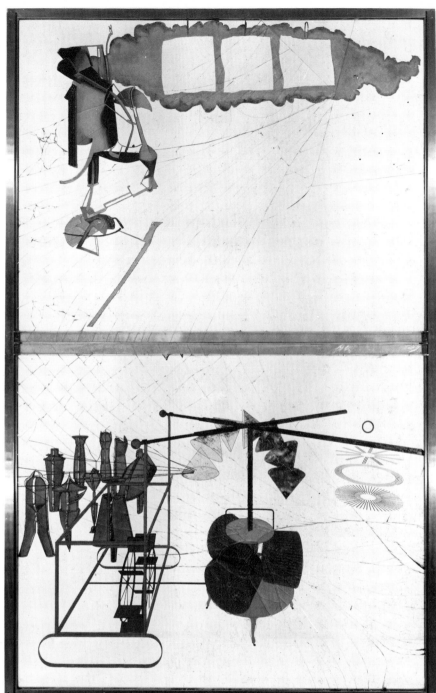

engagement was a 'Friday matinée' at the Palais des Fêtes arranged by the editors of *Littérature*. The event attracted the participation of all the artistic groups who were represented in the pages of the review. Cocteau himself was there to read his poems. In the programme was a piano recital of pieces by Erik Satie and Les Six. Paintings by Gris and Léger, and sculptures by Lipchitz were exhibited; they were artists normally associated with Rosenberg's Galerie de l'Effort Moderne. The older generation of poets also took part: the presence of Max Jacob, André Salmon and Blaise Cendrars emphasized the absence of Guillaume Apollinaire. Tzara, Picabia, Breton, Aragon and Soupault were the Dada vanguard and Tzara set the tone for his future appearances in Paris by

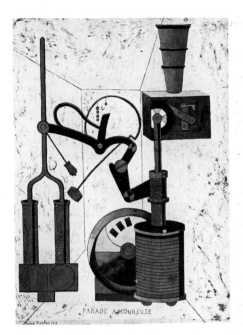

Francis Picabia: *Amorous Parade*, 1917
(Private Collection).

reading aloud a newspaper article while an electric bell kept ringing. His début exacerbated many of the artists present and it was plain by the end of the day that Dada would never gain the allegiance of so many diverse factions.

One of the younger poets at the matinée who was not yet fully committed to Breton's group was Paul Eluard. He had first met Breton by a coincidence that has always been cherished by the Surrealists, when he mistook him for an old friend during the interval in a performance of Apollinaire's *Couleurs du Temps*, not long after the author had died. Then, in 1920, Eluard was introduced to Breton and they recognized each other from their first, chance encounter. Eluard was two months older than Breton. As a youth he had been consumptive and spent two years in a sanatorium in Switzerland where he had read widely and met a young Russian student, Hélène Dimitrovnie Diakona, whom people called Gala, and whom Eluard married in 1917. By that time, he had been at the front and published a collection of war poems, which were followed the next year by a collection of pacifist poems; he published the book himself, risking censorship. During 1919 he had worked with his father in the office of the municipal surveyor of St Denis. His job was prosaic and he took a delight in naming new streets after his favourite writers: Nerval, Apollinaire, Vaché. His poetry appeared in *Littérature* and although in 1920 he started his own review *Proverbe* henceforward he was one of Breton's closest associates.

Dada immediately drove away the poets and painters whose outlook could not accommodate Tzara's nihilism. But everybody was Dada, maintained Tzara, and on a broadsheet he had composed before he left Zurich he drew up a list of adherents. Some of the names express the wish rather than the fact: Chaplin and Gorki. Others attest to Tzara's satiric irony: Clemenceau and Daudet. In February there was a Dada event at the Salon des Indépendants. Thirty-eight performers including Tzara, Breton, Aragon and Eluard read eight manifestoes. It had been rumoured that Charlie Chaplin was going to appear and a large audience had gathered, which grew increasingly restless as the manifestoes were recited one after another. The evening ended in general commotion with a speech made by Monsieur Buisson, 'The King of the Fakirs', who sold newspapers at a Métro entrance and predicted the future.

In March, 'Manifestation Dada' was presented at the Maison de l'Oeuvre. Breton read Picabia's 'Cannibal Manifesto in Darkness' to piano music composed by the author. Tzara's drama *The First Celestial Adventure of M. Antipyrine*, and Soupault's *S'il vous plaît* were performed. Musidora modelled the 'Latest Dada Creations', and the evening was supposed to have ended with Hania Routchine, a vaudeville star, singing yet another manifesto. But by that time the audience was unmanageable. Mademoiselle Hania refused to finish the song and 'for two hours', said Tzara, '... she wept wildly'.

The programme of the Dada Festival, held at the Salle Gaveau in May, included poems, plays and music. Louis Aragon read *Système DD*, a satire on *système D*, short for *système débrouiller*, 'the muddling-through system', which was how the French referred affectionately to their war effort. Philippe Soupault appeared as an illusionist; as he called out the names of the Pope, Clemenceau and Foch, balloons came out of a box and floated up to the ceiling. The audience took exception to every item on the programme; eggs were thrown, and Soupault was hit by a beefsteak, but fortunately Rachilde's suggestion in the press that some '*poilu*' should shoot the Dadaists was not followed.

Dada had begun to occupy the public's attention as outrage followed

OPPOSITE Francis Picabia: *Very Rare Picture on Earth*, 1915 (Peggy Guggenheim Foundation, Venice).

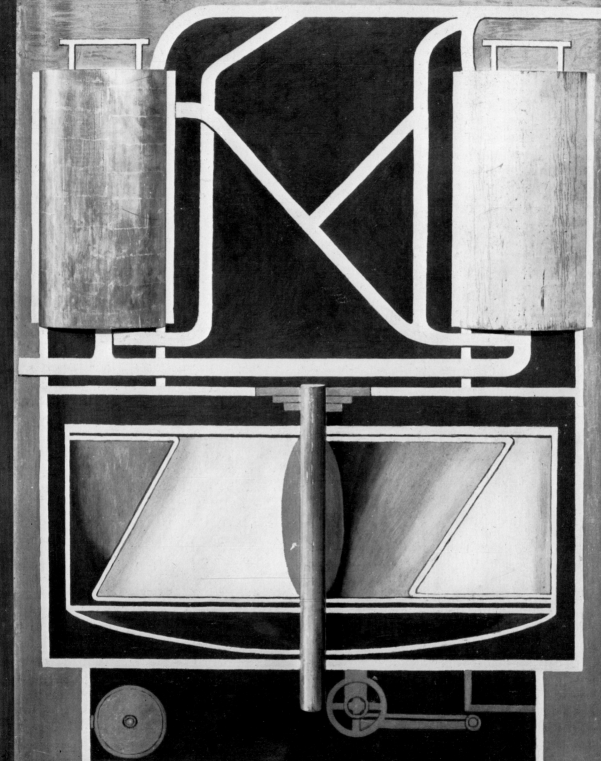

OPPOSITE Max Ernst: *Fantômes*, 1924
(Private Collection).

RIGHT André Breton takes part in the Dada
manifestation at the Théâtre de l'Oeuvre,
March 1920.
BELOW Paul and Gala Eluard, about 1920.

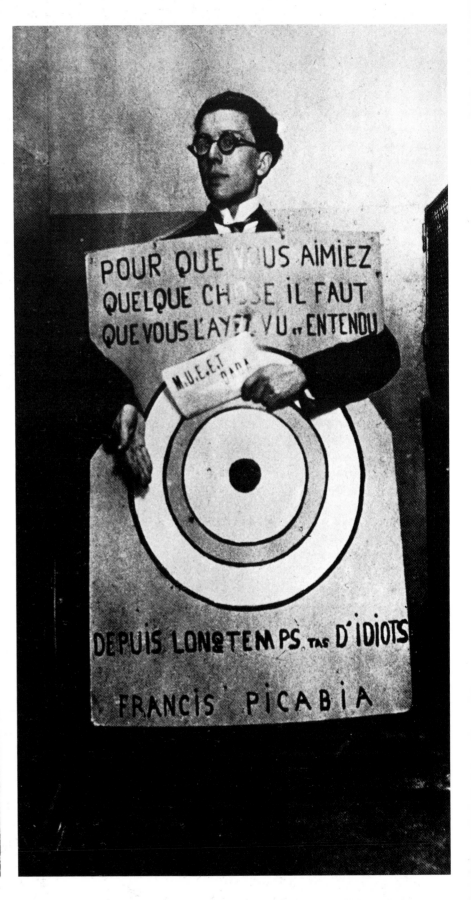

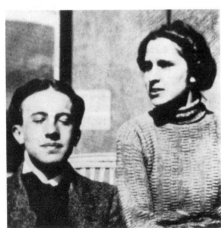

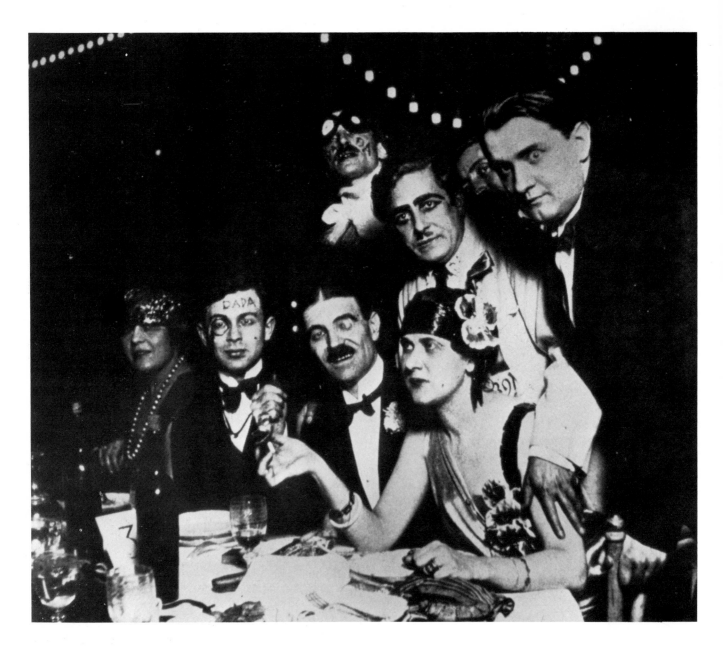

Seated, second from left, is Tristan Tzara.
Standing, left to right: Georges Ribemont-
Dessaignes, Francis Picabia and Georges
Auric. Picabia has his hand on Germaine
Everling's arm. A photograph taken
about 1921.

outrage. Treated at first with more or less jocular indulgence, the movement
provoked the wrath of the fourth estate when it displayed such a complete lack
of veneration for the nation's war heroes. The old insult was hurled at the
Dadaists: '*Boches*!' Despite efforts to enforce a press boycott of Dada, the
printer's ink was poured out unsparingly in irate abuse, learned interpretation
or sardonic lampooning. The commentaries began to annoy Dada, particularly
when its behaviour was explained as a psychological regression to infancy. The
future Surrealists could not subscribe to the belief, however universal it might
be, in the wisdom of maturity that was implied by such an explanation. To be
ignored soon became their fondest wish. *Chansonniers* sang about Dada;
cartoonists caricatured the Dadaists. Nor did the impresarios neglect such
fine material. The perfect opportunity was provided, surprisingly, by Paul
Deschanel, a small, dapper, ineffective politician who in January had been
elected President of the Republic. On a train to Montbrison on the night of 23

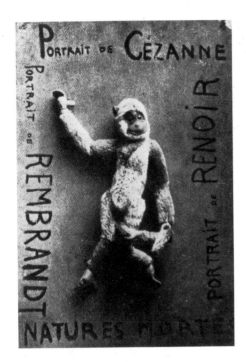

ABOVE Francis Picabia: *Tableau Dada*,
reproduced in *Cannibale* no. 1, April 1920.
Picabia had intended that a live monkey should
be incorporated in this work, but was
persuaded to compromise.

FOLLOWING PAGES
LEFT Max Ernst: *Men Shall Know
Nothing of This*, 1923 (Tate Gallery, London).
RIGHT Max Ernst: *Two Children Threatened
by a Nightingale*, 1924 (Museum of Modern
Art, New York).

May, he took a sleeping-pill and somehow in his slumbers contrived to fall out of the carriage window. He awoke in a ditch; uncertainly he started walking down the line. Eventually he presented himself in his tattered night-attire to a crossing keeper: 'I am the President of the Republic.' The railwayman gave him a knowing look, but realized 'he must be somebody of importance', as the *chansonnier* Vincent Hyspa sang, 'because his feet were clean'. The same month at the cabaret Le Perchoir a new revue presented the irresistible confrontation of Dada and Deschanel. 'Every Dada is a President', Tzara had said.

Another revue, *A Dada*, was an attraction at the Lune Rousse nightclub that season. At La Cigale, Mirka danced the Dada one-step. Tours of Paris included a visit to the Café Certâ in the Passage de l'Opéra where the Dadaists met regularly. The sightseers gawped. 'The scarlet waistcoat,' wrote Breton in *La Nouvelle Revue Française* that August, 'rather than the profound thought of an era, is unfortunately what everybody assimilates.' Worst fate of all, Dada became a subject of conversation in the salons. *Le Tout Paris* had its views on Dada. The avant-garde had long despised '*les snobs*'. In 1913 Apollinaire had called for the suppression, 'with no regrets', of 'snob exoticisms'. Now Dada demanded a truce; in a manifesto of January 1921 some topics of smart chit-chat were listed; had Dada ever mentioned them? 'Never, never, never.' Never had Dada discussed the eight-hour day which had been wrung from Clemenceau's government the previous winter and had remained a talking-point among the disgruntled bourgeoisie. Never had Dada alluded to Parma violets which suddenly acquired a scandalous significance when the heroine of Emile Bourdet's play *La Prisonnière*, showing at the Théâtre Fémina, sent them as a love token to her lady-friend. If the Dadaists had scratched the sensibilities of society, their own had been mauled by the claws of those who condescended but never comprehended. Referring to the situation at this time Soupault would write: 'The great enemy was the public.' For Breton the nadir was reached in December when Parisian society crowded into the Galerie de la Cible in Rue Bonaparte for the *vernissage* of an exhibition of paintings by Picabia. The artist wore a dinner-jacket; Cocteau, Auric and Poulenc played jazz; Tzara recited a manifesto to everyone's delight. Most of the Dadaists were there, perhaps a little dubious about the adulation. Breton was quite disgusted.

It was not a propitious time to compromise with the establishment. In power, the Bloc National was pursuing policies which the future Surrealists must have found loathsome. France had gleefully returned to the chicanery of imperialism, intervening in the affairs of Turkey and sending a military expedition into Syria. The French army and navy were still involved in the war against the Bolshevik revolution. In the Rhineland, and in the Saar where Aragon had been posted in 1919, the French military authorities carried on a campaign of propaganda aimed at the detachment of these regions from the German nation. The soldiers of the occupying power might learn the words of *Deutschland Über Alles* and sing it at every opportunity, but this was to irritate their commanders who had banned the German national anthem rather than to affirm international solidarity. The argument in favour of a French Rhineland was given intellectual garb by the eminent author Maurice Barrès who gave a series of public lectures in Strasbourg promoting his theories. Anti-German feeling ran high in Paris. Wagner's work was still banned from the Opéra; in 1921 Saint-Saëns would die broken-hearted at the thought that the German

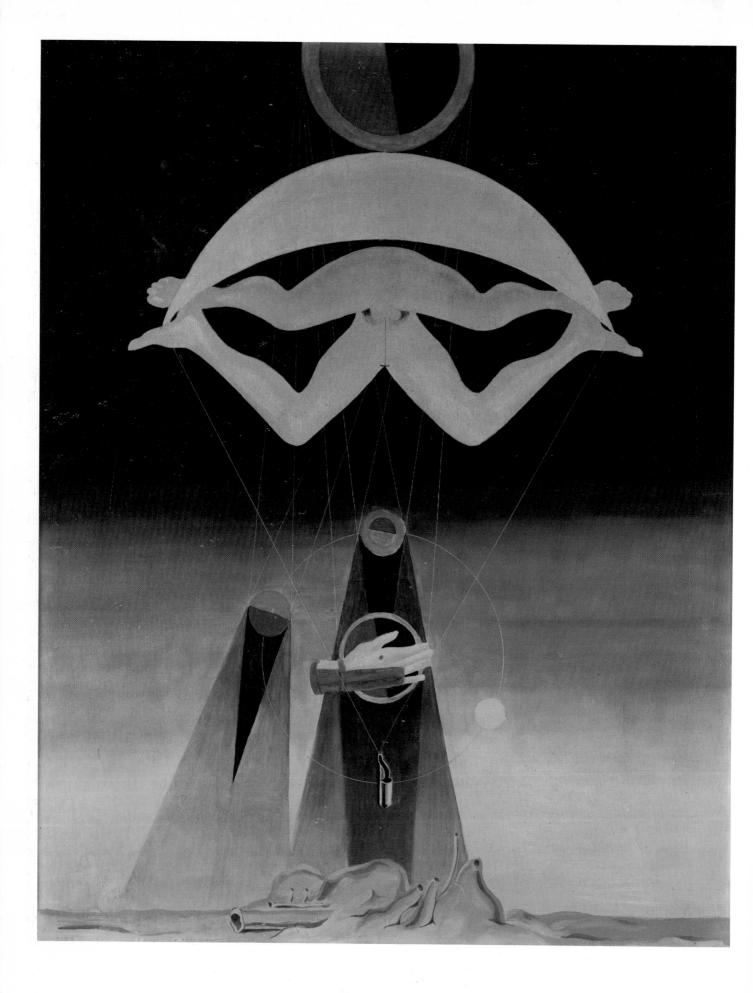

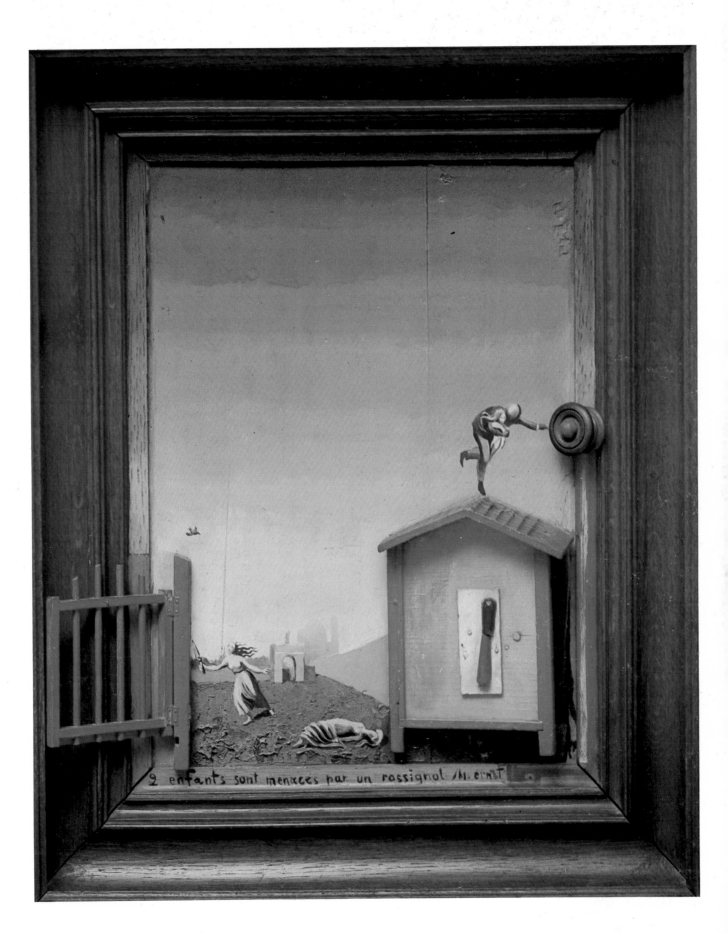

2 enfants sont menacés par un rossignol /M. ernst

ABOVE Railway workers on strike, 1920.

OPPOSITE The Galerie du Baromètre, part of the Passage de l'Opéra. Here the Dadaists used to meet at the Café Certâ.

composer's music should ever again be heard in France. The future Surrealists were dismayed by the restored authority of the Catholic church. Over half the deputies in the 'Sky-blue Chamber' were Catholics and for the first time during the Third Republic there was an exchange of envoys between Paris and the Vatican. Only an administration dominated by nationalism and Catholicism would have sanctioned, in 1920, Joan of Arc's canonization by Pope Benedict XV.

The French establishment had looked askance at Dada when it arrived in Paris at the beginning of 1920. The German Dadaists were avowed partisans of revolution and Communist risings in Berlin and other German cities had barely been crushed. A wave of industrial unrest in France had, it soon turned out, only been temporarily held up by the concession of the eight-hour day. In February the French Socialists had abandoned the Second International and had resolved to find out on what terms the party would be admitted to the

63

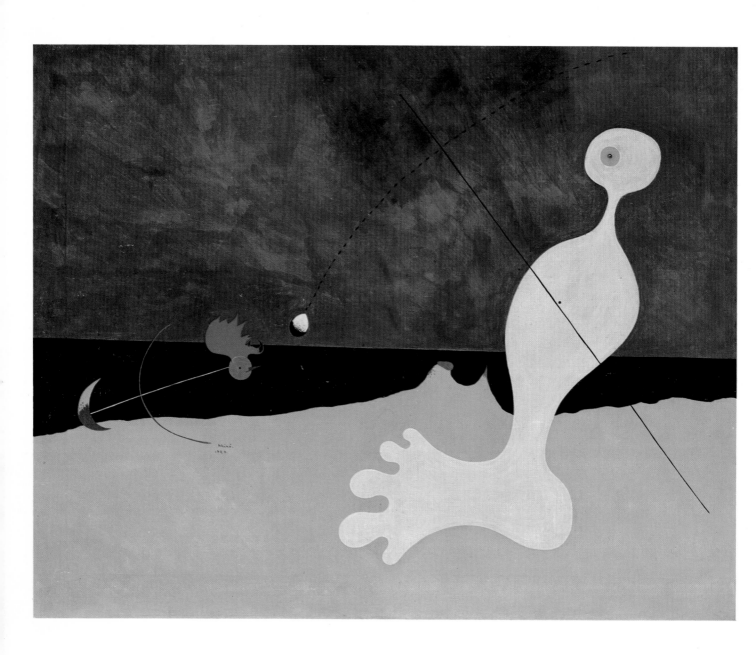

OPPOSITE Joan Miró: *Person Throwing a Stone at a Bird*, 1926 (Museum of Modern Art, New York).

ABOVE Leon Trotsky, who led the Bolshevik armies to victory in the Russian civil war.

Comintern. Conservatives trembled. Were not Trotsky's red legions swarming across Poland? Dada was provocative and subversive. A measure of the public's hysteria that spring may be taken from an article in *La Revue de l'Epoque* which was published in April; there, Jean Drault was quoted as saying: 'The grand master of Dadaism is in reality the Jew Braunstein called Trotsky.'

Aragon had claimed no political affiliation for Dada. 'No more republicans', he demanded in a manifesto which he had read at the Salon des Indépendants in February, 'no more royalists, no more imperialists, no more anarchists, no more socialists, no more bolsheviks, no more politicians. . . .' Aragon felt that any political stance was a compromise. 'I have always placed the spirit of revolt far above *any* politics', he wrote in 1925. Other Dadaists were a little more committed. The sixth number of the review *Dada*, called *Dada Bulletin*, was published that March in Paris, and it was printed in the anarchist colours, red and black; and in April there appeared the first issue of Picabia's review *Cannibale* with a cover in red and black. Anarchic, too, was Dada antagonism towards the church and the military. Picabia gave his paintings titles such as *The Holy of Holies* and *Man Created God in his Image*. 'Dada has always existed', announced the manifesto of January 1921, 'the Blessed Virgin was already Dadaist.' A slogan invented by Picabia debunked the war-hero: 'Men covered with crosses remind one of a cemetery.' But blasphemy and insolence did not amount to political commitment. It was Tzara's aim deliberately to maintain an attitude of levity, almost frivolity. To take a stand, either for or against whatever principle, would weaken Dada's iconoclastic nihilism.

So Dada turned out to be a friendly dog, despite its yapping; it was safe to pat it on the head and let it off the lead. Besides, during the summer of 1920 the political news was reassuring. An attempt to call a general strike aborted and at the Congress of Orléans the Communists failed to gain control of the trade unions. The French government sent General Weygand to Poland where he routed the armies of the Revolution. In August, *le Tout Paris* relaxed at Deauville or Cannes.

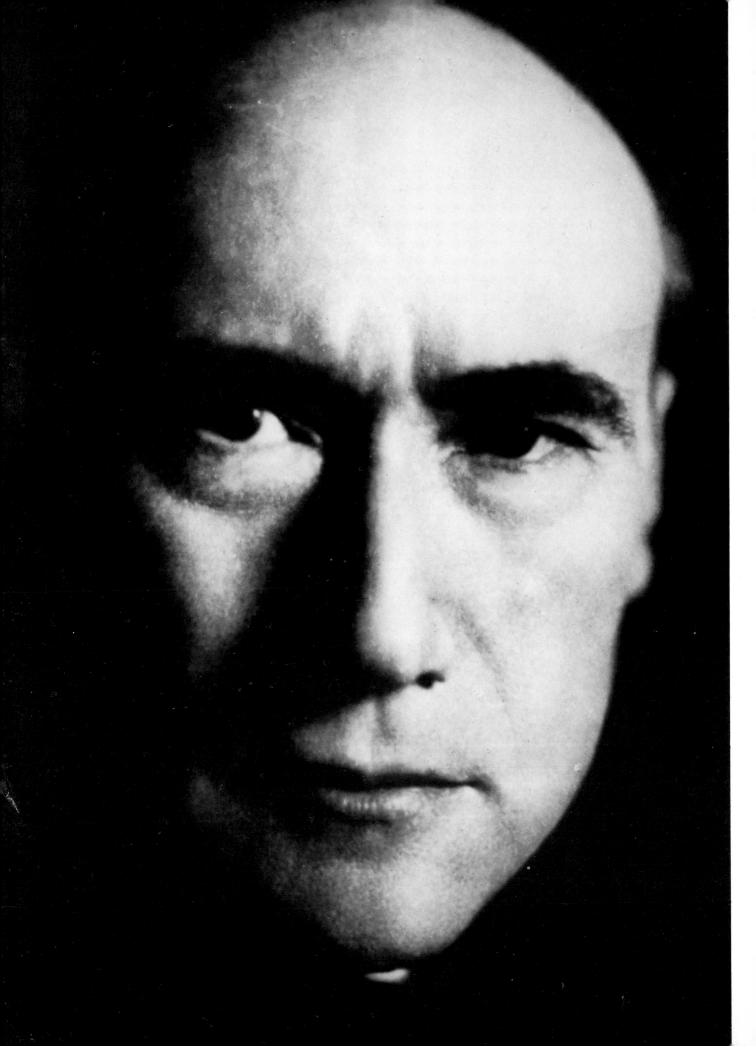

3 'The Safety of the Mind'

Aragon and Breton were under some financial strain during 1920. Eluard lived at home with his parents and Soupault had a small allowance, but after their demobilization Aragon and Breton both found it difficult to make a living. Breton's parents had been aghast at their son's giving up the medical profession and had refused to help him at all. Paul Valéry interceded on his behalf but to no avail. He did, however, find Breton a job as proofreader at the offices of *La Nouvelle Revue Française*; Aragon would find similar work with the Gallimard publishing house. In 1920 Valéry put forward Breton's name for the Blumenthal award for literature, worth 5000 francs: although André Gide and Marcel Proust both endorsed Breton's claim his association with the Dada movement was prejudicial. No award. He badly wanted the money that year, for he was thinking of marriage. At the end of June he was in Luxembourg and through his schoolfriend Théodore Fraenkel he met Simone Kahn. In August, Breton took a holiday at Lorient in Brittany, the province of his birth. He wrote almost daily to Simone, revealing in his letters doubt and depression. 'Beneath my most categorical formulae', he told her, 'every sort of question lies hidden.' He identified with Adolphe, the Romantic hero created by Benjamin Constant whose novel bemoaned the death of spontaneous feeling when the mind is ruled by analytic intelligence.

At the *NRF* offices Breton had seen at close quarters the workings of fine intelligences. Jacques Rivière, the review's editor and André Gide, a regular contributor, were defenders of mental integrity, men who had a sixth sense for cant or humbug. 'France is the least hypocritical country there is', Rivière had written in October 1919, 'so let us stop thinking about the war and stop blinding ourselves with glory.' Gide wrote an article for the *NRF* pointing out the virtues as well as the defects of the German character. He deplored intellectual chauvinism. 'Maurras' classicism', he would write in his 1921 journal, 'is odious because it oppresses and suppresses.' Rivière had joined issue with Henri Massis who in 1919 had founded the Party of Intelligence; Massis was calling for the employment of artistic talent in the service of the nation. In 1913 a survey entitled 'Youth Today' had been conducted by Massis and Alfred de Tarde. From the replies received they had concluded that the great majority of young Frenchmen were patriotic and religious, eager for action and scornful of intellectualism. After the war Massis formed his party to channel this flowing tide of nationalism and Catholicism. Jacques Rivière ardently refuted Massis' assertion of intellectual subservience.

Evidence of the same sort of opposition to intellectualism had been shown by the Italian Futurists. In his initial manifesto of 1909, the founder of the

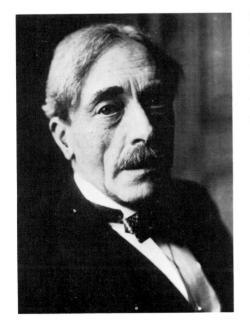

Paul Valéry, writer and philosopher, whom André Breton had first visited before the First World War, and who became his friend and mentor.

Gabriele D'Annunzio, the Italian poet who
seized and occupied the city of Fiume in
defiance of the terms of the Treaty of
Versailles.

movement, Filippo Tommaso Marinetti, had cried: 'We shall sing the love of
danger, the habit of energy and boldness. . . . Literature had hitherto glorified
thoughtful immobility . . . we shall extol aggressive movement. . . . We wish to
destroy the museums, the libraries. . . .' The same Marinetti had clamoured for
Italy's intervention in the First World War. His ideal of the heroic intellectual
had been embodied in the Italian poet D'Annunzio who had raised a private
army and had occupied Fiume in September 1919 in defiance of the Versailles
treaty. He had ruled the city for fifteen months, hailed as a dictator by his
legionaries who had sung the *Giovanezza* ('Youth'), the marching-song of
the elite corps in the Italian army. In January 1921, a few weeks after
D'Annunzio's ejection from Fiume, the Dadaists demonstrated against
Marinetti when he gave a lecture in Paris. They published a manifesto which
declared: 'The Futurist is dead. From what? From DADA.' It was the same
manifesto which claimed that Dada ignored such topics as the eight-hour day
and Parma violets; also on the list were Fiume, D'Annunzio and heroism.
Mocking the political activity of the Italian Futurists, the Dadaists, in an
allusion to the fall of Premier Leygues' administration that month,
proclaimed: 'The government is overthrown. By whom? By DADA.' But it
was not hard to see that the mockery and protest was in part defensive. To an
extent, Dada was the spawn of Futurism. Artistic nihilism was not so far
removed from anti-intellectualism, and the subjection of the Dadaists to Dada
was analogous to the allegiance shown by their followers to Marinetti or
D'Annunzio. It had been *à propos* Dada that Gide had written the previous
year: 'Youth has much less resolution than it thinks, much more submission
and unconscious obedience.'

Breton's attitude to Dada during 1921 was one of growing suspicion. His
participation in the activities of the movement became rarer and he began to
assert the independence of his own ideas. It became impossible to share with
Tzara and the other Dadaists any thought of prolonging a movement which
used essentially shock tactics. Dada had served the purpose which had been
Vaché's, to reduce Art, to flatten Taste, to destroy Language. But it had failed
to establish any moral justification for itself and it could set free no prisoners.
Surrealism invited man not to be ashamed to live by the morality of dreams, to
accept the discoveries of Freud who, although he himself drew back from the
moral implications of his research, had nevertheless revealed in the uncon-
scious a new innocence and a new guilt.

In April a series of Dada excursions, to various more or less ridiculous
destinations, was arranged. It seemed no more stupid to take sightseers to an
old abandoned church in the middle of a piece of waste ground than to lead
them to the Passage de l'Opéra and show them the Dadaists. The only Dada
visit that actually took place was to the church of St Julien-le-Pauvre. Breton
organized it and despite pouring rain a handful of Dadaists and sympathizers
arrived at the church. Some anti-religious speeches were made but nobody
listened very long; it was too wet.

For the summer a 'Grand Dada Season' was planned. Two items were
included in the programme on Breton's initiative. The Season would open, on
2 May, with an exhibition of Max Ernst's paintings at the Galerie au Sans
Pareil; this was a bookshop on the Avenue Kléber which René Hilsum, another
of Breton's schoolfriends, had opened the year before. On 13 May there would
be the mock trial of Maurice Barrès and this too would be organized by Breton.

In a small hall at the Théâtre des Champs-Elysées a Salon Dada would open on 6 June and there three manifestations would be held.

Max Ernst was a German artist living in Cologne. He had contributed drawings to several Dada publications where they had attracted Breton's attention. Towards the end of the First World War Giorgio de Chirico's painting had lost much of its power to evoke the fears and desires of dream worlds. The artist had apparently set out on a sentimental journey through the serene art of Raphael, and it was with incomprehension and some dismay that the canvasses which he now sent from Italy were unpacked at Paul Guillaume's gallery in Paris. In Ernst, however, de Chirico, the painter of mysteries, had found an heir. The German's work also showed a positive reaction to Picabia's fantastic diagrams. A synthesis of both these influences was emerging and Breton looked forward to seeing the paintings which Ernst would bring to Paris. But Ernst was not permitted to make the journey and his pictures had to be sent. The British military authorities had suppressed the revolutionary newspaper *Der Ventilator* published by Ernst's friend Johannes Baargeld, and because Ernst had been a contributor he would have been counted as a Communist agitator by the authorities. So they stopped him travelling to Paris. Eluard had met Ernst in Cologne the year before; it transpired that in 1917 Ernst had been a gunner in a battery which was bombarding the position occupied by Eluard's regiment. They immediately became lifelong friends.

The *vernissage* on 2 May was unconventional. Breton's elaborately planned publicity drew *le Tout Paris* but he was plainly resolved that this should be no repetition of the charming event which Picabia's *vernissage* had been six months earlier. It took place in the basement of the gallery; all the lights were

Left to right: Max Ernst, Gala Eluard and Hans Arp.

St Julien
le
Pauvre

out. The Dadaists, tieless, wore white gloves and their behaviour was apparently insane. Aragon miaowed, Benjamin Péret and Serge Charcoune kept shaking hands, Georges Ribemont-Dessaignes shouted incessantly: 'It's raining on a skull.' Jacques Rigaut stationed himself near the door and counted out loud the number of pearls worn by each lady visitor, having already announced the type of car by which she and her escort had arrived. André Breton chewed matches. Soupault and Tzara played hide-and-seek. All this proceeded to a continuo of groaning that came from beneath a trapdoor. Another disembodied voice, emanating from a cupboard, greeted some arrivals with enthusiasm but most with insults; Kees van Dongen, the erstwhile Fauve who had become the most fashionable portrait-painter in Paris, received a tirade of abuse. So did Gide; so did Louis Vauxcelles, the art critic from whose jeering opinions on modern art had been derived the names of both Fauvism and Cubism.

Ernst showed paintings, drawings, collages and *Fatagagas*. The last named were collages Ernst made in collaboration with Arp or Baargeld; *Fatagaga* was short for '*Fabrication des Tableaux Garantis Gazométriques*'. Among the exhibits were works owned by Aragon, Soupault and Tzara, as well as by Breton who wrote the preface to the catalogue. He departed from the Dada style established by Tzara in his notes for the catalogues of Ribemont-Dessaignes' and Picabia's exhibitions the year before. Instead of a lyrical accompaniment to the paintings, Breton provided a perceptive commentary, relating Ernst's collages to the cinema where special effects seemed to substantiate Einstein's theory of relativity and produced uncanny *rapprochements* between remote images. It was Breton's first essay in art criticism, and despite the Dada context, he was formulating an aesthetic which was new and important. Ernst's show did not have the same prestige among cultured Parisians as was commanded that summer by the exhibition of Ingres' paintings organized by

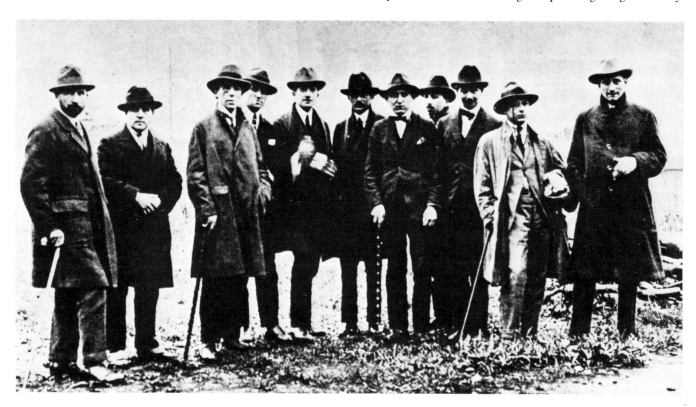

the impresario of fashionable entertainment, Comte Etienne de Beaumont. Nor was it such a commercial success as the show, also held that summer, of Marie Laurencin's work, so widely appreciated for its feminine grace. Ernst's art was not classical nor charming; it was not even French. It *was* German, blasphemous and, one imagined, Bolshevik. It was, however, significant.

What Breton admired in Ernst's work was the 'unequalled light' which it cast on 'our interior life'. The artist was a man of 'infinite possibilities'. Maurice Barrès, on the contrary, was an author who had forfeited his potential intuition for a socially acceptable code of morals. He had allowed his genius to become the tool of national interest. Breton, in the name of Dada, accused him of having 'renounced what may be unique within himself'. The novels Barrès had written at the beginning of his literary career, in the 1880s and 1890s, had expressed his concern for the liberty of the individual; the instincts of the Self were a higher consideration than any respect for social or intellectual institutions. The future Surrealists admired these early books; they had had an important influence on Aragon, in particular, who would write about Barrès after his death in 1923 with the appreciation of a disciple. But now Dada protested: 'He disturbs in its potential revolutionary power the activity of those likely to be influenced by his earlier teaching.' From the turn of the century Barrès' work had been imbued with nationalism. He had regarded the nation as the greater Self and had employed his talents in its service. He had

OPPOSITE ABOVE A sketch made by Théodore Fraenkel at the time of the Dada excursion to St-Julien-le-Pauvre (Private Collection). OPPOSITE BELOW The Dadaists on their excursion to the church of St-Julien-le-Pauvre. Left to right: Jean Crotti, (a journalist), André Breton, Jacques Rigaut, Paul Eluard, Georges Ribemont-Dessaignes, Benjamin Péret, Théodore Fraenkel, Louis Aragon, Tristan Tzara and Philippe Soupault.

BELOW An illustration by Max Ernst to *Les Malheurs des Immortelles*, 1922, poems by Paul Eluard.

been elected a deputy and in daily newspaper articles during the war his patriotism had been unrestrained. Now, his campaign for separatism in the Rhineland was the culmination of a career that Breton found criminal.

'Dada', ran the preamble to the indictment of Maurice Barrès, 'considering that the time has come to use executive power to support its spirit of negation and determined above all to use that power against those who dare to prevent its dictatorship, is taking measures as of today to beat down their resistance.' Breton's words set a Jacobin tone to the proceedings, a spirit of moral authority which hardly accorded with Dada lightheartedness. The trial took the form of a debate on lines similar to those which had been drawn by Léo Poldès for his Club du Faubourg. At Poldès' club public issues were aired; anybody was allowed to speak. A prominent politician or a leading intellectual was invited to state his case before a *canaille* of bohemians and cranks. A possible reconciliation between France and Germany had been argued at the club; Tzara had pleaded the cause of Dada, and to this 'court' Dieudonné, a survivor of the Bonnot gang who had been granted a free pardon, had explained how such clemency had been justifiable. Poldès modelled his club on the Revolutionary debating clubs at one of which Camille Desmoulins had instigated the attack on the Bastille. Now Breton, in the name of Dada, accused Barrès of 'a crime against the safety of the mind'. He consulted an old Communard on the judicial procedures which had been followed during the Commune of 1871. As Poldès always did, Breton called witnesses of different opinions: Rachilde, a novelist and an ardent nationalist; Georges Pioch, a Communist who defended political murderers in the real courts and who regularly contributed to Poldès' debates; Louis de Gonzague Frick, Apollinaire's anarchist friend; as well as Dadaists. Breton wanted an exchange of opinions, not just another spectacle. He wanted Dada seen in broad daylight, not behind footlights.

The trial took place on 13 May 1921 at the Salle des Sociétés Savantes which was often used by the Club du Faubourg. Barrès himself did not appear so a mannequin was seated in the defendant's box. It was an apt substitution, for Barrès' 'gestures were those of a puppet'. As an English journalist described him at that time: 'Never have I seen anybody whose limbs appeared to be so wooden.' Breton was his judge, Ribemont-Dessaignes prosecuted. Among the witnesses was Benjamin Péret who had come to Paris from his home near Nantes the year before and had immediately attached himself to Breton. Péret had been in the army during the war and years later he would recall that military service had been 'a veritable prison, with the officers not speaking except to utter the most filthy abuse, accompanied by threats of punishment'. Now he relished his role at the trial as the Unknown Soldier, wearing a scruffy old French army uniform and, when questioned, answering in German. Tristan Tzara's enthusiasm for the Barrès trial was never great and on the occasion he tried to sabotage the proceedings with his farcical testimony. He was reprimanded by the judge. It must have become clear to Breton at that moment that what he called the dictatorship of Dada was seen by Tzara in terms of personal hegemony.

Henceforward Breton made little pretence of belonging to Tzara's movement. Surrealism led him in a different direction on a road which for some time he would have to travel almost alone. Aragon, Soupault, Eluard and Péret all contributed to the Salon Dada in June but the only part which Breton

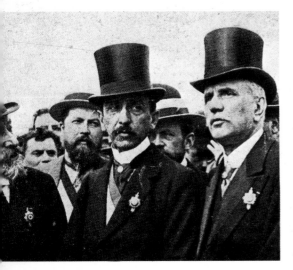

Maurice Barrès (centre), photographed in 1914 on being appointed President of the League of Patriots.

The trial of Maurice Barrès, 1921. André Breton is third from left, and in the middle two Dadaists are supporting the mannequin representing the accused.

took was to collaborate with Théodore Fraenkel on a work ascribed in the catalogue to Franton and Brekel. Nor was Breton involved in the manifestation of 10 June, a Soirée Dada, which included a performance of Tzara's play *Le Coeur à Gaz*. The evening consisted of the usual Dada fare; the orchestra would be conducted, it was announced, by 'Monsieur Joliboit, china restorer of the 6th *arrondissement*'. A week later the Dadaists again performed at the Théâtre des Champs-Elysées, but their appearance was unscheduled. They rowdily disrupted a '*concert bruitiste*' being given by Marinetti. The theatre-manager, Jacques Hébertot, was angry, and when the Dadaists arrived at the theatre the following afternoon for a Conference of the Dada Movement they

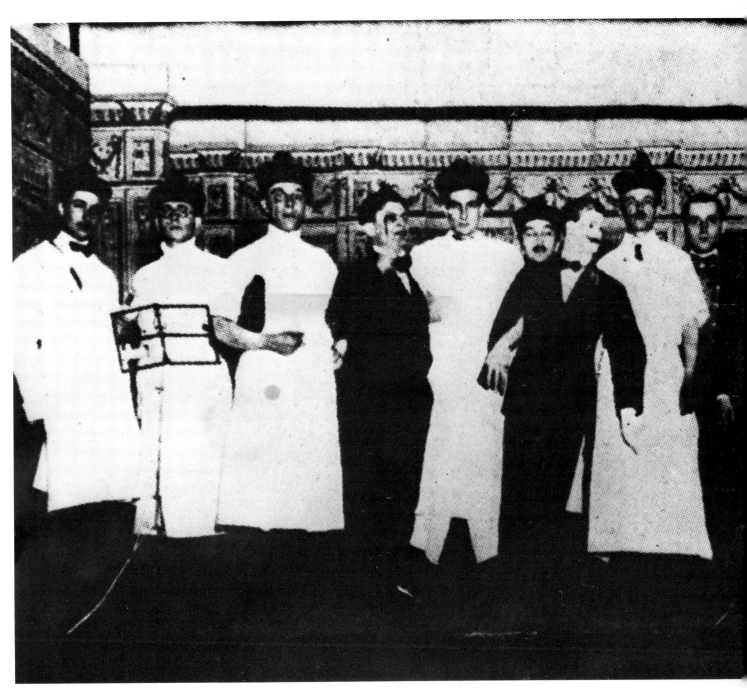

75

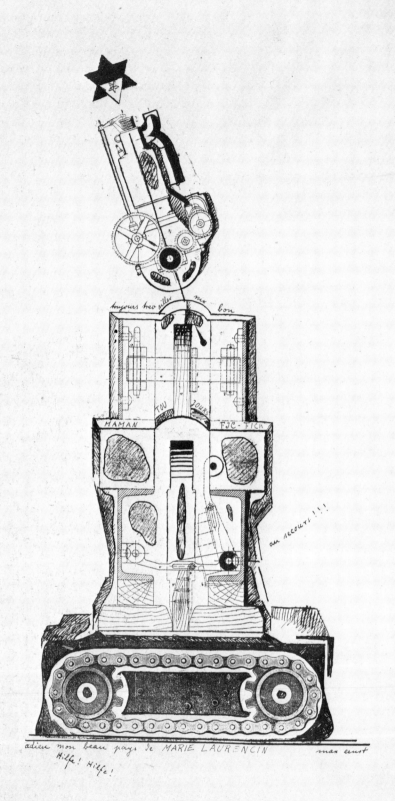

adieu mon beau pays de MARIE LAURENCIN max ernst

Hilfe! Hilfe!

found the doors barred against them. An opportunity for revenge came quickly. The same evening Cocteau's *Les Mariés de la Tour Eiffel* was given its first performance at the theatre, and the Dadaists infiltrated an audience composed of the notables and noticeables always avid for their idol's latest offering. As the Swedish Ballet company disported themselves on stage, the Dadaists, scattered round the auditorium, stood up in turn and shouted 'Vive Dada!' Most people must have felt that Dada had already lived too long and Breton at least would have sensed the irony of Dada's protestations against both Marinetti and Cocteau. To him, Dada had become as dictatorial as one and as superficial as the other; and as insidious as either of them.

In September André Breton was married to Simone Kahn. Paul Valéry was one of the witnesses. They went for their honeymoon to the Austrian Tyrol where they joined Eluard, Tzara, Ernst and Arp. Even among the serene peaks the polemics of the Parisian avant-garde raged. Francis Picabia had announced his retirement from Dada in the journal *Comoedia* at the time of the Barrès trial which he had considered unnecessarily doctrinaire. He had taken no part in the rest of the Grand Dada Season and, in September, he had shot down Tzara in the press. Now Tzara retorted with a tract insulting his adversary. Breton

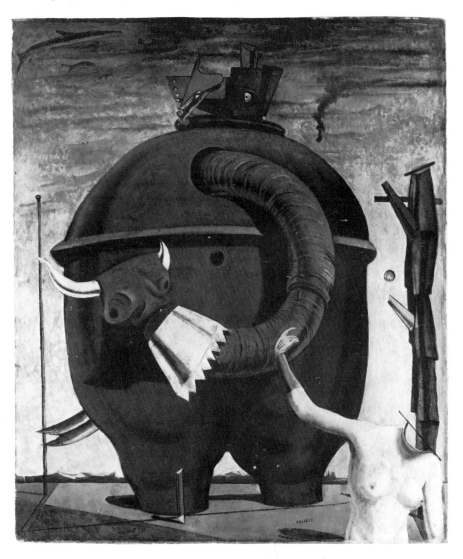

RIGHT Max Ernst: *Celebes*, 1921 (Tate Gallery, London).

was not among the signatories. With Simone he went on to Vienna where he had arranged to meet Sigmund Freud. The psychoanalyst was touched by Breton's letter asking for the interview but in the event their meeting was not a great success. Breton found Freud living in a nondescript house in a remote part of Vienna; nothing about the décor of the doctor's house was interesting. Freud proudly showed Breton the first translation of his work into French, a collection of five lectures, but he made it plain that he was not enamoured of France where the value of his work had been discounted for so long. Conversation was difficult; they had no common language. But Breton's journey to Vienna signified his renewed commitment to the exploration of the unconscious. It was a journey that took him yet further away from the Dada scene.

In Paris, in December, there was a last Dada exhibition. The work of Man Ray was shown at the Librairie Six, a bookshop which Philippe Soupault had started in the Avenue Lowendal. Man Ray had come from New York earlier in the year. He had been one of the few American artists whose ideas had been advanced enough to respond to the art of Marcel Duchamp when the Frenchman had taken refuge in New York during the First World War. It had been Duchamp who that summer had introduced Man Ray to the Dadaists at the Café Certâ. At his room in the Hôtel des Ecoles, Rue Delambre, just off the Boulevard Montparnasse, Man Ray invented the Rayograph: he found that trivial objects of everyday existence, placed on photographic paper and left in the light, cast their white shadows on the blackened paper. A key or a piece of lace was invested with such an alien reality that the image was more of a phantom than a fact. Man Ray robbed photography of its primary function and invented a graphic surrealism. His show in December included work from the years before he had arrived in Paris and it was quite clear that to the names Duchamp, Picabia and Ernst that of Man Ray had to be added as an artist of 'infinite possibilities'. The catalogue of the exhibition included tributes from Tzara, Aragon, Soupault, Eluard, Ernst, Arp and Ribemont-Dessaignes; with Dada irony a plan was printed on the front showing the location of the bookshop midway between the Hôtel des Invalides and the Ecole Militaire.

No longer belonging to Dada, feeling perhaps a little isolated as he watched his closest friends whirling past still firmly astride the horses on Tzara's roundabout, André Breton established a *ménage* with Simone at 42 Rue Fontaine in Montmartre. The artistic focus of Paris had by now shifted to Montparnasse; the transition had occurred during the war and was reflected in the title of the review *Nord–Sud* which was also the name of the Métro line connecting the two centres. '*Nord–Sud* lacks ventilation especially when it breaks down under the Seine', was one of Picabia's witticisms. To choose Montmartre at that point in time was perhaps Breton's declaration of independence. In the twenties the younger artists drifted inevitably to Montparnasse where Picasso had been before them, where the editorial office of Apollinaire's *Les Soirées de Paris* had drawn all the significant painters and poets in the last months before the First World War. Breton required a degree of detachment, a retreat away from the forum of modern art and a sanctuary where he could guard the flame of Surrealism. But his next enterprise was to lead him into a maelstrom of avant-garde polemics.

At the beginning of 1922 Breton planned the Congress of Paris, an 'international congress to determine the directives of the modern spirit, and its

Théodore Fraenkel: *Artistic and Sentimental*, 1921 (Private Collection). A collage of the type made by several Dadaists, and exhibited at the Salon Dada in 1921.

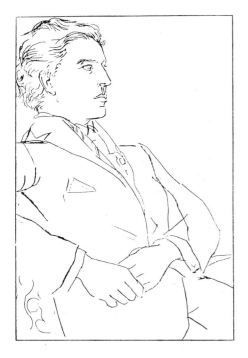

ABOVE Pablo Picasso: *André Breton*, 1923. Etching used as a frontispiece for *Clair de Terre*, a book of Breton's poetry.
BELOW Rayographs by Man Ray: LEFT 1927, and RIGHT 1923 (Peggy Guggenheim Foundation, Venice).

defence'. There was nothing to be gained from internecine sniping within the ranks of Dada; instead, Breton wanted to renew the wider debate which had been conducted in the pages of *Littérature* before Tzara's advent. 'Indeed his arrival', Breton would write later that year, 'cut short all those good old arguments that wore down the streets of the capital a little more every day.' Breton recruited an organizing committee representing the different artistic tendencies whose emergence Apollinaire had noted in his 1917 lecture on *l'esprit nouveau*. The members were: Robert Delaunay, the painter whose personal development of Cubism, called Orphism, had inspired one of Apollinaire's finest poems, *Les Fenêtres*; Fernand Léger, another painter who had created his own version of Cubism; Amédée Ozenfant, the champion of classical precision who, with Le Corbusier, had started a review called *L'Esprit Nouveau*; Georges Auric, one of Les Six, the group of composers inspired by the music of Satie and the ideas of Cocteau; Jean Paulhan, secretary-general of the *Nouvelle Revue Française*; and Roger Vitrac, who edited the review *Aventure* round which had gathered a group of young poets whose ideas owed much to Apollinaire and Marcel Duchamp, and not a little to Breton himself. The 'international' aspect of the Congress of Paris and the wording of its full title were Breton's acknowledgement of the inspiration which another Congress had been to him. Just over a year earlier the Congress of Tours had taken place. There the Socialists had voted three to one in favour of joining the Third International. The French Communist party, the *PCF*, had been born. What had particularly impressed both Breton and Aragon about the Congress of Tours was the presence of Clara Zetkin, a leader of German Communism. Such internationalism was far more convincing than the halting indifference

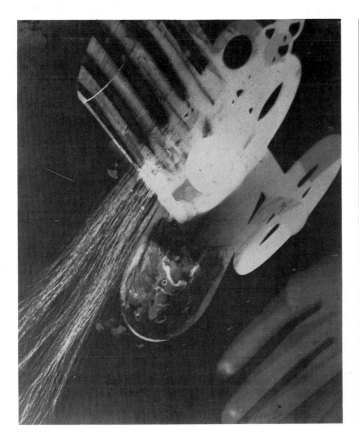

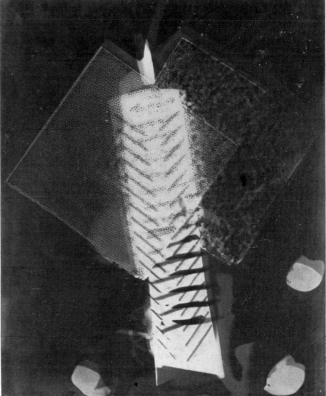

with which national governments were responding to the League of Nations. As the *mise-en-scène* of Barrès' trial had recalled the political debates of the French Revolution, so the Congress of Paris would borrow its style from the debates following the Communist revolution in Russia.

Tzara was invited to participate in the Congress of Paris, but answered: 'It is with regret that I inform you that the reservations which I had formulated even as to the concept of the Congress are not altered just because I am to take part. . . .' Tzara's refusal went a long way towards destroying the object of the Congress which would, in fact, never take place. But the matter was not allowed to rest there. The rumour went about that Breton had assured the committee of the Dadaists' good behaviour at the Congress. Tzara and his supporters were outraged by Breton's presumption. They called him to account for his attitude. He was heard at the Closerie des Lilas in Montparnasse on 17 February. By that time, the members of the committee, apart from Breton, had signed a communiqué in *Comoedia* expressing their dissatisfaction with the Dadaists' intractability and referring to Tzara as 'an outsider from Zurich'. Breton would never have endorsed such chauvinism which belied the internationalism of the Congress; but the remark ruled out

RIGHT Left to right: Vincente Huidobro, Robert Delaunay, Tristan Tzara and Hans Arp.

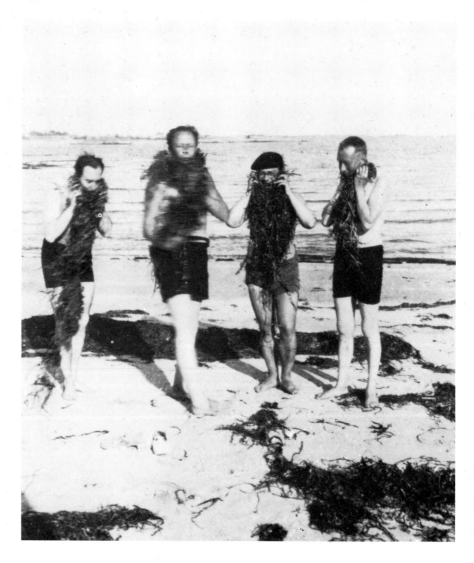

OPPOSITE Joan Miró: *Dog Barking at the Moon*, 1926 (Philadelphia Museum of Art, A. E. Gallatin Collection).

conciliation. At the Closerie des Lilas, Breton was harangued and insulted; only Aragon stood by him. The Dadaists then published further denunciations in the press. Tzara's most vicious attack on Breton, '*Le Coeur à Barbe*', appeared in *Comoedia* in March. At last, in the April issue of *Littérature*, there appeared Breton's adieu to Dada: 'Leave Everything.'

A new series of *Littérature* had begun in March, eight months after the last number of the original series had appeared. The review now had a front cover designed by Man Ray whose work Soupault was selling at the Librairie Six bookshop. From April, however, Breton was the sole editor and the review which had become entirely dominated by the Dada spirit reverted to the wider sympathies of its early issues. 'Leave Everything' was Dada's knell. 'I grasp your hands, comrades', wrote Breton, and he called on Soupault, Aragon and Eluard to rally to their old convictions: 'Do you remember Guillaume Apollinaire and Pierre Reverdy? Isn't it true that we owe them a little of our strength?' After Apollinaire's death, Breton, Aragon and Soupault had often called at Reverdy's apartment in Rue Cortot, at the top of Montmartre. It was perhaps during these frequent pilgrimages that Breton had begun to admire the locality. Reverdy had edited *Nord-Sud* and preferred to live *nord* rather than *sud*, geographically and intellectually a little aloof from the avant-garde across the river. André Masson, the painter, was to describe him as 'at once sombre and solar', and it was Reverdy's power of reconciling reality and mystery in his poetry which had appealed to the future Surrealists, when they had lost Apollinaire's understanding guidance. Now Reverdy, deserting his wife for weeks on end, stayed with Coco Chanel at 29 Rue du Faubourg St Honoré. The opulence, just the comfort, of Coco's house was irresistible to a poet whose work could never attract more than a handful of admirers to purchase his books. She was the most successful fashion designer in Paris, socially as well as financially. Doucet hardly, Poiret only a little more, had broken down the barrier standing between the *couturiers* and their clients, but Chanel was accepted at the grandest salon. At Rue du Faubourg St Honoré, when the high camp of Cocteau and company became sometimes too nauseating, Reverdy used to retire to the garden with a bucket, hunting for snails. But it was memories of the illuminating conversations at Rue Cortot which Breton was evoking when he mentioned Reverdy in 'Leave Everything', and the wit and wisdom which had flown about the Café Flore when he mentioned Apollinaire.

Other names he called upon: 'Picabia, Duchamp, Picasso are still with us.' These were the living artists in whose work Breton had found the anarchy of humour and desire where the roots of Surrealism had been nourished. When the barrenness of Dada buffoonery had begun to oppress Breton, he had found sustenance in a closer association with Picabia. Although the Barrès trial had first driven Picabia to leave Dada, his feud with Tzara and his former links with Apollinaire made him Breton's natural ally in the spring of 1922. In March he had published a manifesto announcing the end of Dada and adding maliciously: 'Snobs, beware!' It was Picabia's refusal to belong to any group, or to demand the allegiance of any adherents, which Breton respected and admired. The attitude recalled Vaché's insistence on a state of complete availability. From the June number of *Littérature* its covers were designed by Picabia. In November Breton accompanied him to Barcelona where an exhibition of Picabia's paintings had been arranged. On the evening of the *vernissage* Breton gave a lecture at the Ateneo. In 'Characteristics of the

OPPOSITE Robert Delaunay: Study for *Portrait of Philippe Soupault*, 1926 (Hirshhorn Museum, Washington DC).

FOLLOWING PAGES
LEFT Max Ernst: *The Virgin Spanking the Infant Jesus Before Three Witnesses*, 1928 (Madame Jean Krebs Collection, Brussels).
RIGHT René Magritte: *The Lovers*, 1928 (Zeisler Collection, New York).

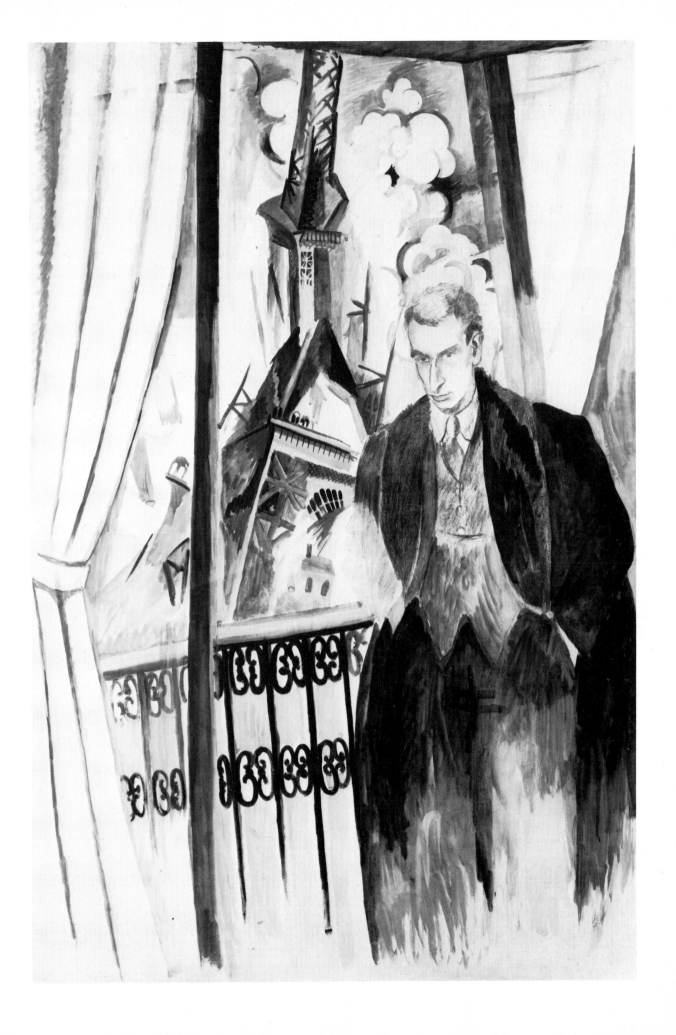

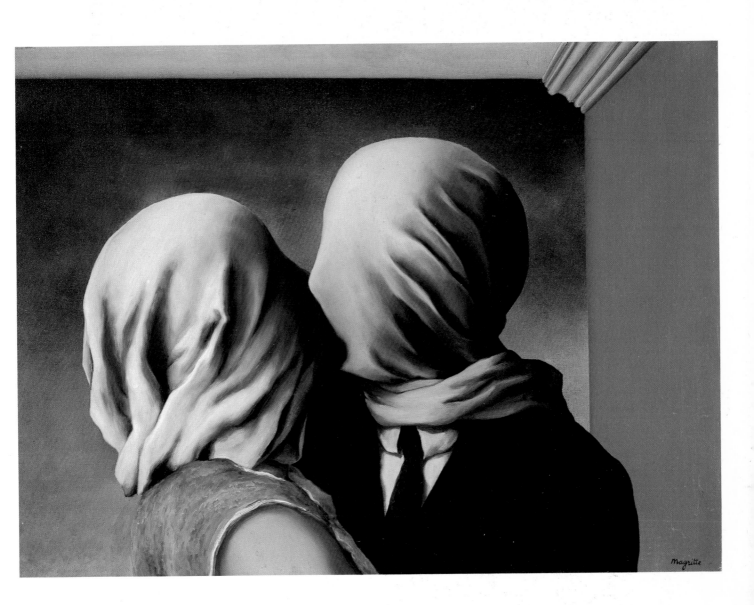

Littérature

3

Nouvelle Série

Modern Evolution and What It Consists of' he stressed the necessity not to be the prisoner of any system, to escape from the 'awful cage' of Dada; he announced his intention to be severe with Dada 'mercenaries'; and he suggested that 'the laws of the Reign of Terror' should be re-introduced to deal with such aberrations of the mind. Liberty, as Breton once said, is one thing one should not take liberties with. In Tzara's hands, Dada had become an infringement of intellectual rights. Condemning the movement, Breton alluded to the French Revolution as he had done when he had condemned Barrès for betraying the revolutionary ardour of his youthful mind, for sacrificing his intellectual freedom to the national cause.

Less than three weeks before Breton's lecture in Barcelona, armed bands of Fascists had marched on Rome and Mussolini had been made Premier of Italy. It was a triumph for the principle of nationalism which almost every day commanded greater obedience across a Europe yet recovering from the destruction and misery of the First World War. In France there was Action Française led by Charles Maurras who was urging more and more openly the violent overthrow of the Third Republic and the restoration of hereditary monarchy. The party newspaper, edited by Léon Daudet, attacked Protestants, masons, Jews and immigrants. In its pages, Mussolini's methods were reported with approbation, his successes with admiration. The darker aspect of anarchy was discernible in Maurras' and Daudet's scorn for democratic government, and in 1914 Mussolini had proclaimed 'the holy religion of anarchy'. Was it so easy to draw a clear line between a Bonnot who exploited the speed of the automobile in acts of terrorism and a Marinetti who not only thought 'a racing-car ... more beautiful than the "Victory of Samothrace"', but also glorified 'militarism, patriotism, the destructive arm of the anarchist'?

Louis Aragon's *Le Libertinage*, published in 1924, includes a story called 'When the Game Is Up' which is a reprise, largely fictional, of the Bonnot gang's

OPPOSITE Cover by Man Ray for *Littérature*, new series, 1922.

RIGHT Francis Picabia, photographed by Man Ray at the wheel of one of the many sports cars Picabia owned.

OPPOSITE Yves Tanguy: *Outside*, 1929 (Sir Roland Penrose Collection, London).

BELOW RIGHT A sketch by Fernand Léger for the cover of a programme for the Swedish Ballet season, 1922 (Private Collection).

adventures. The first-person narrator who eventually betrays the gang to the police tells how the bandits, when they started using their car, drove it 'in such a state of spiritual intoxication that nothing else mattered'. The speed and skill of their raids gave them a feeling of immunity; their leader, B____, seemed to them a hero, a predestined angel. But as B____ grew giddy with power, their raids became more frequent, more violent. Then came the betrayal and B____ was killed by the police. Aragon's story demonstrated the narcotic effect of successful terrorism and it could be read as an ironic comment on Futurism and Dada. There had been a cover of *Cannibale* which had carried a photograph of Picabia and Tzara in a sports car with the ambivalent caption:

'*Messieurs les révolutionnaires,* your ideas are as narrow-minded as those of a Besançon *petit-bourgeois*.' In 1918 Tzara had written: 'The artist creates for himself.' Dada implicitly accepted the philosophy of Stirner who had asserted the rights of the individual above the laws of society. When Picabia came to express his disenchantment with Dada, in an article published in *La Vie Moderne* in February 1923, he said that he found 'Victor Hugo more interesting than Max Stirner'. Perhaps he was trying to indicate the potential confusion between the anarchic individualism of Dada and the cult of the despotic individual preached by the leaders of Action Française; for it was well-known to the Parisian intelligentsia that Léon Daudet had nurtured a

OPPOSITE, RIGHT and OVERLEAF Covers of *Littérature*, new series, designed by Francis Picabia.

HP 85
MERCER NEW YORK
1920

RIGHT Tristan Tzara (left) and Francis Picabia in an 85 hp Mercer. This photograph was reproduced on the cover of *Cannibale*, 1920.

BELOW Benito Mussolini with his pet lioness Italia.

deep enmity for the Hugo family ever since his divorce from Victor Hugo's granddaughter in 1895. Breton was anxious about the intellectual aridity of Dada, from which soil Surrealism, a term which he first started using at this time, could never have grown successfully. He must have been afraid, moreover, that Tzara's zeal for organization would deprive his nascent movement of any members. Tzara and most of the Dadaists never condoned Fascism. Some of them became its most implacable foes. But Breton, in 1922, saw the threat that their nihilism posed to the process of intellectual sanitation which he proposed and wanted to lead. Now he upbraided Dada. 'In the long run', he wrote in autumn 1922, 'its omnipotence and tyranny had made it unendurable.' As the Fascists marched on Rome singing 'Youth' did he recall Gide's early warning? 'Youth has much less resolution than it thinks, much more submission and unconscious obedience.' Breton could not have submitted for long to the regime of a movement he did not himself control.

4 'Sometimes I'm Happy...'

OPPOSITE A poster advertising La Coupole,
one of the most popular cafés in Montparnasse,
the centre of the Parisian avant-garde during
the twenties.

In 'Clairement' Breton had written: '. . . already Jacques Baron, Robert Desnos, Max Morise, Roger Vitrac, Pierre de Massot are waiting for us'. These were young writers who admired Breton and understood the direction in which Surrealism was pointed. All of them were discontented with the stagnancy of Dada. At the end of 1922 Max Ernst, who was now living in Paris, painted *The Meeting of Friends*, a group-portrait of the Surrealists. It was another two years before they would be known by that name and Ernst included in his picture some who never became Surrealists, besides Raphael and Dostoevsky who were there only as harbingers. But that he painted the picture at all affirms the emergence of the group's corporate identity. There are Breton, Soupault and Aragon, the founding fathers; Eluard and Péret, the earliest adherents; Morise, Desnos and René Crevel, later recruits; Fraenkel who was only sporadically involved in the movement; Jean Paulhan, whose experiments with language had won the admiration of Breton and Eluard; Giorgio de Chirico, who had been an inspiration to all of them and to none more than Ernst himself; Arp and Baargeld, the artist's friends from the Dada movement in Cologne; and Gala Eluard, who was in love with Ernst and whose infidelity with such a close friend Paul Eluard would try generously to ignore. Appropriately they are all shown sitting or standing in the postures of mannequins, each one a doll which moved only at the bidding of the unconscious. They are situated in a landscape which might be taken from a painting by Uccello, the Renaissance master preferred by the Surrealists, or which might represent the terrain of the unconscious itself.

Among the newest members of the group, the most important that winter was René Crevel who had been an associate of Roger Vitrac on the administration of the review *Aventure*. Crevel had had some tuition in the techniques of spiritualism from a woman who considered he had mediumistic powers. In September Crevel had initiated other members of the group when they had begun to experiment with hypnotic trances. For Breton it had been the continuation, after a break of over three years, of the research which he and Soupault had inaugurated with *Les Champs Magnétiques*. Now the Surrealists stormed the unconscious in force. Seances were held almost daily through that winter, at the homes of either Breton or Picabia who also joined in these psychic explorations. Others who attended the experiments were Desnos, Péret, Morise, Eluard and Ernst. Robert Desnos was found to be a particularly apt subject who slipped easily into a state of trance. Soon he did not even require the atmosphere of the seance. 'In a café, amid the sound of voices, the bright light, the jostling', Aragon wrote in 1924, 'Robert Desnos need only close his

Robert Desnos, photographed by Man Ray.

eyes, and he talks, and among the steins, the saucers, the whole ocean comes down with its prophetic roar and its mists bespangled with long *oriflammes*.' The inspired nature of Desnos' utterances, which sometimes took the form of a steady stream of word-play, made immaterial the question of whether or not he simulated his trances. Some thought he did. Anyway, to an extent the seances were a game, one of the many different games they played which were intended to rouse the unconscious. One of the principal functions which Théodore Flournoy had ascribed to unconscious activity was the fulfilment of the instincts to create and to play.

Sometimes the seances could be frightening. Crevel began making chilling predictions, prophesying disease, madness and death for his friends. On another occasion he instigated their collective suicide; some had to be hurriedly woken when they began to hang themselves. Eluard was pursued by Robert Desnos brandishing a knife. A halt to the sessions was called. Apart from the dangerous situations that arose, the Surrealists again found their footsteps dogged by the public, as ever hunting greedily for a new diversion. Psychic phenomena were the rage in Paris that winter. The daily press reported the experiments undertaken at the Sorbonne on the medium Eva who was supposed to be capable of materializing ectoplasm. The results were negative but the public's curiosity was roused. The *Treatise on the Metapsychic*

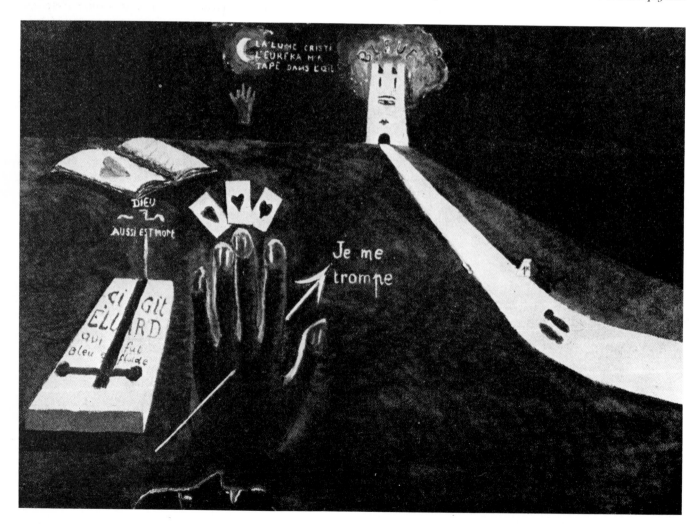

by Charles Richet, the physicist, was published in November. The book was avidly devoured by readers who a few weeks before probably knew nothing of the subject beyond a visit to a gypsy woman in a fairground booth. The Club du Faubourg debated spiritualism and fakirs. High on many hostesses' lists was Ghilighili, a fakir of indefinite Oriental extraction, who had been discovered wandering about Paris by the poet Léon Fargue. Among those who witnessed his début at one of Adrienne Monnier's literary soirées was André Gide. The clinical jargon of psychiatry was carelessly bandied round the salons and the cafés, and Paul Bourget's 'psychological' novels were bestsellers. Bourget, who wrote *The Physiology of Modern Love*, had been listed on one of Picabia's manifestoes, along with such detestables as Barrès and Rachilde.

Spiritualism and psychiatry became fads of a post-war society which wanted to be entertained. It was looking for novelty, expansive if frivolous in its taste. 'Paris was decked with flags for ten years after the Armistice', wrote Maurice Sachs, 'I remember that decade like a perpetual Fourteenth of July.' Sisley Huddleston, the Paris correspondent of *The Times*, looking back over the decade listed some of its gimmicks: 'Cubist and other queer paintings . . . typewriters . . . one-way streets . . . cocaine, silk stockings . . . monkey glands for rejuvenation . . . Freudism . . . unnatural vices . . . aeroplanes and cocktails.' When Gide had arrived at Ernst's *vernissage* in 1921 the voice from the cupboard had insulted him fluently. The author was becoming a salon idol; he was the cultural hero of the 'unnatural vices'. What *La Prisonnière* had done to make Parma violets a symbol of enlightenment in the twenties, *Corydon* would do to make male homosexuality a cultural preoccupation among the *haute-bourgeoisie*. When Gide's novel had been written in 1911 only twelve copies had been issued and only another twenty-one had been printed in 1920; but in 1922 an edition of five and a half thousand was quickly snapped up. Unconnectedly, perhaps, the emancipation which women had won in factories and hospitals during the war became another object of widespread enthusiasm during the twenties. In the air lady aviators and, on the tennis-court, Suzanne Lenglen fired the popular imagination. Advertisements for the Gillette lady's razor appeared at the same time as the safety razor for men. Recognition of homosexuality and the liberation of women were causes which the Surrealists were unwilling to support, not because they thought them unworthy, but because everybody whom they least respected was chattering about them.

Sport was another rage. In the stadium, the war continued. In Paris, at the Stade Pershing in May 1921 hundreds of athletes had taken part in a gymnastic display called the 'Festival of Spring', watched by Marshal Pétain. When England had beaten France at 'Le Rugby' the same year, Marshal Foch was one of forty thousand spectators. A poster for the Salon Dada in 1921 had carried the ironic notice: 'Athletes wanted'. Thousands flocked to the six-day bicycle races at the Vélodrome; thousands went greyhound racing. It was the era when sun-bathing and winter-sports became popular; Cannes and Chamonix began to mean as much as Monte Carlo and Biarritz. Sachs was regretting in 1924 that the bourgeoisie talked of nothing but golf and relativity; the latter was generally dismissed as 'Futurism'. At the Coliseum, Auric's ballet *Paris-Sport* was danced by Caryathis.

From across the Channel came the Prince of Wales and crosswords. But it was from across the Atlantic that the more powerful ingredients of the twenties

OPPOSITE Robert Desnos: *Here Lies Eluard*, 1922 (Galerie François Petit Collection, Paris). One of the images produced by Desnos from the trances into which he so easily slipped.

OPPOSITE Josephine Baker, the idol of Paris, in the early twenties.

cocktail were imported. A 'beauty-parlour' opened in Paris; it belonged to Fanny Ward, the star of numerous Hollywood melodramas. She and Jack Dempsey, among other glamorous personalities made in America, were to be seen in clubs like the So Different, and Josephine Baker danced at the Théâtre des Champs-Elysées. Her performance, thought the staid Parisian critic Robert de Flers, proclaimed 'the cult of ugliness, the reign of disequilibrium, the apotheosis of discordance'. But soon she was topping the bill at the Folies-Bergère, and then she opened her own club where La Revue Nègre performed nightly. The *chansonniers* had to contend with American popular songs: 'Ain't She Sweet', 'Black Bottom Blues', 'Breezin' Along with the Breeze' or 'Sometimes I'm Happy'. Not only jazz, but even the music of the Harvard Glee Club visiting the French capital in 1921 gained the Parisians' plaudits. More and more cinemas were opened in Paris to show more and more Hollywood productions. There were thirty-two cinemas in 1921; a year later, forty-three. The old Vaudeville became the Paramount.

'Surprise' parties were another American innovation, though it is difficult to imagine any party coming as a surprise to anyone in Paris during the twenties. There were the costume-balls which followed each other with debilitating rapidity through the season. Etienne de Beaumont's was probably the most exclusive, Paul Poiret's perhaps the most lavish. The theme of one which the *couturier* gave was 'Kings and Queens', where Poiret himself made a great impression as Oedipus Rex. 'Freudism' made the ancient Greek king the most talked about monarch in Paris, with the exception perhaps of King Ferdinand of Romania who was seen at the best places with the best people, but always incognito.

Midinettes on strike, September 1923. The emancipated woman of the twenties gained a new awareness of her rights.

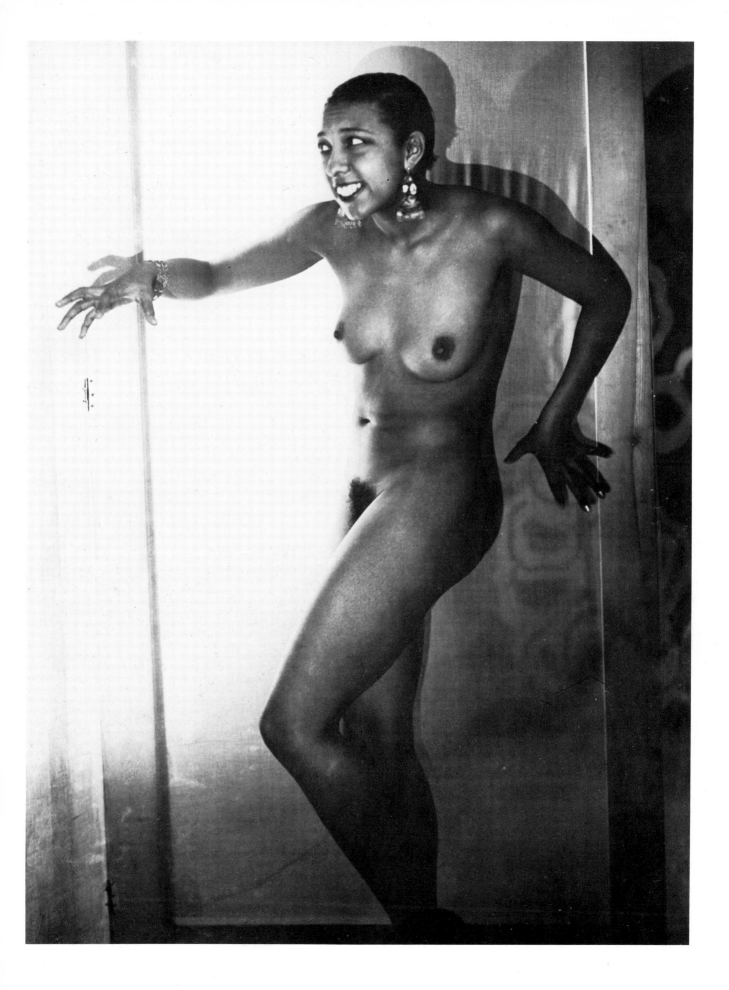

Kiki, photographed for *Vogue* by Man Ray, holding one of the African masks which influenced the style of Modigliani's portraits.

OPPOSITE Pablo Picasso: *Seated Bather*, 1930 (Museum of Modern Art, New York, Mrs Simon Guggenheim Fund).

James Joyce, Sylvia Beach (centre) and Adrienne Monnier. During the twenties Sylvia Beach's bookshop, Shakespeare & Co., where this photograph was taken some time later, and Adrienne Monnier's La Maison des Amis des Livres were centres of the literary avant-garde in Paris.

Cocteau, it has been claimed, 'invented' the twenties; certainly he patented them. Delighted when his homosexuality became fashionable, it was not long before his name was identifiable with opium, equally fashionable. He and his admiring circle used to gather at the Gaya, one of the piano-bars which were gaining popularity; Harry's Bar had been opened in 1918, starting a rash of such establishments *à la* Manhattan over the French capital. When there was no longer any room to move at the Gaya its owners opened the Boeuf sur le Toit in Rue Boissy d'Anglas, only a short walk from the Opéra and Maxim's restaurant. Here gathered the Parisian élite, drawn like the children of Hamelin by the music of Cocteau's pipe; Sachs recalled his voice, to be heard above all others, 'high-pitched, glass-shattering'. Among the guests on any evening might have been Picasso, Léger and Marie Laurencin; Diaghilev plus half a dozen dancers from the Ballets Russes; Satie and up to half a dozen of Les Six; Etienne de Beaumont and Lucien Daudet; Coco Chanel with only one eyebrow and the Grand-duke Dmitri in tow; Princess Murat and the Comtesse de Noailles. In shapeless gowns or grey flannels celebrities milled round from ten to one o'clock. Louis Aragon was often there, André Breton sometimes. Poets and painters luxuriated in an unprecedented atmosphere; modern art, poetry as well as 'Cubist and other queer paintings', had become a Parisian staple. The era of the genius starving in the garret was apparently over. Maurice Sachs' opinion in the early twenties was that his generation was compensating for the neglect which a Rimbaud, a Gauguin and a Van Gogh had suffered: 'For fear of passing by a "genius", we will soon be so encumbered with them that one will be able to walk along with a lantern saying: "I'm looking for a man with no talent".' The market for modern art

was booming in Paris. Francis Picabia had written a manifesto in 1922
declaring that Cubism was finished. It was 'nothing more than commercial
speculation'; and maliciously he had added: 'Collectors beware!' But the en-
trepreneurs on Rue de la Boétie, Léonce Rosenberg and Paul Guillaume, were
thriving. Rosenberg, a small, nervous man, sold paintings by Picasso, Braque,
Léger and Laurencin. With a sacerdotal air he would lead his clients round a
gallery where the walls were draped in red silk. Paul Guillaume was more self-
assured. He had taken up the trade in modern art at the suggestion of Derain
whom he had met at the front, and whose paintings he now sold. Bookshops,
too, were thriving. At Stock's or Champion's fashionable ladies lingered as
they might have ten years before at their milliner's or haberdasher's. Camille
Bloch and Ronald Davis did a brisk trade in fine and rare editions. Sylvia Beach
at Shakespeare & Co. and Adrienne Monnier at La Maison des Amis des
Livres catered for a public eager to buy avant-garde literature, while on the
Quai de l'Horloge Princess Lucien Murat supplied the *haute-bourgeoisie* with
books by the more conservative moderns. The princess' little shop was called
Fermé la Nuit, an allusion to *Ouvert la Nuit*, a best-selling collection of stories
by Paul Morand, *littérateur* and diplomat. The old, bearded *bouquinistes* had
disappeared from the quays on the Seine, their places taken by smart young
women selling first editions tastefully laid out on lengths of black velvet.

The tourists who came to Paris in their thousands were taken not only to the

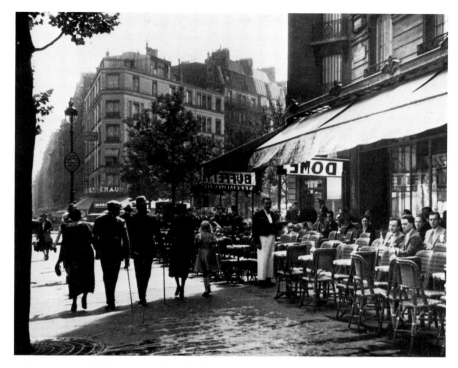

Louvre, and to the Passage de l'Opéra to see the Dadaists in the Café Certâ, but also to Montparnasse where 'genius' had found its natural habitat. Apollinaire had prophesied it as long ago as 1914: 'Montparnasse will soon have its nightclubs and singers, as it already has its painters and poets . . . Thomas Cook will be bringing charabancs loaded with sightseers.' During the twenties, the quarter attracted young intellectuals from the provinces, Russian *émigré* artists and America's 'lost generation'. At tables on the terraces of such cafés as the Dôme and the Rotonde sat poets and painters from all over the world, more or less talented, more or less itinerant. For every Desnos, for every Foujita, for every Hemingway and every Unamuno there were a hundred imitators and a thousand tourists who thronged the famous cafés. And for every Kiki there was a legion of young girls with good figures and high hopes. Kiki modelled for Utrillo, Soutine, Kisling, Foujita, Derain and Man Ray. She was unrivalled, even by the beautiful mulatto girl, Ayesha. The memory of Kiki is enshrined in her autobiography and in the preface which Robert Desnos wrote for the catalogue to the exhibition of her own paintings. At the Jockey, another Montparnasse café, she would entertain the tourists, but she was apt to forget the words of her scurrilous songs. At the Jockey too there was Chiffonette, a diminutive lady who sometimes danced a Charleston on the tables.

Montparnasse abounded with characters. Each café was a sideshow where, for the price of a drink, one might goggle at the intellectual freaks. For example, there was Raymond Duncan, Isadora's brother, who dressed himself and his band of followers in Greek robes and sandals. He had spoken up for Dada at the Club du Faubourg; at the first performance of Cocteau's *Antigone*, not only were the Surrealists there protesting at the fashionable frivolity of the event, but also Raymond Duncan and his followers who tried to stop what they considered a travesty of Sophocles' drama. Massimo Bontempelli and his Novecentisti strutted round Montparnasse; they adored Mussolini and called themselves 'I Giovani'. They used to gather at the Café de la Consigne

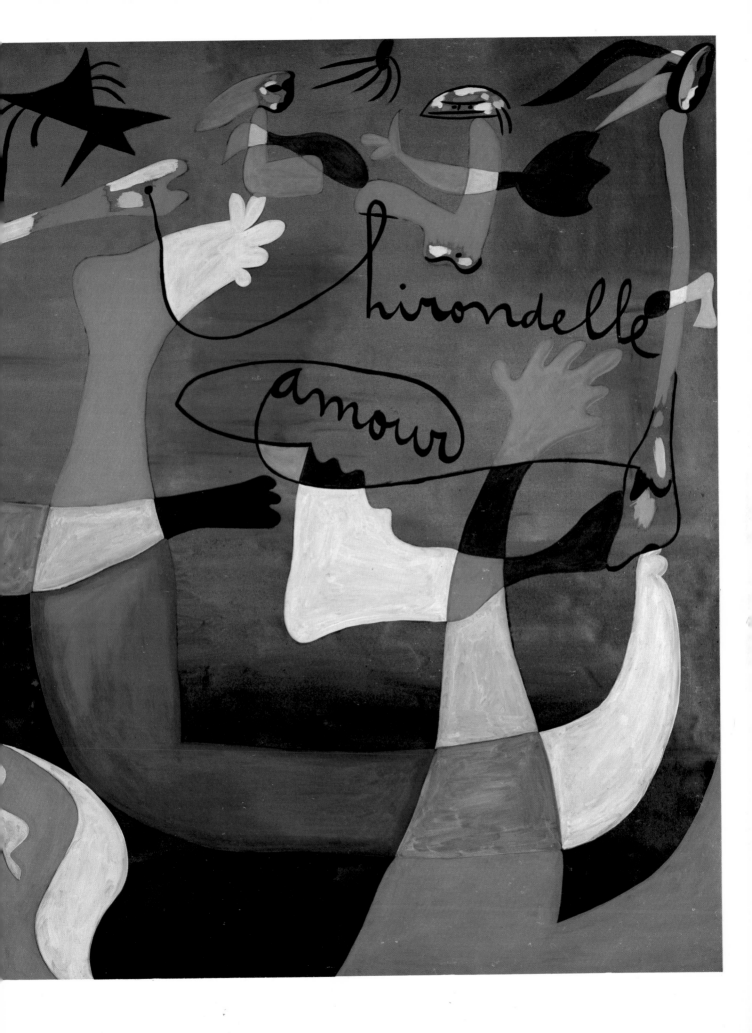

opposite the Montparnasse railway station. There they might be joined by Ramon Gomez de la Serna with his entourage, supporters of Primo de Rivera the Spanish dictator. A strange figure was cut by Aleister Crowley, in plus-fours or a kilt and with his head shaved except for a waxed forelock. Ilya Ehrenburg was often to be seen sitting on the terrace of the Rotonde. Ehrenburg was Moscow's observer at this focal point of Western decadence; disgustedly, he watched the carnival pass.

The procession of oddities winding through Montparnasse on that protracted Quatorze Juillet was but one aspect of artistic life in Paris during the twenties. There was also a core of poets and painters working hard, constantly exploring the frontiers of the intellect. Expatriates, like Picasso and Brancusi and e.e.cummings, and natives like Léger and Derain, not to mention the Surrealists, made Paris a rich mine for perceptive collectors. Of these, perhaps the most enterprising was Jacques Doucet the *couturier*. His period of pre-eminence in the Parisian fashion business had been during the *belle époque* at the beginning of this century. There had been no Zola to characterize him in the novel as that author had portrayed Worth, as Worms, in the Rougon-Macquart saga. Proust's ladies had all been dressed by Doucet but nowhere in *A la Recherche* is the *couturier* himself encountered. Once when he had implicitly requested an invitation to a certain fashionable salon, he had met with a rebuff; surely he could not have expected to be asked to meet socially the women he was accustomed to seeing only half-dressed at his studio? Paul Poiret, formerly one of his assistants, had bought himself an almost mythological image; Coco Chanel with her grit and charm had won first the admiration and then the intimacy of *le Tout Paris*. But Doucet remained a more enigmatic figure, chasing foxes and women with an aristocratic ardour but never winning the status he craved. In 1912 he had sold a magnificent collection of French eighteenth-century art which had realized more than thirteen million francs in the saleroom. Then he had begun to concentrate on contemporary art. He used to say that he had formed his grandfather's collection first, then his father's and finally his own.

Doucet realized that he had neither the time nor the knowledge to make a definitive collection of modern art, so he employed experts, recouping the expense by making artists reduce their prices for him. His collection would go to the Louvre, he used to tell them; how else could they ensure their immortality? Even Picasso was not impervious to such coercion and sold Doucet *Les Demoiselles d'Avignon* for quite a moderate price. Neither the artists nor the consultants had great respect for his judgement or his business methods. When he asked Derain to price a canvas, the painter took out a tape-measure and estimated the value of the work in square centimetres. Doucet was humbled; it was one of the few occasions when he paid the price asked without argument.

At the *vernissage* of Ernst's show in 1921, the voice from the cupboard greeted Doucet with a stream of blandishments. Among the experts he employed were Breton and Aragon. Breton worked five hours a day in this capacity and to a great extent relied on Doucet's fees for his livelihood. He kept him informed of new work being done in the painters' studios and arranged for Doucet to visit the artists. While Breton attended to the paintings, Aragon reported regularly to Doucet on the literature of the avant-garde. The *couturier* collected a complete cultural environment rather than a stack of canvases or a

Aleister Crowley, the English poet who devoted his life to the occult, was one of the many colourful characters passing through Montparnasse during the twenties.

pile of books. When 'Art Deco' became the modern style of French architecture and the applied arts he had a new studio built for himself at Neuilly. It was decorated by Pierre Legrain and Rose Adler and furnished with the work of designers such as Eileen Gray and Jean Dunand. Aragon, encouraged by Camille Bloch, organized Doucet's library according to the principles enunciated by Isidore Ducasse, Comte de Lautréamont. His duties also included providing Doucet with a regular résumé of developments in modern French literature. Doucet's acumen in employing two minds aware of what was happening in the arts, despite their apparent prejudices, has to be respected. But Breton and Aragon themselves had little respect for their patron. He was a hard master. On one occasion, when Reverdy was working for him, the poet failed to be in attendance on Doucet at the appointed time. He sent his apologies, pleading sickness. But Doucet was not satisfied. He made his way to Rue Cortot and unceremoniously entered Reverdy's bedroom in order to authenticate the excuse. 'Breton is after my head', Doucet used to say, apparently sensing his expert's disapproval of the brusque, almost boorish, way he treated artists.

Breton had taken Doucet to meet Ernst at his studio soon after the painter had settled in Paris. Ernst had been very poor at the time, forced to make tiny elephants for cheap bracelets. Doucet had wanted to pay only 500 francs for a painting of five transparent vases holding flowers which grew inwards. In the circumstances, Ernst had had to agree. Doucet, however, had decided that the painting would look better with three vases, so he cajoled Ernst into painting another version. Its price, Doucet had insisted, should be only 300 francs! Another time, Doucet, on his own initiative, bought a painting by André Masson. What did Breton think of it? In Breton's opinion it was not one of the artist's best works. Perhaps, suggested Doucet, something was missing? A little bird, or something? Breton could not say, but he was amazed to find next time he saw the painting that Doucet had indeed persuaded Masson to add the little bird.

Familiarity with a large number of leading artists and a knowledge of the market for their work enabled Breton and other Surrealists to supplement their slight incomes by some speculation for themselves. Aragon and Breton had bought important Cubist paintings at a sale of the dealer Kahnweiler's old stock in 1921, and there were large profits to be made on the purchases. Aragon had bought a *Bathers* by Braque and sold it in 1928 for ten times what he had paid for it. Eluard borrowed money from his parents with which he used to buy paintings and first editions. If he needed cash he would sell whatever was showing the best return on its original price and, having repaid his parents, keep what was left over to finance himself and Gala. In 1923 he went to Rome to visit Giorgio de Chirico, buying several canvases in advance of the exhibition in Paris which had been arranged for the following year. It must have been a profitable gambit, but Breton was scornful of de Chirico's new work. It had little to do with Surrealism.

Aragon was the Surrealist who was most *au fait* with the commerce of the artistic world. He worked for a time as secretary to Jacques Hébertot, the manager of the Théâtre des Champs-Elysées, a position where he had the opportunity of meeting people who were buying or selling culture. Hébertot acquired the moribund *Paris-Journal* and asked Aragon to resuscitate it. He was able to line the pockets of his friends with fees for articles and reviews,

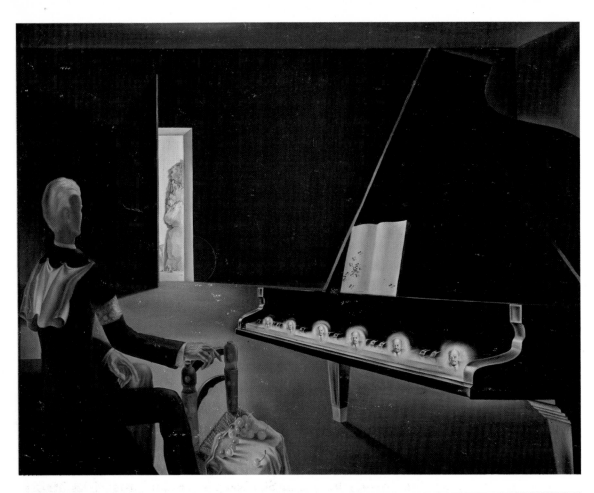

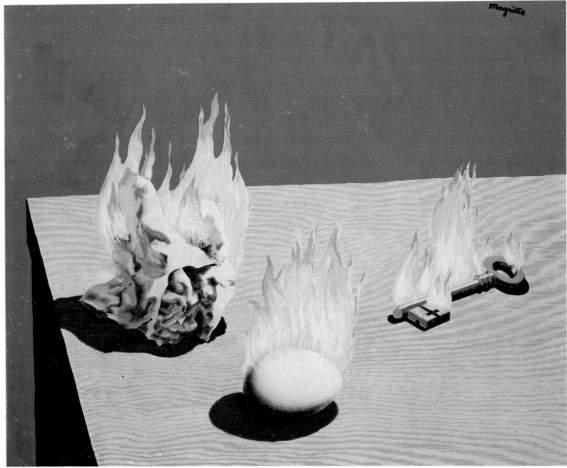

and became acquainted with another group of useful contacts. His mild homosexuality, which seems to have been no imposition on his relations with women, was an open-sesame to other circles. He was friendly with Pierre Drieu la Rochelle, a writer whose articles and stories condemning the hedonism and immorality of post-war Paris were based on a considerable measure of personal experience. Raymond· Radiguet was also one of Aragon's closer friends, although they had quarrelled before Cocteau's young protégé died in 1924. Breton had to abide Aragon's homosexuality because he needed the stimulus of his radical intellect. At that time it was Aragon who, more than Tzara had ever done, took the place of Vaché. Aragon was a dandy who used to wear rubber gloves; who would stand outside Van Cleef & Arpel's until he saw an attractive girl approaching, when he would loudly proclaim: 'That's the window that always tempted me most in my shop-breaking days.' Soupault, too, had loved to indulge in the idiotic: he would ask for sausages at the florist's, or pull the emergency chain on a bus and inquire of all the passengers their birth-dates. On a day when the sun was shining, he would open an umbrella and invite a girl who tempted him to take shelter under it. He used to suggest to customers at cafés that they should swop drinks with him. But during 1923, Soupault was drifting away from Breton and Surrealism. He was running his bookshop and had joined the editorial board of *La Revue Européenne*. He was also writing novels, a form of literary prostitution which Breton hardly tolerated. In the May issue of *Littérature* Soupault's name was followed by several blank pages.

Aragon travelled when he had the time and the funds. In 1921 he spent the autumn and winter in Berlin and on his return wrote a book about the city's low-life. In 1923 he was in Strasbourg for a time, astonishing Maxime Alexandre with his system for winning at poker and shocking the bourgeoisie by walking in the streets without a hat. He made other journeys to Spain, Holland and Italy at about this time. Speaking perfect English, he was popular with the Americans in France. He stayed for a while at Giverny where he began writing a novel, most of which he would destroy in 1927. Monet's step-daughter was married to the American painter Theodore Butler and the village on the Epte had become a transatlantic colony. Malcolm Cowley, an American writer who had a house there and whose guests included, as well as fellow 'colonials' such as e.e.cummings and John Dos Passos, several Dadaists and Surrealists, described Aragon in a letter of 4 June 1923: '. . . this elegant young man . . . has so much charm, when he wishes to use it, that it takes him years to make an enemy; but by force of repeated insults he succeeds in this aim also . . . He is always seriously in love; he never philanders . . . I ought to add that he has a doglike affection for André Breton.'

Jacques Prévert once said that André Breton was loved by the other Surrealists with an emotion with which they would only otherwise have loved a woman. Adrienne Monnier described as 'libidinous' the power which Breton had over his friends. His beauty, Adrienne considered, was 'archangelic', by which she meant, as she explained, that there was more gravity and grace in his features than the term 'angelic' might convey. She might well have been thinking of Cocteau when she made this distinction, for Cocteau's good looks were sometimes described as those of an angel, and it was as an angel that Cocteau often saw himself. Breton's head was massive and on top of it he had thick, curly, light-brown hair which he wore long, brushed back from a high forehead. 'Lion-like' was how Maxime Alexandre, the young Surrealist from

OPPOSITE ABOVE Salvador Dali: *Evocation of the Apparition of Lenin*, 1931 (Museum of Modern Art, Paris).
OPPOSITE BELOW René Magritte: *The Ladder of Fire*, 1939 (Edward James Foundation).

Strasbourg, described him. His lips were heavy and sensual, but the firm outline of his mouth denoted, Adrienne Monnier thought, a sense of duty. He smiled seldom, and laughed without his features moving much. The expression in his blue-green eyes was 'both phlegmatic and pitiless' as one Surrealist described it. To poets and painters, the value of his friendship lay in his perceptive intelligence, in the integrity of his intellectual morality. Because he maintained his own standards with conscientious rigour he was intolerant of those who compromised their convictions. He did not demand loyalty to himself, but a servitude equal to his own. Many of his adherents who cherished his friendship nevertheless found its demands oppressive. Robert Desnos, who became a victim of Breton's censure, was to write: 'To be a friend of Breton is one of the moral horrors of the times; many who have fallen into an

André Breton's powerful personality was expressed in his looks, considered by Adrienne Monnier as 'archangelic' and by Maxime Alexandre as 'lion-like'.

RIGHT A corner of André Breton's studio at 42 Rue Fontaine. 'Like one big museum' was how André Thirion described Breton's collection of primitive sculpture, strange objects and paintings. Works by Ernst, Duchamp and Picasso appear in this photograph.
BELOW Marcel Duchamp: *Nude Descending a Staircase*, 1912 (Philadelphia Museum of Art). A study for the painting can be seen in the illustration on the right.

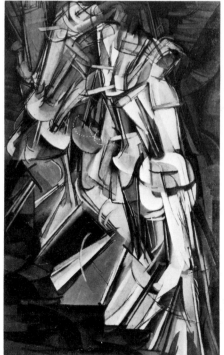

OPPOSITE Les Buttes Chaumont in Montmartre held a particular fascination for the Surrealists. The park's gloomy atmosphere reflects the tragedy of the many lives which were ended there.

irremediable decline give no further excuse than the fact that they were, for only a day, his friend.'

In Montmartre Breton used to lead a simple life. When the Passage de l'Opéra was demolished, the Café Cyrano in the Place Blanche at the northern end of Rue Fontaine became Beton's regular meeting place and there, twice a day, he would be joined by the other Surrealists. The initiated ordered mandarin-curaçao. On the front door of his apartment Breton left a board for messages headed '1713' which, written in Continental numerals, appeared as his initials. Inside, the studio was 'like one big museum'; it was so described by André Thirion, a Surrealist who first visited Breton in 1927. Paintings by de Chirico, Picasso, Ernst, Duchamp and Picabia hung on the walls and objects of Oceanic art were placed round the room. 'Of course', Thirion wrote, 'every

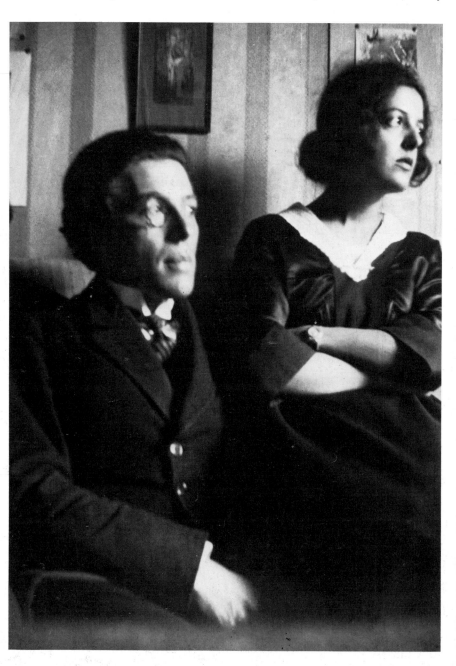

André and Simone Breton, a photograph taken during the early twenties at 42 Rue Fontaine.

painting, every object sent out an exceptionally powerful emanation . . . which adhered to it like a shadow wherever it was put.' There was an atmosphere of unworldliness, even other-worldliness, in the studio, 'something timeless'; and Thirion's description continues: 'The presence of human beings was not taken for granted there; meeting people from another era would probably have come as no surprise.' Those people might have included de Sade, Hegel and Lautréamont.

Breton had nothing to do with the Montmartre of Mistinguett and Maurice Chevalier; he avoided tourist traps such as the Bal Tabarin, the Moulin Rouge and the Casino de Paris. As far as eating was concerned, the Surrealists used to move on from the Cyrano to some modest restaurant in the area, tactfully chosen by Breton who always used to bear in mind the finances of his fellow diners. There was a good, cheap restaurant on Rue Lepic they often visited. Breton was happy to eat anywhere providing, to quote Thirion again, 'the food was of good quality, the wine pleasant, and the clientele didn't make too obvious a show of bourgeois manners and habits'. Arrangements for meetings of the Surrealists, or invitations between them, were usually made by *petits bleus*, the messages which used to be transmitted across Paris through pneumatic tubes. *Les grands boulevards* was the area which Breton found most sympathetic, especially the side-streets. This was not the sightseers' Paris, it was not the Paris of noisy arguments between colourful intellectuals. It was the quiet, business-like Paris. Breton would take his place at the Batifol, a café in Rue Faubourg St Martin, as if he were seating himself behind his office-desk. He did not care for the café society of Montparnasse. Most people there he thought *passé*, mediocre and too concerned with creating images of themselves.

When the Surrealists met they indulged in the activities which made the group as important to the movement as the movement was to the group. When the seances had been stopped, playing games had become their most significant activity. They played word-games which helped them recognize the totally unexploited potential of language. Games of chance, especially variations on the theme of 'Consequences', taught them to revere the fortuitous and the miracle of coincidence. The element of competition was quite absent from their games; there is absolute opposition between the spirit in which the Surrealists gathered to play and the wearisome need to win settling over the bridge tables where the bourgeoisie in those years found the latest sublimation of their commercial instincts. The games provided an interdependence among the group which thereby gained in cohesion.

Protests and demonstrations were Surrealist activities which required mutual trust among the conspirators. From the Barrès trial sprang a long line of attacks against personalities or productions. But, as the Barrès trial had been, these were positive protests establishing a right or a freedom, not merely destructive raids in the spirit of Dada. On some occasions, the Surrealists demonstrated in favour of somebody, if he expressed ideas similar to their own, for instance Raymond Roussel whose *Impressions d'Afrique* had inspired Marcel Duchamp, among others. When Roussel's *Locus Solus* was performed in 1922, the Surrealists attended the first six nights vigorously applauding the play and equally vigorously dealing with anyone in the audience who dissented from their appreciative enthusiasm. They regularly barracked Cocteau's theatrical offerings; they found his artistry as light and as thin as the bank notes he was busily stuffing in his pocketbook. Aragon maintained a protracted

OPPOSITE Surrealist playing cards depicting Freud, Alice and Lautréamont. To the Surrealists card games signified the power of chance, not the thrill of competition.

OPPOSITE Erik Satie, as he appeared in the film *Entr'acte* by René Clair, 1923. The film was shown during the intermission of *Relâche*, written by Francis Picabia for the Swedish Ballet. The Surrealists did not approve of Satie's and Picabia's entry into the world of the commercial theatre.

campaign of abuse against the writers of *La Nouvelle Revue Française*, in particular André Gide who was evidently enjoying the acclaim he had won from society for the frank confession of his delicate emotions. On the death of Barrès in 1923, Aragon wrote to Gide ironically consoling him for the loss of his 'boy-friend'. Eluard picked on Anna de Noailles the aristocratic poetess; in the review *Feuilles Libres* he satirized her work in the analysis of a short poem by 'Anne Ilda-Salon'. In July 1923, Ilia Zdanevitch, an *émigré* Russian Dadaist, organized the Soirée du Coeur à Barbe. Zdanevitch had been one of the signatories to Tzara's most vicious attack on Breton the year before, and many of the other signatories were involved in this entertainment at the Théâtre Michel. A performance of Tzara's *Le Coeur à Gaz* was to be given by a cast which included Jacques Baron, Pierre de Massot and René Crevel, all of whom had been counted among Breton's adherents but were estranged from the group. Poems by Eluard were to be read, until he discovered that Cocteau's verse was also featured. He objected. Breton was indignant about the whole event, which had assumed the nature of a society function. Moreover, Tzara was trying through the Soirée to regain his position as leader. The evening could not be allowed to pass without a strong protest. While *Le Coeur à Gaz* was being performed the Surrealists stormed the stage. The actors were hampered by Sonia Delaunay-Terck's tubular costumes; Breton broke Pierre de Massot's arm. Crevel was hit. The police were summoned. Aragon and Péret were ejected. Eluard, resisting the same treatment, was thrown into the footlights. 'My nice little house', wailed the theatre manager, 'my nice little house.'

Eluard was sued for the cost of repairing the damage. He was already overwrought, assailed by doubts of what intellectual direction he should be taking. He made his trip to Rome, leaving Gala to deal with the lawyers. In August Breton too escaped from the strains of in-fighting among the

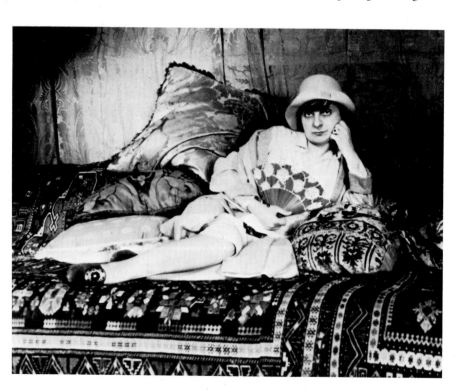

Comtesse Anna de Noailles, the aristocratic poetess.

LA RÉVOLUTION SURRÉALISTE

Directeurs :
Pierre NAVILLE et Benjamin PÉRET
15, Rue de Grenelle
PARIS (7ᵉ)

Le surréalisme ne se présente pas comme l'exposition d'une doctrine. Certaines idées qui lui servent actuellement de point d'appui ne permettent en rien de préjuger de son développement ultérieur. Ce premier numéro de la Révolution Surréaliste n'offre donc aucune révélation définitive. Les résultats obtenus par l'écriture automatique, le récit de rêve, par exemple, y sont représentés, mais aucun résultat d'enquêtes, d'expériences ou de travaux n'y est encore consigné : il faut tout attendre de l'avenir.

Nous sommes

à la veille

d'une

RÉVOLUTION

Vous pouvez y

prendre part.

Le BUREAU

CENTRAL

DE RECHERCHES

SURRÉALISTES 15, Rue de Grenelle,
PARIS-7ᵉ

est ouvert tous les jours de 4 h. 1/2 à 6 h. 1/2

avant-garde; he went to Brittany again and wrote poetry. The Surrealists needed all their strength for next year's strife; 1924 was to be a critical year.

Protests continued. In February Desnos insulted Madame Aurel at a literary banquet. At the first performance of Erik Satie's ballet *Mercure*, in June, the Surrealists applauded Picasso's décor but hurled abuse at the composer. Satie had helped to sabotage the Congress of Paris and, a worse sin, was collaborating in this production with Etienne de Beaumont. If the Surrealists were united in their assaults on 'les snobs', this unity was threatened by internal dissensions. Aragon's situation at the *Paris-Journal* was considered

suspect by those who followed Breton's lead in not seeking any remuneration from journalism. Aragon stepped down. But the matter gave prominence to the group's urgent need for a statement of their principles and a more consciously partisan mouthpiece than *Littérature*. In June there appeared the last issue of that review and Breton promised a manifesto. The pressure mounted: Picabia had begun producing *391* again and was using the review to pour scorn on Breton and his enthusiasms. In August the poet and playwright Yvan Goll, writing in the review *Journal Littéraire*, discussed the term 'Surrealism'; he claimed that since Apollinaire's invention of the word, the artists whose work might be characterized as Surrealist were Blaise Cendrars, Marc Chagall, Robert Delaunay and Jacques Lipchitz. The claim was quickly refuted by the Rue Fontaine group in a letter which appeared in the same review the following week. Now it was a sprint to the line which Goll, supported by Paul Dermée, appeared to have won with the publication of a new review, *Surréalisme*, in October, which included a manifesto. But the same month, Breton's manifesto was distributed and the Bureau of Surrealist Research was opened in Rue de Grenelle.

Avant-garde opinion soon identified Surrealism with Breton and his followers. Goll's theories were only an emasculated version of the ideas to which Breton's manifesto gave intellectual substance. Breton defined Surrealism as 'pure psychic automatism', the dictation by the unconscious to the writer who should become merely a 'recording device', a phrase taken directly from Régis' *Précis de Psychiatrie*. Surrealism, according to Breton, was a revolt against all literature which obeyed the conventions of logical composition; it was a revolt, too, against bourgeois morality which stifled the unconscious and discounted the irrational. Surrealism was not an artistic movement. This claim was corroborated by the activity of the Bureau on Rue de Grenelle where all members of the public were invited to share with the Surrealists their dreams, their desires or any wondrous experience which the world might call illogical. 'At number 14, Rue de Grenelle', wrote Aragon, 'we opened a romantic inn for unclassifiable ideas and continuing revolts.' The plaster cast of a nude hung from the ceiling, and a volume of *Fantômas* was fixed to the wall with table-forks.

On 1 December appeared the first issue of *La Révolution Surréaliste*. It included accounts of dreams, automatic texts, some poems and articles. Its appearance was restrained, almost that of a scientific journal: no typographical tricks, a few drawings, some photographs by Man Ray. But on the front cover it bore the slogan: 'It is necessary to start work on a new declaration of the rights of man'; and inside the front cover was printed a short statement: '. . . Certain ideas which are useful today as a point of departure must not be allowed to prejudice later developments . . . we have everything to expect from the future.'

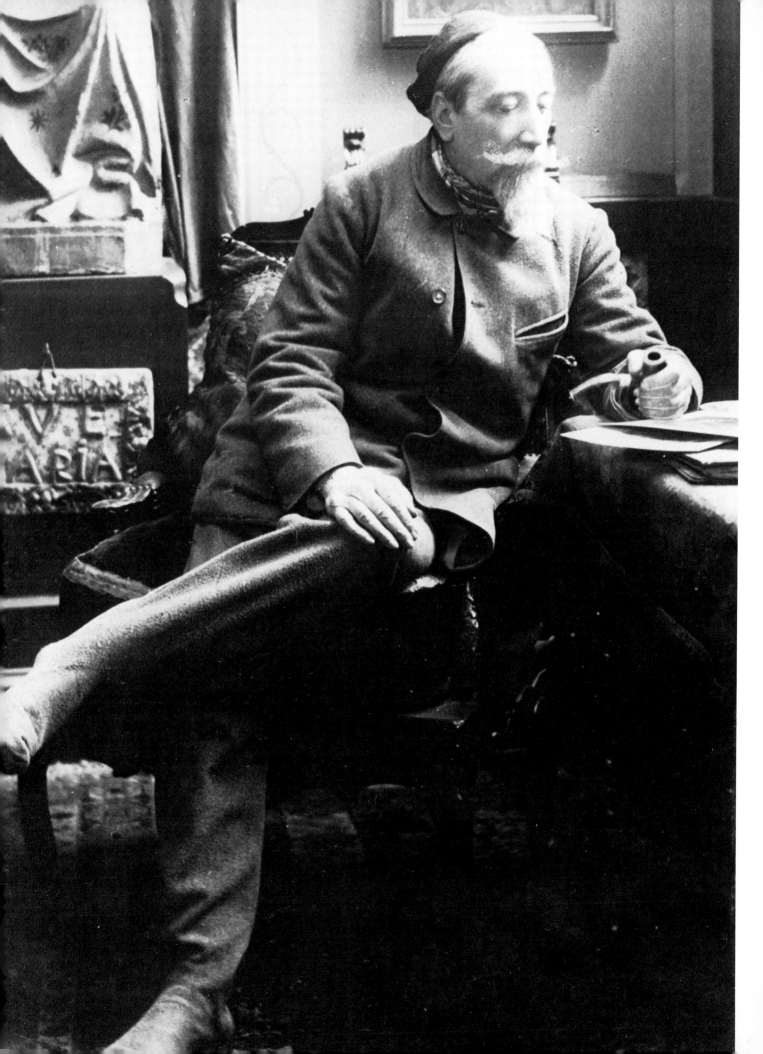

5 '... Sometimes I'm Sad'

Anatole France died in the autumn of 1924, aged eighty. He was an Academician and had won the Nobel Prize in 1921. For sixty years he had turned out quantities of literature, sometimes fictional, sometimes philosophical, which had been readily absorbed by the public. The virtues of his writing were the virtues of a mild man, lusty enough to include slightly pornographic passages, witty enough to be elegantly satirical, and intellectual enough to be engagingly erudite on a wide range of subjects. Although, perhaps because, he displayed in his work all the qualities expected of the French, his books had been translated and widely read throughout Europe and America. At his death he was an honoured and respected man of letters.

The Surrealists published a pamphlet reviling his memory. It appeared in October and was entitled, in large black letters, *Un Cadavre*. Aragon, Breton, Eluard and Soupault contributed short pieces of invective. If they could not demolish the reputation of the great man, they at least had to register their dissent from the rapturous encomiasts and point out the enormity of the dead author's crimes. They blamed him for having abused language, a considerable fault in the eyes of the Surrealists who had undertaken to rescue words from the oblivion of thoughtless usage, and expand their meaning. Aragon found France's language 'universally vaunted, when language, moreover, exists only beyond, aside from, vulgar estimates'. France had upheld the Revolution, had been a Dreyfusard, had admired Jaurès and actively supported the Socialists and towards the end of his life he had adopted a belief in Communism. But the Surrealists cursed him for having made his compromising self-interest identifiable with such causes. 'Let us never forgive him', wrote Breton, 'for adorning the colours of the Revolution with his smiling inertia.' The author had ensured that his political posture had never disturbed an amiable chauvinism. 'Execrable mountebank of the mind, did he really have to incarnate French ignominy for this obscure nation to be so delighted to have lent him its name?' Aragon asked. He referred to the ambiguity of the allegiances professed by France who was 'hailed simultaneously today by the imbecile Maurras and the feeble-minded Moscow'. France numbered among his intimates the Bolshevik lawyer Rappoport who had long been accepted by the politest society despite his political persuasion and his unkempt appearance. This combination of qualities had made Rappoport the butt of several *chansonniers*, and he had been the inspiration for the frenzied assassin, knife between the teeth, who stared out of the famous anti-Bolshevik poster. But he was a wild beast tamed who would often be rubbing shoulders with Maurice Barrès and Raymond Poincaré at the salon run by Madame Arman de Caillavet

at her home in Avenue Hoche. There, too, Anatole France regularly paid his respects.

'Now that he's dead, this man no longer needs to make any dust,' concluded Breton. But round the dead man's bier the dust began to fly. Even at his funeral there were disputes over precedence among the hostile politicians who paid their respects. 'Today I witnessed some fine ceremonies', wrote Soupault, 'bickering undertakers, walking in front of a coffin.' Sisley Huddleston called it 'the most grotesque ceremony I have ever seen in Paris'. Very soon, France's secretary disclosed the fact that France had been acutely embarrassed by his working-class comrades whenever they had visited him at his elegant house, the Villa Said. This was angrily refuted by Georges Pioch, the Communist lawyer. But the Clarté group of Communist intellectuals published in their review, also called *Clarté*, an attack on the vapidity of France's ideological stand. No one could prevent the Club du Faubourg debating whether it had been his intimates' duty to expose the author's shams. When Paul Valéry took the vacant chair at the Académie Française, he failed to make the customary eulogy of his predecessor. But, if the Surrealists were not alone in their assault on Anatole France's reputation, innumerable were those who were shocked by the disrespect. Louis Vauxcelles challenged Breton to a duel; Jacques Doucet, too, was outraged. Aragon and Breton were summoned, unusually, to his shop on Rue de la Paix. They failed to understand the *couturier*'s long mumbling speech, but finally he produced a copy of *Un Cadavre*. He had had enough, he said, of being surrounded by hooligans. They were dismissed.

The Surrealists persevered in their campaign against the intellectual establishment, against the nationalism, imperialism or Catholicism of closed minds. During the next year the note of their protest became shriller. Their problem was to keep harassing a bourgeoisie who accepted moral censure with the very complacency scorned by the assailants. The Surrealists took warning from the fate of Dada. To be a recognized 'school' in the Parisian world of art and letters, to titillate the dulled sensibilities of '*les snobs*' were the doldrums from which Breton had to steer as distant a course as possible. He and his friends maintained a constant sense of despair allowing themselves no respite from the horrors of the human condition. 'Around me stirs the wretched process of a universe where all greatness has become the object of derision', Aragon wrote in *Un Cadavre*, and in the same pamphlet Eluard despaired of 'life, which I can no longer imagine without tears coming into my eyes'. The Surrealist tone was often suicidal.

Suicide was the subject of an inquiry which was announced in the first issue of *La Révolution Surréaliste*. The editors invited replies to the question: 'Is suicide a solution?'. The spectre of Young Werther had been haunting the Romantic literature of Europe for a hundred and fifty years. But during the twenties, particularly in Paris, suicide had gained the proportions of a social evil. Hotel receptionists looked long and curiously at any person, alone and without luggage, who asked for a room. One establishment was known as 'Hotel Suicide'. At the end of the nineteenth century Emile Durkheim had established that the suicide rate was increasing. He had suggested that modern man, his desires no longer subject to the restraint of rigid social stratification, was constantly the victim of his unfulfilled ambitions. The prevalence of suicide was the result of social '*dérèglement*', as Durkheim called it, using the very word with which Rimbaud had described the mental state of the inspired

poet. 'It seems that one is killing oneself as one dreams', said the editors of *La Révolution Surréaliste*. The press notices of suicides were reprinted in the pages of the review without comment. They needed none, coming as they might opposite or below an article where almost every sentence testified to the Surrealists' despair of modern society. Another review, *Le Disque Vert*, had asked twelve personalities for their opinions on the same subject and their replies had been published a month before the editors of *La Révolution Surréaliste* posed their question. But to the Surrealists suicide was not a topic of current debate; it had been an abiding problem since Vaché's enigmatic death in 1919. Breton, in his answer to the inquiry, implied the paranoia which had characterized his friend's behaviour; he quoted Théodore Jouffroy: 'Suicide is a badly formed word; the man who kills is not the same as the man who is killed.' That opinion Breton did not offer as a clinical observation, however; even less was it meant as a reproof. Insanity, the Surrealists believed, was the liberation of the soul.

In desperation the Surrealists were unremitting in their provocation of the bourgeoisie. The first issue of *La Révolution Surréaliste* carried a photograph of Germaine Berton surrounded by the portraits of Surrealists and their sympathizers. In 1923 the young anarchist woman had shot and killed Marius Plateau who was a leader of the Camelots du Roi, the hard core of Charles Maurras' Action Française faction. The assassination had taken place in the offices of the newspaper *L'Action Française* and there was some suspicion that Léon Daudet, its editor, had been the target. Germaine Berton was supposed to have been in love with Philippe Daudet, Léon's son, who, it transpired in the course of inquiries into his own mysterious death in November 1923, had been in close contact with a group of anarchists. So doubts lingered about Germaine Berton's motive and the anarchists themselves had tended to discount her martyrdom. Aragon commented in *La Révolution Surréaliste* that the suicidal nature of her act, whatever its motivation, made her 'the greatest rebel I know against slavery, the most beautiful protestation raised before the world against the hideous lie of happiness'.

In the second issue of *La Révolution Surréaliste*, which appeared in January 1925, the Surrealists demanded an end to imprisonment and military service: 'Open the prisons, disband the army.' Any restriction of liberty should be unacceptable: 'There is no liberty for the enemies of liberty.' On 25 January, the Surrealists issued a Declaration. Its typography recalled the epoch of the French Revolution. First, it was categorically stated that Surrealism had nothing to do with literature, 'but we are quite capable, if the need arises, of making use of it like anybody else'. Then the Surrealists declared their determination to make a revolution. 'We have joined the word Surrealist to the word Revolution to show the disinterested, detached, and even absolutely despairing nature of this revolution.' Finally, a warning, addressed 'to the Western world in particular', that Surrealism will burst the fetters of the mind, 'if need be, with material hammers'. In April, in the third issue of their review, the Surrealists pinpointed the arch-criminals of the Western world – the Pope, the rectors of universities, the doctors in charge of lunatic asylums – to all of whom protests were addressed; but to the Dalai Lama an address of willing submission, and to the schools of Buddha a letter of admiration.

The tone of these missives is bombastic, unlike the scrupulously argued declarations written by Breton. The author was Antonin Artaud, an actor with

Caricature of Léon Daudet, the monarchist, by Pavil.

RIGHT A group of Surrealists at 42 Rue
Fontaine in 1925. Simone Breton is at the
typewriter. Clockwise, from her: Roger Vitrac,
Max Morise, Jacques Boiffard, André Breton,
Paul Eluard, Giorgio de Chirico, Pierre Naville
and Robert Desnos.

BELOW Germaine Berton, sketched by a press
artist at her trial.

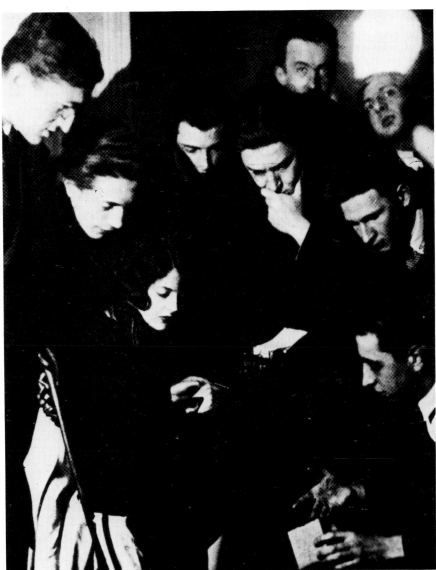

progressive ideas about the theatre. He was, more or less, mentally ill. 'I am a
man who has suffered much in his mind, and because of this *I have the right* to
speak', he had written in January 1924. The passage is from a letter to Jacques
Rivière who had rejected some poems which Artaud had sent him for
publication in *La Nouvelle Revue Française*. This correspondence continued
until June when Rivière suggested that, instead of the poems, the letters about
their rejection should be published. They appeared in the *NRF* in September
when Breton was writing the Manifesto of Surrealism. Artaud's admission in
the letters that the flow of images from his mind was too rapid to allow time for
their arrangement as coherent poetry would have interested Breton, close as it
was to his idea of psychic automatism. Probably they would have met sooner or
later, but there already existed a link between them that quickly brought about
the encounter. Artaud was one of those artists who often visited André
Masson's studio in Rue Blomet on the western edge of Montparnasse. In
February 1924 Masson had had his first one-man show at the Galerie Simon,
and it could have been through his work for Doucet that Breton met Masson

RIGHT Robert Desnos and André Masson,
about 1924.

OPPOSITE André Masson: *Automatic Drawing*,
1924 (Private Collection). Many of Masson's
automatic drawings were reproduced in *La
Révolution Surréaliste*.

Antonin Artaud, the actor whose fanaticism
and mental instability were an inspiration to
the Surrealist group.

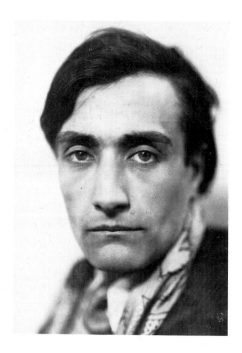

that winter. Round Masson a group of writers and painters had gathered who
became Surrealists while retaining a distinct identity of their own. At Rue
Blomet, the *habitués* used to drink and smoke hashish; some of them took
opium. They read travellers' tales and books by German, English and Russian
outsiders. They were interested in the theory and the practice of Oriental
mysticism. Joan Miró lived in the studio next door and another artist who
belonged to the group was Georges Malkine, so their adherence to Surrealism
brought an influx of painters to the movement. Work by Masson and Miró
appeared in the pages of *La Révolution Surréaliste* during 1925.

From Rue Blomet, and particularly from Antonin Artaud, came an interest in
the mystical philosophies of the East, new to Surrealism. In 1924 Paul Eluard,
perplexed by the intimacy that had grown up between Gala and Max Ernst,
had precipitately left Paris for a journey round the world. Nothing had been
heard of him until it had been learnt that he was in the Far East. Gala had
joined him there and together they had returned to France. But Eluard's
concern had been to distance himself from Paris, not to pay homage to the
mysteries of the Orient. Considering the Surrealists' love of Oceanic art there
may have been an element of speculation in his travels, as there had been in his
trip to Rome the year before. Anyway, Orientalism was in the air. Since 1921
books and articles by René Guénon had been presenting the philosophies of the
Orient to the French intelligentsia. In 1925 the review *Cahiers du Mois*
conducted an inquiry into the attractions of Eastern thought to the West. Many
intellectuals, Soupault among them, had become absorbed in Oriental
philosophy. Gide and Valéry had reservations. Henri Massis could not tolerate
an influence which, in his view, diluted the essence of Cartesian philosophy and
Catholic ethics. But Artaud was an eager neophyte. In 1922, at the Colonial
Exhibition in Marseilles, he had been overwhelmed by a troupe of Cambodian
dancers, and the following winter, acting in a Pirandello production, he had
made himself up in the style of actors in the classical theatre of China. He had

André Masson: *Automatic Drawing*, 1927 (Private Collection).

written the appeals to the Dalai Lama and the Schools of Buddha in *La Révolution Surréaliste* no. 3, which he had been invited to edit. During the first half of 1925 he was an important figure in Surrealism, directing the Bureau of Surrealist Research in Rue Grenelle and contributing significantly to Surrealist doctrine.

Another new adherent to the group was Pierre Naville, who had made available funds to pay for the lease on the premises of the Bureau in Rue Grenelle. It had been Naville, too, who had suggested the muted format of *La Révolution Surréaliste*, based on the popular scientific journal *La Nature*; Aragon had chosen the flaming orange paper for the covers. Naville and Benjamin Péret normally edited the review. In the issue edited by Artaud there had appeared a difference of opinion between Naville and the Rue Blomet group. In a short article on the fine arts Naville declared: 'No one remains ignorant of the fact that there is no such thing as *surrealist painting*.' Neither automatic drawing, nor the representation of dreams, nor 'imaginative fantasies' qualified. This could not be accepted by the painters of Rue Blomet and elsewhere in the same issue Masson affirmed: 'There must be made a physical concept of the revolution.' Masson's automatic drawings, scribbled lines from which emerge fluid anatomies and phantom architecture, were reproduced in the review and clearly owed something to the psychic calligraphy of Chinese art. Naville's notion of art was very different. He recommended the cinema which incorporates fortuitous glimpses of 'the streets, kiosks, cars, shrieking doorways, street lights bursting in the sky'. There were more fundamental differences, however, between the two factions. A meeting had been arranged on 2 April between Naville and the representatives of the Rue Blomet group. They had gathered 'to determine which of the two principles, surrealist or revolutionary, was the more likely to direct their course of action'. They had jointly made quite vague resolutions but had parted 'without reaching agreement on the subject'. Artaud and Masson had not been prepared to compromise their mysticism for Naville's more material concept of revolutionary action.

Louis Aragon was associating closely with Artaud at this time. When he lectured to students in Madrid later in April he brought them news of 'the end of the Christian era', an affirmation which had appeared only days before on the cover of Artaud's issue of *La Révolution Surréaliste*. 'I announce to you', Aragon said, 'the arrival of a dictator: Antonin Artaud . . . may the Orient, your terror, answer our voice at last.' Aragon arranged for Doucet, with whom there had been a degree of *rapprochement*, to finance the publication of Artaud's *Le Pèse Nerfs* that summer. In May Artaud produced a play by Aragon, *At the Foot of the Wall*. But the performance, at the Vieux-Colombier on 28 May, was the scene of a protest – from the Surrealists themselves. Breton was never enthusiastic about the theatre, so self-consciously artistic, and requiring financial arrangements which tended to be compromising. He had little sympathy with Artaud's theatrical ambition, and less with his theatrical friends. Artaud was particularly close to Roger Vitrac who had been expelled from the movement towards the end of 1924 after a disagreement with Eluard. There was also Robert Aron who particularly fostered relations with the cultural élite who could provide financial backing. Aragon's play was preceded by an address from Aron on the subject of 'The Typical Frenchman'. But the Surrealists noisily and violently put a stop to the event. A crisis was brewing.

OPPOSITE Paul Claudel, author and diplomat.

Opportunity for common action came as a relief. It was afforded by Paul Claudel, writer, diplomat and good Catholic. On 17 June in an interview reported in *Comoedia* he described Dadaism and Surrealism, with more bravery than comprehension, as 'pederasty'. In the same interview he proudly claimed to have saved his country some two hundred million francs through purchases of wheat, tinned meat and lard made in South America during the war. The Surrealists retorted in an open letter. They dissociated themselves from everything French, finding treason more poetic than 'the purchase of "large quantities of lard" on behalf of a nation of pigs and dogs'. They deplored Claudel's seeking salvation in a 'Catholic or Graeco-Roman tradition'. When the guests sat down to table at a banquet given early in July at the Closerie des Lilas in honour of the Symbolist poet Saint-Pol-Roux, they found a copy of the open letter to Claudel under each of their plates. The Surrealists were at the banquet themselves. André Breton had long admired the mystical poetry of Saint-Pol-Roux. who had, moreover, been a contributor to *L'Endehors*, one of the more outspoken anarchist reviews of the 1890s. Breton had visited his fairy-tale château of Camarel, in Brittany, when on holiday at Lorient. The current issue of *La Révolution Surréaliste* contained a beautiful photograph of the poet's daughter sitting on the rocks by the sea, an enormous gull perched with appropriately Freudian menace on top of her head. Not all the guests at the Closerie des Lilas were of the same mind as the Surrealists. The banquet was organized by the *Mercure de France* and the editor Rachilde's wife was among those present. Provoked by the open letter to Claudel, she began lecturing her neighbours on the subject of patriotism, and many heard her remark that 'a French woman could not marry a German'. This, Breton considered, was an insult to his friend Max Ernst who was also at the banquet. For a moment the exchanges were absurdly dignified; then some fruit was thrown, then uproar. Philippe Soupault swung gracefully on the chandeliers, his feet cutting a swathe through the debris of the feast. A crowd gathered outside, drawn by the splintering window panes, and soon the battle spilled into the Boulevard Montparnasse. The police arrived and restored some sort of order.

The Surrealists were gratified to find that they had gone too far. From all sides, they received blame and obloquy. Madame Rachilde was said to have suffered at the hands of 'German agents'. A correspondent writing in *L'Action Française* called for a total boycott of Surrealism; the movement should not be mentioned, the Surrealists' violence was to be deplored. This was an odd sentiment to find in the columns of the newspaper whose readers presumably believed in Maurras' violent creed. The *Journal Littéraire* decided not to notice their publications. The Society of Men of Letters hurled their anathemas on them. But that summer the Surrealists could hardly be other than ostracized from the writers' fraternity. Colonial wars in Syria and Morocco inspired a ferment of patriotism such as had not been seen in France since the dark days of 1917. The *Académiciens* and *littérateurs* of the establishment published a manifesto: *The Intellectuals on the Side of the Nation*. At the Saint-Pol-Roux banquet the Surrealists had shouted: 'Long live Germany! Bravo China! Up the Riffs!' In Canton, the Communists threatened to take over the Kuomintang after the death of Sun Yat Sen. In Morocco the Riffs, a tribe of hard mountaineers who had been led by Abd El Krim to victory over the Spanish army, had turned against the forces of Marshal Lyautey. They had been almost at the gates of Fez and Pétain had been sent out to deal with them. Some

RIGHT Marshal Lyautey (right), Governor-General of French Morocco, photographed in Casablanca.
BELOW Abd El Krim (seated), leader of the Riff tribesmen who invaded French Morocco in 1925.

French Communists openly supported the Riffs in their war of liberation. Jacques Doriot, a leader of the *PCF*, had sent a telegram to Abd el Krim congratulating him on the success of this armed rebellion. A few days after the riot at the Closerie des Lilas an 'Open Letter to Intellectuals' was published jointly by the Surrealists and the group of Communists associated with the political review *Clarté*, where the letter appeared. Both parties protested against the French military engagement in Morocco and condemned the intellectuals who supported it.

Breton announced in *La Révolution Surréaliste* in July that he was taking over as editor of the review. He was concerned about the factions within the group and stated the broad principles on which Surrealism was based:

> We want, we shall have the Beyond in our time. For this we need heed only our own impatience and remain perfectly obedient to the commands of the marvellous. . . . Is surrealism a force of absolute opposition, or a group of purely theoretical propositions, or a system based on the confusion of all levels, or the corner-stone of a new social structure? Depending on the answer such a question seems to require, each man will attempt to contribute all he can: contradiction does not in the least disconcert us.

He wanted to see an end to 'such petty acts of sabotage as have already occurred at the heart of our organization'. There was no more of Artaud's fanatical mysticism in the July issue, although long extracts from Aragon's lecture in Madrid were printed. Breton published the first part of his long essay on modern art entitled 'Surrealism and Painting'. There he refuted Naville's contention that there could be no Surrealist painting, although he admitted that it was a 'lamentable expedient'. The artists of the Rue Blomet group could take heart in Breton's contention that painting was a valid means of expressing the Surrealist revolution. There remained, however, the question of political commitment to a 'new social structure'.

In Paris, and at Thorenc in Provence where many of them spent the summer of 1925, the Surrealists debated the political implications of their revolution and the tentative alliance with Clarté. Since its foundation in 1919 the Clarté organization had supported Communism while always remaining distinct from the French Communist Party. From the beginning it had been international; the membership of the original Directing Committee had included writers such as Thomas Hardy, H. G. Wells, Upton Sinclair and Stefan Zweig. But Anatole France had been a member too, and, anyway, Breton and his friends had been engaged at that time in resisting the revival of classicism. They could not have adhered to an organization whose founder, Henri Barbusse, had described Communism as 'the clarification of reason'. Anarchy, rather than Communism, had been their ideology then, the anarchy of Emile Henry, and, as applied at the artistic level, the anarchy of Dada. When Clara Zetkin had addressed the Congress of Tours, Breton and Aragon had been impressed. 'I will talk to you endlessly of Clara Zetkin's eyes', Aragon would write many years later. There was never much distinction in the Surrealist mind between the ardour of romantic love and the ardour of political commitment. Georges Pioch had been the Communist whom Breton and Aragon had admired most during the early twenties and he was reported as having called Communism 'the organized and pacific form of love'. It had been to Pioch that Aragon had earlier turned when he had thought of joining the *PCF*, but Pioch had doubted the integrity of his political sympathy and had turned him away. Pioch had

Clara Zetkin, the German Communist leader, who as a young woman held a particular fascination for the Surrealists.

been expelled from the Party in 1923, along with other intellectuals who had resisted the directives of the International. There had been a further, larger purge in 1924 when many Party members had been expelled for not accepting Zinoviev's denunciation of Trotsky.

Many who had been dazzled by the October Revolution and the Bolsheviks' gallant stand against the forces of reaction had begun to see more clearly when Stalin took control in Moscow. Desertions from the Party ranks had become more frequent and *Clarté*, supposedly the organ of ideological debate, had ceased to play any significant role. Vaillant-Couturier, a leading executive of the *PCF*, had called the organization 'a tribune of education and free discussion'. But when the triumvirate of Stalin, Kamenev and Zinoviev had taken over in Moscow, arguments about party dogma had been discouraged. Bernier, Fourrier and Victor Crastre had taken control of the review. In 1925 Barbusse was attacked in the pages of *Clarté*, which would have pleased the Surrealists, if it was not done at their behest. The new leaders of Clarté were eager to gain adherents with revolutionary ideas, even if they came without political credentials. The Surrealists' notion of a world without barriers, whether those barriers were interposed between different nations or different classes, between man and god, or between the conscious and the unconscious, was not exactly Marxist orthodoxy. But if the Surrealists were willing to join forces on the issues which were important to Clarté, their other preoccupations did not need to invalidate their political commitment.

The Surrealists and the Clarté group had first discovered that they held common ground when both had ridiculed the comfortable philosophy of Anatole France. But Aragon's reference to 'feeble-minded Moscow' in *Un Cadavre* had earned the reproof of Jean Bernier, one of *Clarté*'s editors. In reply, Aragon had further antagonized the Communists by describing the Russian revolution as 'no more than a vague ministerial crisis'. In January *La Révolution Surréaliste* had published indignant retorts from Jean Bernier and another member of *Clarté*'s editorial board, Marcel Fourrier. About this time Breton had met Fourrier and had found him modest, kind and intelligent. Fourrier had been attracted to Surrealism and his response to Surrealist painting and Oceanic art had been enthusiastic. Through Fourrier, Breton met Boris Souvarin who had been a leading member of the *PCF* until 1924 when his support for Trotsky had caused his expulsion. He had arranged the translation and publication of Trotsky's books in France. The Clarté group was also in close contact with Victor Serge in Moscow who contributed articles on the opposition to Stalin and the Chinese revolution, and who visited the editors of the review when he was in Paris. He had been associated with the Bonnot gang and had been imprisoned for five years in the Santé. Released in 1917, he had taken part in the Barcelona uprising that year and on his return to Paris was re-arrested. In 1919 he had arrived in Russia where he had joined the Party, working with Zinoviev until 1923 when he had followed Trotsky into the political wilderness. Souvarin and Serge both impressed Breton, who became absorbed in Trotsky's writings.

Drieu La Rochelle, Aragon's friend who was still close to the Surrealists, wrote, many years later: '. . . Moscow was our great temptation. . . . Since nothing was being done in France, we dreamed of all the things that were being done over there'. In Russia, it appeared, the avant-garde artist was honoured. Lunacharsky, Lenin's Commissar of Public Instruction, had acknowledged the

important contribution which art could make to the revolution. Trotsky appreciated the value of literature as a means of rousing the minds of the proletariat. Sergei Yesenin, who had married Isadora Duncan, was an example of a wayward genius allowed to flourish under Communist rule. Vladimir Mayakovsky was another; his long revolutionary poem *Vladimir Ilyich Lenin* had appeared in 1924 and his work was being hailed by progressive critics in the West. The Surrealists were not to know in the summer of 1925 that Yesenin would hang himself in a Leningrad hotel later that year, or that Mayakovsky would shoot himself five years later, both victims of official disapproval as well as unresolved personal problems. Assurance came from the very person most likely to move the Surrealists: Clara Zetkin, writing from Moscow in 1925, claimed that the artist's right to pursue his private ideal was not questioned in the Soviet Union. As the revolution in China gained momentum, Communism rather than any doctrine from the Schools of Buddha seemed to be the Eastern philosophy which would engulf and destroy Western thought. At least the conservatives thought so; Albert Sarraut, the Governor-General of Indo-China, called the *PCF* 'the vanguard of an Asian movement against Europe'.

In September Breton wrote to Artaud urging him to return to the Surrealist fold. Since the demonstration at the Vieux-Colombier in May, Artaud had been acting in films and had gone on holiday with Roger Vitrac to Carteret on the Channel coast. He had been far removed, both physically and mentally, from the debates at Thorenc. Breton would have wanted him to join in the discussions which continued when the Surrealists returned to Paris. A measure of agreement on the political position of Surrealism was emerging which became fully clear with the publication at the end of September of a political manifesto, *La Révolution d'Abord et Toujours*, composed by Breton. Its title was an allusion to the motto of Action Française – '*la politique d'abord*'. The manifesto starts with a declaration of the necessity for revolution. The ideas on which the whole of European civilization is founded are rejected. Turning to the East, Breton explains, in a footnote, that 'the Orient is everywhere'; it is a state of mind opposed to the enemies of philosophy 'who are the enemies of liberty and contemplation'. The plight of the wage-earner is seen as desperate: 'It is monstrous that a man who owns nothing should be enslaved by a man who owns property', and 'the form of slavery which international high finance imposed on whole populations . . . is an iniquity which no massacre will ever succeed in expiating. . . .' Lenin's capitulation at Brest-Litovsk in 1918 was 'a magnificent example . . . which we do not believe *your* France capable of ever following'. Again the war in Morocco is condemned and the 'priests, doctors, professors, writers, poets, philosophers, journalists, judges, lawyers, policemen, and academicians of every variety' who support it are denounced as 'dogs trained to benefit the nation'. Among the signatories there were Surrealists, members of the Clarté group, two Belgian writers who had close contacts with Surrealism, members of a group called 'Les Philosophes' who had ideas in common with the Surrealists, and some individuals including the ex-Dadaists Georges Ribemont-Dessaignes and Pierre de Massot and the anarchist Henri Jeanson.

The manifesto was reprinted in the fifth issue of *La Révolution Surréaliste*, to which Breton also contributed a review of Trotsky's biography of Lenin. He thought that Communism, although it might have its defects, was the only system to have completely overthrown the old order, and he could not believe

RIGHT Aristide Briand, France's opportunist Foreign Minister who negotiated the Locarno Treaties with Gustav Stresemann. Life, Briand said, is made of rubber.

that the revolution which had started in Russia had yet run its course. Lenin emerged from Trotsky's book as an unimpeachable figure. In the same issue of *La Révolution Surréaliste* there was a letter from André Masson in Antibes, affirming his belief in 'the Dictatorship of the Proletariat as conceived by Marx and made a reality by Lenin', and he renounced 'once and for all, the "bohemian revolutionary" both within me and without'.

Elsewhere in the October issue Camille Aymard, a conservative politician, was quoted as saying: 'France is ripe for revolution. Or for a *coup d'état*'. That autumn, the country was suffering from weak government. The Cartel des Gauches, an electoral alliance of Radicals and Socialists, had won the elections of 1924, driving the Bloc National out of power. Within a few weeks of taking office the Radical Premier Edouard Herriot had granted an interview to a

139

OPPOSITE The Exposition des Arts Décoratifs,
1925 – the main entrance nearing completion.

BELOW The Eiffel Tower illuminated with the
name of Citroën during the Exposition des Arts
Décoratifs.

reporter from *Vorwärts*, the leading German Socialist newspaper. The French
occupation of the Ruhr had not achieved German payment of reparations and
had been an expensive operation. In 1925 the French troops had been
evacuated and with Stresemann at the helm in Germany some sort of
rapprochement between the two traditional enemies had become possible. It
had been achieved in the summer of 1925 at Locarno and France's eastern
frontier had been at last secured by the obligations of Britain and Italy under
the terms of the treaty. But the Frenchman's distrust of the German could not
be so easily laid to rest. By September, *L'Illustration* was pointing out that no
treaty could alter the fact that if the current rate of population increase in each
country was maintained, in thirty years' time Germany would have ninety
million inhabitants to France's thirty-nine as well as greater industrial
capacity; it would never be possible to trust the Germans. At Magdeburg one
hundred thousand Germans of the 'Banner of the Empire' organization called
for the annexation of Austria. Next year Germany would be admitted to the
League of Nations, to the consternation of most Frenchmen. In Syria there had
been a revolt against the colonial power and the French artillery had
bombarded Damascus. Pétain's campaign against the Riff tribesmen in
Morocco went on relentlessly. Lyautey, who had tried to govern his province
without resorting to military force, returned to Paris where he was shunned by
society, treated as a defeated general. A rising in Indo-China, following the
Chinese revolution, was ruthlessly crushed.

At home, the economic situation deteriorated. The franc lost value steadily,
despite higher taxation. Paris, however, was festive in 1925, the year of the
Exposition des Arts Décoratifs. Thousands visiting the capital brought good
business, even if the profits were soon dispersed by taxes and inflation. The
exhibition announced the advent of the modern style in architecture and the
applied arts. The Champ de Mars was covered in streamlined pavilions. Glass
fountains by Lalique reflected lights spelling out the name of 'Citroën' which
blazed at the top of the Eiffel Tower. Le Boeuf sur le Toit opened on the Seine
in a specially hired boat and Poiret had three floating restaurants moored
nearby. The window displays at the fashionable shops were transformed
overnight: Louis XV chairs and drapes were put away, tubular steel and abstract
patterns took over. Everywhere, square edges and plain glass predominated.
'Art Deco' had arrived, 'Cubism' had triumphed. In *La Révolution Surréaliste*
of July appeared a photograph of the exhibition buildings taken with
devastating irony by Man Ray, and revealing the bleak poverty of the modern
style. '*Grand Art*, Dada, they gave you something to ponder on', wrote Aragon
in October, 'But Decoration! Well, personally I prefer, after all, *Grand Art*.'
He attributed the impoverished utility of the style to positivism sanctioned by
bureaucracy, and suggested that it should all be blown up, and a little dynamite
kept for the demolition of Auguste Comte's statue in Place de la Sorbonne.

At the Galerie Pierre, Rue Bonaparte, a very different exhibition took place
during November, a show which must have seemed like a gesture of defiance in
the face of the lucid geometry of Art Deco. It was an exhibition of Surrealist
painting and included works by de Chirico, Picasso, Klee, Arp, Ernst, Masson,
Miró, Man Ray and Pierre Roy. The last had been a friend of Apollinaire's; he
painted with nightmarish realism objects and figures inhabiting inappropriate
environments. Klee's works were reproduced in *La Révolution Surréaliste* but
otherwise they were hardly noticed in France at that time. The disorientated

anatomies which Picasso painted had always intrigued the Surrealists. Man Ray's photographs appeared regularly in the Surrealists' review, as did Masson's automatic drawings. Ernst had recently invented a new technique of 'forcing inspiration' by placing paper over uneven surfaces such as wood-graining and rubbing the back with chalk; he called it '*frottage*'. Ernst and Miró now had studios in Rue Tourlaque, Montmartre, and Arp had come to live nearby. They were conveniently close to Place Blanche and Rue Fontaine. The text of the exhibition catalogue was written by Breton and Desnos.

No amount of exhibitions could divert the Parisians' attention from the economic situation which worsened daily that winter. Financial interests were pressing for the stabilization of the franc and wanted a conservative government in power. The Radicals beat their heads against 'the wall of money' but not a stone was loosened. Some right-wing politicians, bankers and industrialists formed a group called '*Redressement Français*' which campaigned for a stronger executive and greater freedom for big business. Their symbol was the Dying Gaul. But the risk of unseating the Radical administration, as reactionaries recognized, was a Socialist one in its place; Cardinal Dubois' 'Letter of a Parisian Catholic' had been reprinted in *La Révolution Surréaliste* in October. He appealed to the faithful to subscribe to the government loan even if that government had failed to meet the Catholics' demands for legislation guaranteeing their rights. 'Should the loan fail', wrote the Cardinal, 'a new ministry – a socialist one – will take power. That will be the beginning of social and religious disorganization, the disastrous results of which cannot be foreseen; a further step, perhaps a decisive one towards the bloody oppression with which we are threatened by those whose programme is "*La Révolution d'Abord et Toujours*".'

The Radical party was traditionally anti-clerical but had not had the time or sufficient strength in the Chamber to cut off diplomatic relations with the Vatican, which the Bloc National had instituted. Nor had the laws against church-schools yet been applied to Alsace, an omission which had irritated anti-Catholics ever since 1919. So the cardinal had had justification for urging maintenance of the status quo. Indeed, having enjoyed under the Bloc National its period of greatest *entente* with any administration of the Third Republic, the Roman Catholic church in France had consolidated its powers both temporal and spiritual. The Popular Democratic Party had been founded in 1924 to represent Catholic interests and a handful of deputies had been returned from the strongly religious enclaves of Brittany and Alsace. Probably more effective power was wielded by the National Catholic Federation, a pressure-group which was established in the mid-1920s. But what most horrified the Surrealists was the Catholic revival among intellectuals which reached its apogee in June 1925, with the conversion of Jean Cocteau. The next year his 'Letter to Jacques Maritain' appeared: 'Art for art's sake, art for the crowd are equally absurd. I propose art for God.' At their home in suburban Meudon, Maritain and his wife Raissa, who had both been converted, conducted an evangelical mission to intellectual agnostics. André Gide recorded in his 1923 Journal an interview with Maritain who was trying to stop him publishing his *Dostoevsky*. 'His curved, bent way of carrying his head and his whole body displeased me', wrote Gide, 'and a certain clerical unction in his voice and gesture'. Gide had been predisposed to regard Maritain with suspicion, for his former companion Henri Ghéon was among the members of the 'circle of

N° 7 — Deuxième année 15 Juin 1926

LA RÉVOLUTION
SURRÉALISTE

LES DERNIÈRES CONVERSIONS

ADMINISTRATION : 12, Rue Fontaine, PARIS (IX°)

ABONNEMENT.
les 12 Numéros :
France : 55 francs
Étranger : 75 francs

Dépositaire général : Librairie GALLIMARD
15, Boulevard Raspail, 15
PARIS VII

LE NUMÉRO :
France : 5 francs
Étranger : 7 francs

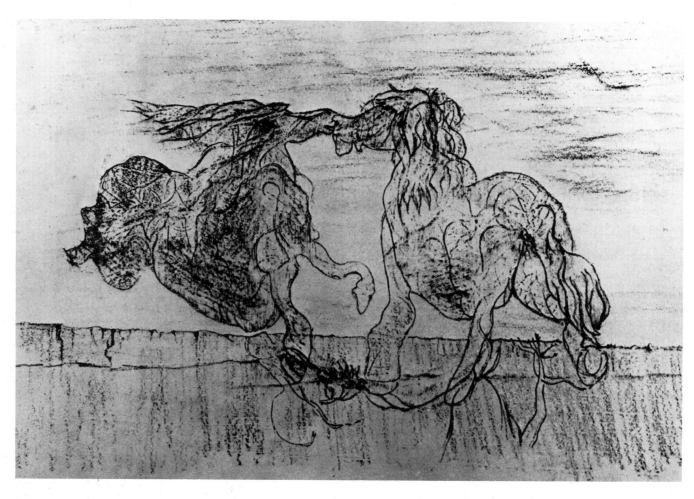

Max Ernst: *The Stallion and the Bride of the Wind*, 1925 (Bibliothèque Nationale, Paris). A drawing produced by the technique of *frottage*.

OPPOSITE Salvador Dali: *The Birth of Liquid Desires*, 1932 (Peggy Guggenheim Foundation, Venice).

Thomist studies' at Meudon. The painter Rouault was another member. Maritain, a professor at the Institut Catholique, had found himself a useful ally in Henri Massis who held an established position in the literary world. Although the association of Catholicism with reactionary political views, represented for instance by the *Revue Mensuelle* edited by Massis and the royalist Jacques Bainville, was not conducive to successful evangelism among the younger intellectuals, in 1926 the Action Française movement was condemned by the Pope and the appeal of Catholicism was immeasurably enhanced for those who might have voted Radical or even Socialist. In his letter to Jacques Maritain, Cocteau endorsed the new liberality by expressing his admiration for the Russian revolution. To many of those who were not altogether confused by the formula, it proved overpowering.

The wave of conversions rolled on. Reverdy received the sacraments at Solesmes. Jacques Copeau, who had started the Théâtre du Vieux-Colombier and was drama critic on *La Nouvelle Revue Française*, was added to the list; there were even rumours about Gide. The Surrealists found the spectacle of this lemming-like precipitation ridiculous, nauseating. In June 1926 the cover of *La Révolution Surréaliste* bore a photograph of a crowd of people in the street who gazed heavenwards, probably watching an aeroplane; 'The latest conversions' was the caption. René Crevel and Georges Ribemont-Dessaignes wrote articles condemning the hypocrisy and flabby morality of the proselytized. Péret contributed a poem reviling the Eucharistic Congress in

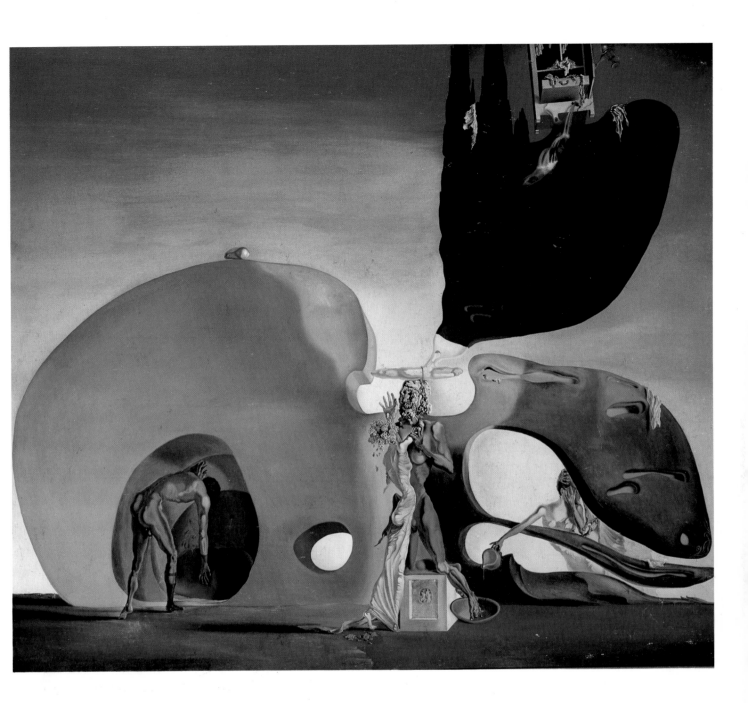

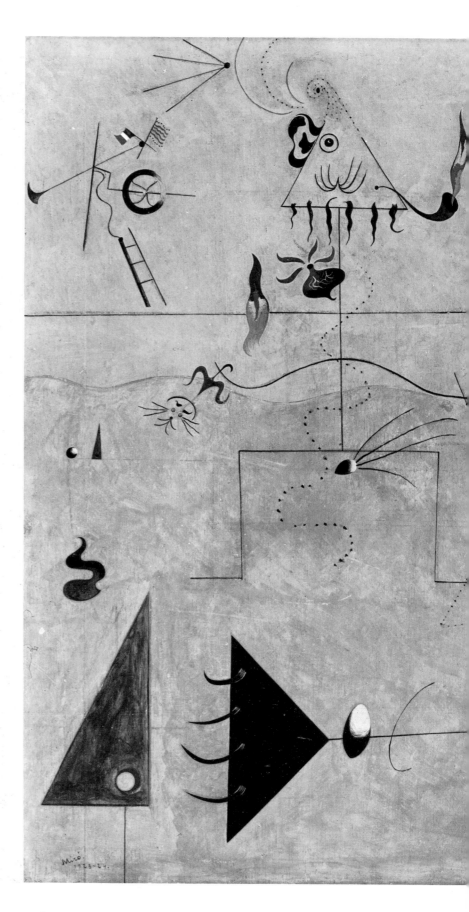

RIGHT Joan Miró: *The Hunter (Catalan Landscape)*, 1923–4 (Museum of Modern Art, New York).

FOLLOWING PAGES
LEFT Cover of *Minotaure* no. 1, 1933, by Pablo Picasso.
RIGHT Cover of *Minotaure* no. 11, 1938, by Max Ernst.

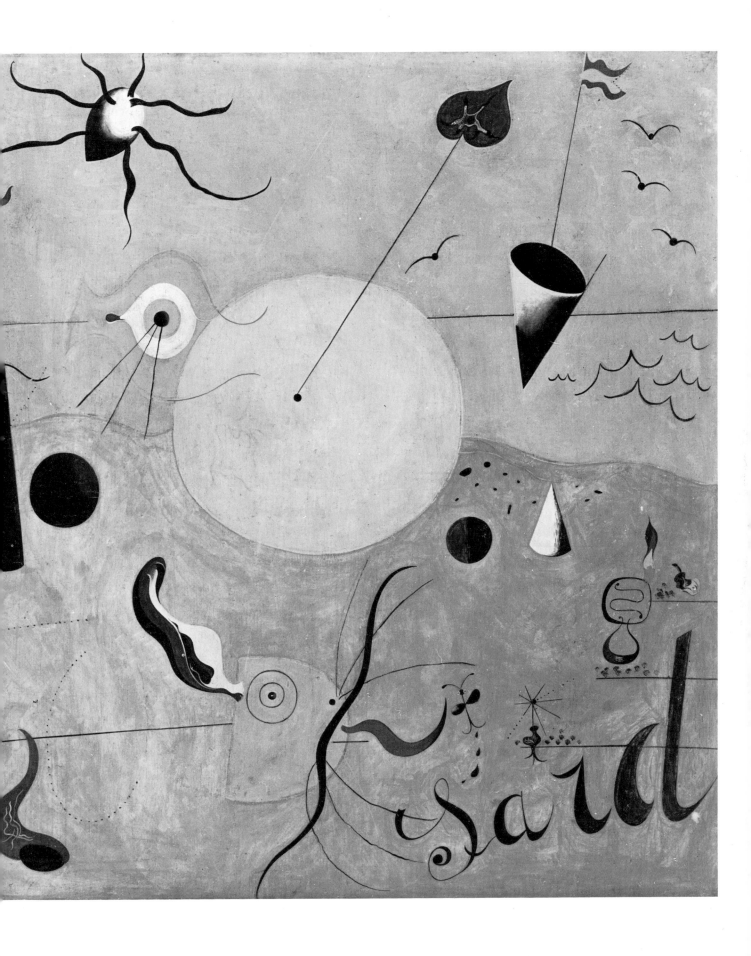

Chicago; a photograph of him insulting a priest was reproduced in the review. Max Ernst's 'manifesto' painting of *The Virgin Spanking the Infant Jesus Before Three Witnesses* (André Breton, Paul Eluard and the artist) was also reproduced. But a much greater victory over revived Catholicism was the adherence to the Surrealists of Abbé Gengenbach, a Jesuit priest who had fallen in love with an actress at the Odéon. He had started taking her out to restaurants and dance halls when the Jesuit authorities had stepped in, defrocking him and trying to hush up the scandal. In his letter introducing himself to the Surrealists, published in *La Révolution Surréaliste* in October 1925, he related how he would have attempted suicide by drowning himself in the Gérardmer lake, broken-hearted because his actress had given him up now that he no longer wore the soutane 'which exercises a morbid attraction over certain women'. But he had read a copy of *La Révolution Surréaliste* which included the replies to the inquiry about suicide and had faltered in his desperate intent. He had written to *La Révolution Surréaliste* to reveal the whole scandal and to let people know how the good Church treated its servants.

The letter had been dated 10 July 1925, written within a month of Cocteau's conversion. It must almost have restored Breton's faith in God's providence if its content did not so amply demonstrate the hollowness of Christianity. It had been, rather, a marvellous coincidence of the sort which sustained the spiritual life of the Surrealists. Gengenbach returned to Paris and kept company with the Surrealists, living at Place Pigalle, Montmartre, one stop on the Métro from Place Blanche. He led a libertine's life, dabbling in 'Satanism and finance' according to Maxime Alexandre who saw him frequently at this time. Gengenbach used to visit Montparnasse, sitting at a table on the terrace of the Dôme or the Sélect, wearing his soutane with a girl on his lap. Breton introduced him to an audience at the Salle Adyar in April 1926; his address to the public was hardly a society event. Sometimes he would spend a few weeks with his mistress, a Russian woman, an artist, who lived in Clamart; sometimes he would stay with the monks at Solesmes. In July 1926 he wrote a letter to André Breton which was published in *La Révolution Surréaliste*. He assured Breton that the Surrealists need have no anxieties about his visiting the monastery: 'My pronounced taste for escapades in monasteries is well-known in the Surrealist milieu.' Nor had he any intention of joining the 'neo-Conversion' business of 'Cocteau, Maritain, Reverdy & Bros'. 'As for the ecclesiastical costume, I am wearing it just now because my three-piece suit is torn . . . I find, too, that it adds a little spice to sadistic adventures with American women who pick me up at night in the Bois' Gengenbach's attachment to his ecclesiastical habit contrasted with that of Maurice Sachs who had not only followed Cocteau into the Church but had taken holy orders: '. . . recalling that even as a child I dreamed of being a girl, it is easy to imagine what strange desires, unknown even to myself, were gratified when I used to gather the folds of my gown in both hands, like a young woman, to climb the stairs'. On holiday from his seminary and staying at Juan-les-Pins, Sachs was overwhelmed with affection for a good-looking American boy. The seminarist lent him his soutane to wear as a beach-robe and, holding hands, the couple strolled along the fashionable beach.

In 1926 the Radicals gave up trying to balance the books and the nation turned to Poincaré, the hard man of France, nicknamed 'Poincaré-the-War' or 'Poincaré-the-Ruhr'. Now he would earn a new *sobriquet*, 'Poincaré-the-four-

The letter from Abbé Ernest Gengenbach printed in *La Révolution Surréaliste*. The illustrations show the abbé in his soutane, and the lake of Gérardmer where he had intended to drown himself.

UNE LETTRE

Gérardmer, ce 10 juillet 1925

MESSIEURS,

Ces jours-ci, un jeune homme a tenté de se suicider, en se jetant dans le lac de Gérardmer. Ce jeune homme était, il y a un an, l'abbé Gengenbach, et se trouvait chez les Jésuites, à l'Externat du Trocadéro, 12, rue Franklin... A cause de cela on a essayé d'étouffer le scandale à Gérardmer, mais je sais que le désir de ce jeune homme était au contraire qu'on fit du bruit autour de ce suicide. Ce jeune homme c'est moi. Quand vous recevrez cette lettre, j'aurai disparu, mais si mes renseignements ne vous suffisent pas, je vous autorise à vous adresser à ma cousine, M^lle J. Viry, institutrice à Retournemer, près Gérardmer.

Il y a un an exactement, j'étais abbé chez les Jésuites à Paris et étais appelé à une belle situation dans le monde ecclésiastique. Il m'arriva une ébauche d'aventure amoureuse avec une jeune actrice de l'Odéon, à la suite d'une soirée que j'avais passée en civil, au théâtre de l'Athénée. On jouait *Romance* avec M. Soria. La pièce, représentant l'idylle d'un jeune pasteur protestant et d'une cantatrice italienne, m'avait beaucoup ému. Les Jésuites furent au courant. Quelque temps après, j'allai dîner, avec mon actrice, au Romano, grand restaurant dancing de la rue Caumartin. Le lendemain, les Jésuites me renvoyèrent, me laissant seul sur le pavé de Paris. Je vins à Plombières, dans ma famille, et menai une vie assez mondaine. En pleine saison, mon évêque m'interdit de porter la soutane... et je dus défroquer.

Je me trouvai ainsi tout désorienté à vingt et un ans, au milieu de l'existence... Je me rendis compte très vite que j'étais perdu. J'ai trop subi l'empreinte sacerdotale pour pouvoir être heureux dans le monde. D'autre part, ma jeune amie, qui aurait aimé devenir ma maîtresse si j'avais continué à porter la soutane (laquelle exerce sur certaines femmes un attrait morbide), m'abandonna dès que je ne fus plus qu'un banal civil...

Je tombai dans la neurasthénie aiguë

LE LAC DE GÉRARDMER LA NUIT

FOLLOWING PAGES
LEFT Joan Miró: *Object*, 1936
(Museum of Modern Art, New York,
Gift of Mr and Mrs Pierre Matisse).
RIGHT Salvador Dali: *Outskirts of Paranoic-Critical Town*, 1936
(Collection E.F.W. James Esq.).

sous-franc' when in 1928 he would manage to stabilize the French currency at a value eighty per cent below its pre-war parity. But confidence was restored and the financial good health which France enjoyed in these years would be sustained even through the Wall Street crash and the ensuing slump. Not until 1931 was the country seriously affected by the Depression. Meanwhile France was intoxicated on the 'spirit of Locarno' and danced wildly through 'the crazy years'. With feelings of well-being, however, came the vindictive persecution of the Communists who could be harried now without any fear of provoking a popular rising. The Surrealists reacted by trying to draw closer to their Clarté friends and by deploring in *La Révolution Surréaliste* the Fascist sympathies

RIGHT Doodles on cabinet ministers' blotters, reproduced in *La Révolution Surréaliste*.

FOLLOWING PAGES
LEFT Salvador Dali: *Man with His Head Full of Clouds*, 1936 (Edward James Foundation).
RIGHT René Magritte: *Napoleon's Death Mask*, *c*. 1935 (Collection E.F.W. James Esq.).

which emerged in France at this time. In March 1926 Paul Eluard quoted Marinetti saying: 'The least of the Italians is worth a thousand foreigners. Italian products are the best in the world. Italy had every right to keep a total monopoly in creative genius. Each foreigner ought to enter Italy religiously.' Eluard was shocked that Ungaretti, once Apollinaire's friend, dedicated his poems to Mussolini. When an attempt to assassinate Il Duce failed, Eluard lamented: 'But God-the-Swine guards Mussolini-the-Cow.' Henri Béraud, a conservative politician who repeatedly demanded a Fascist government in France, was reviled in the columns of *La Révolution Surréaliste*. A real satirist's scoop was the publication in March 1926 of the doodles made on their blotters by the nation's rulers at a meeting of the Council of Ministers. Nothing could have been more condemning than these drawings, some childish, some pretentiously artistic, each of them, as Aragon pointed out, suggesting that a psychoanalyst should be urgently consulted by its author.

In 1926 Pierre Naville wrote a tract entitled 'The Revolution and the Intellectuals: What Can the Surrealists Do?' in which he expressed his dissatisfaction, and probably that of all the political friends of Surrealism, with the group's revolutionary activity. Assaults on Catholicism and nationalism, Naville argued, were only effective on a moral level and the bourgeoisie were unlikely ever to be overthrown by moral scandals. What was the point of collective effort if it was confined to the reassessment of individual values? The Surrealists' co-operation with the Clarté group had floundered. Through the winter they had contributed to each other's reviews, Bernier, Fourrier and Crastre supplying *La Révolution Surréaliste* with articles of a strong Marxist bent, while Aragon and Breton wrote for *Clarté*. Aragon, in an article entitled 'The Proletariat of the Mind' demonstrated how under Capitalism even ideas were turned into negotiable goods. Breton's article made it clear that there was a distinction to be made between the political revolution which involved social and economic structures, and the Surrealist revolution which implied an upheaval in mental and moral values. That was Naville's complaint. Breton seemed happy to contemplate the Surrealist revolution taking place under Capitalism, before the Communist revolution had been achieved. The joint review *La Guerre Civile*, which was intended to take the place of *Clarté* and *La Révolution Surréaliste*, was never to appear.

Breton's 'Legitimate Defence' was issued in September. In this tract he expressed the Surrealists' dismay at finding themselves, as allies of the Clarté group, in opposition to the *PCF*, and their frustration at not being invited to play a significant role in the Party's literary activity. Neither Clarté nor the *PCF* could afford to offend their diminishing number of supporters whose literary tastes were staid. In 'Legitimate Defence' Breton demonstrated a clear link between poetry and revolution but it was not an argument likely to win over the readers of *Clarté* or *L'Humanité* who thought, and, as Breton complained, were persuaded by those journals themselves to think, entirely in terms of a material revolution. 'It is not', wrote Breton, 'the material advantage which each man may hope to derive from the Revolution which will dispose him to stake his life – *his life* – on the red card'. Breton had been appalled by the poverty of ideas which the columns of *L'Humanité* revealed, the paper 'discouraging all extra-political activity but sports'. Barbusse, its literary editor, had shown remarkable ingenuousness by asking Breton to contribute 'a short work of fiction', which if he had read the Manifesto of Surrealism he

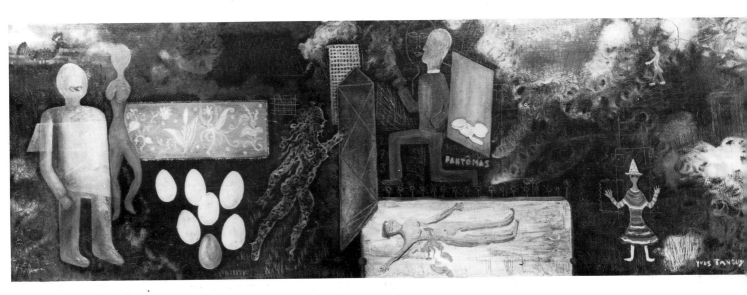

Yves Tanguy: *Fantômas*, 1925–6 (Private Collection).

would have known was a literary form detested by the Surrealists. If he was trying out the political loyalty of revolutionaries who had a suspiciously bourgeois background, he was imposing too stiff a test, especially when, in the pages of *L'Humanité*, he was, according to Breton, 'abusing the confidence of the workers by praising Paul Claudel and Cocteau, authors of infamous patriotic poems, of nauseating Catholic professions of faith, ignominious profiteers of the regime, and arrant counter-revolutionaries'.

The trouble was that the Surrealists had sought in political commitment the armour of moral integrity, clad in which they might better wage battles with their literary and artistic foes. But they found that the commitment merely involved them in a second front where the enemy was Marxist orthodoxy as it was interpreted by the Party. Writing in the June issue of *Clarté*, Marcel Fourrier had said: 'It would obviously be absurd at the present time to ask the Surrealists to renounce Surrealism. Have they asked the Communists to renounce Communism?' The question had been rhetorical, but to an extent the answer had been yes, and what to Fourrier had been an absurdity was exactly what Naville and others were doing. The alliance with the Communists seemed to have failed.

When Breton, Aragon, Eluard, Péret and a young Surrealist called Pierre Unik joined the *PCF* in January 1927 it came as a surprise after 'Legitimate Defence'. The logic of the move lay in the fact that it had been the Trotskyists Pierre Naville and Marcel Martinet who had particularly attacked the Surrealists' political apathy. The Surrealists had behind them a history of sympathy and fraternization with anarchy and in 'Legitimate Defence' Breton had expressed a belief in the possibility of reconciliation between Communists and Anarchists. But it had been Trotsky who had argued even more fervently than Lenin against the decentralization of the Soviet government. Naville and Martinet chose to ignore Trotsky's dictum: 'The field of art is not one in which the party is called on to command', and to exalt his demands for bureaucratic control and total commitment to the workers' interests. The other motive which drove Breton and his friends into the *PCF* was the ambivalence of their position outside it. 'We have joined the *PCF*', wrote Breton in *Au Grand Jour*, his answer to the Surrealists who questioned the new political stance,

OPPOSITE René Magritte: *The Rape*, 1934 (George Melly Collection, London).

'considering first that not to do so might imply on our part a reservation which did not exist, a hesitation beneficial only to its enemies (who are ours as well, and our worst)'. Breton was referring to the Catholic intellectuals who argued that poetry and art without political commitment were necessarily motivated by religious feeling. In 1926 Breton had already alluded disparagingly to Abbé Henri Brémond whose book *Prayer and Poetry* was published in 1927. Breton had suggested ironically that no doubt Brémond would have an explanation ready for the mystery of de Chirico's painting. It was at this time that the Surrealists began to renounce some of their idols whose work it was possible to interpret as a search for lost faith.

The leadership of the *PCF* was largely indifferent to the Surrealists' commitment. At that time, the Party was undergoing an intensely doctrinaire house-cleaning. After the denunciation of Trotsky, and the internal quarrelling which had ensued, Party discipline was rigidly imposed and the directions of the Third International, rather than the dictation of the unconscious, were preoccupying the minds of Party officials. There was certainly no opportunity for the ideological debate to which the Surrealists believed they could constructively contribute. Breton, Aragon and the others submitted to a committee of inquiry which examined their doctrine. Eluard was assigned to a cell of tramway workers, Breton and some of his friends belonged to a cell in the Gobelins quarter. They conscientiously tried to find the time and the patience to busy themselves with Party activities. Breton used to wear a workman's cap at the Cyrano and began to find marvels even in the realistic novels of Zola. But he could not take it seriously when he was required to furnish a group of gas-workers with a report on the social and economic structure of Mussolini's Italy, a task which he refused to undertake. He stopped attending the meetings of the cell. Otherwise, the Surrealists were expected to serve the Party as journalists. 'Literary work is dirty work', Breton had told Fourrier, 'such as we had never undertaken in any circumstances.' The Surrealists could not understand the acquiescence with which the *PCF* accepted the expulsion of Trotsky from the Russian Communist Party in November. To Breton Trotsky had seemed a revolutionary genius; Stalin was just another politician. Within days the Surrealists abandoned the *PCF*.

Surrealism and Communism would remain uneasy partners but Breton's attempt to integrate poetry and revolution had been frustrated. André Thirion has summed up the difficulty of the Surrealists' political commitment by posing the question: 'What could the Party do with Max Ernst or André Breton to win over the miners of Lens whose novels could describe with sentimentality the workers' oppressed lives or the misery of unmarried mothers in the spinning mills?'

6 'The Most Marvellous and Disturbing Problem'

OPPOSITE Yves Tanguy: *Girl with Red Hair*,
1926 (Private Collection).

In February 1928, Breton's *Surrealism and Painting* was published in book form. To the essays on Picasso, Braque, Miró, de Chirico, Ernst, Man Ray and Masson which had appeared in *La Révolution Surréaliste*, there had been added sections on Arp and Yves Tanguy. The book was as important a study of Ecole de Paris painting as any that had appeared, even if its author attended only to the artists whose work had inspired, or been inspired by, Surrealism. The geometrical style of Ozenfant and Le Corbusier did not come within the book's frame of reference; nor did Léger's monumental depictions of urban life; nor did the sculpture of Brancusi or Lipchitz. Breton could not have discussed the formal values with which these and many other artists were principally concerned. Painting could only relate to Surrealism so long as it disorientated the observer, so long as it provoked a response from the eye of the unconscious rather than the eye of the intelligence.

Early in 1926, not long after *Surrealism and Painting* had started to appear in *La Révolution Surréaliste*, premises had been found in Rue Jacques-Callot where the artists associated with the movement could show their work. It had been a little ironic that the Galerie Surréaliste had been opened in rooms previously occupied by the staff of *Clarté*, for Pierre Naville, who became the review's editor, had never accepted painting as a revolutionary activity. But Marcel Fourrier had probably had a hand in the arrangement and Roland Tual, one of the Rue Blomet group and close to Masson, had been the director of the gallery from its opening. The first show had featured the work of Man Ray; exhibitions of paintings by Tanguy, Masson and Arp had followed. Primitive art from the collections of Breton, Aragon, Eluard and others had also been shown; Oceanic objects had accompanied Man Ray's work and American Indian objects had been exhibited with Tanguy's. The mixture had been appropriate: both kinds of art operated on the level of magic. Their power was not simply aesthetic but above all totemic. The Surrealists had begun to make drawings with an equivalent power, the *cadavres exquis* (exquisite corpses) which were the prizes won by all from their new game; inevitably, once painting had been accepted by the Surrealists their games of 'Consequences' were extended to include figures drawn in sections by different hands, the paper being folded so that no one knew what the rest of the figure was like. The results had sometimes been monsters from the pages of *Maldoror*. Their compound imagery was an equivalent to the animal and bird symbols of idols from the Pacific islands or pre-Columbian America. Not just the painters played *cadavres exquis*; all the Surrealists contributed. The best results were reproduced in *La Révolution Surréaliste*, together with photographs of fetishes

The Surrealists composed *cadavres exquis* on the principles of the game of Consequences. This figure was drawn in 1929 by André Breton, Suzanne, Georges Sadoul and Robert Desnos (Private Collection).

and totems from New Mexico or New Mecklenburg. The Surrealists also produced their own fetishes, strange objects which had remained on the retinas of their minds when they had woken from dreams. These too were exhibited at the Galerie Surréaliste. They were not sculptures; they were creations made under directions from the unconscious.

More artists joined the movement. René Magritte came from Belgium to settle in Paris; the 'interior' which had been for so long a subject of Flemish art took on a new meaning in his paintings. The realism of his work he owed to the traditional painting of his homeland but his iconography was Freudian. The paintings of de Chirico's early period in Paris were an inspiration both to Magritte and to Tanguy; the latter had to get off his bus at the next stop when he saw one in the window of a gallery. In part of *Surrealism and Painting* which had appeared in 1926 Breton had made his excuses and had taken his leave of de Chirico whom nothing or nobody had persuaded to resume his visionary work. Breton had called him a coward, a cheat and a viper. Raymond Queneau, writing in *La Révolution Surréaliste* in 1928, divided his work into two periods: the first and the bad. An exhibition of his recent work was held at Léonce Rosenberg's gallery early that year. His themes now were piles of furniture and horses on a sea shore, and processions of lictors and centurions who appeared to tramp through history from the Caesars to Il Duce. At the Galerie Surréaliste all the earlier paintings by Giorgio de Chirico which belonged to the Surrealists were hung as a protest. Because de Chirico had complained that the title of one of his paintings had been changed when it was reproduced in *La Révolution Surréaliste*, all the works on show were given new names in the catalogue. In the window of the gallery there was a plaster model of the leaning tower of Pisa, surrounded by little rubber horses and doll's furniture, beside which was a notice: 'Here lies Giorgio de Chirico'. The Italian had devoted himself to studying the technique of the Renaissance masters. Subject-matter had become secondary, and the brushstroke facile. The effect was decorative,

Giorgio de Chirico: *Amazons*, 1927 (Private Collection).

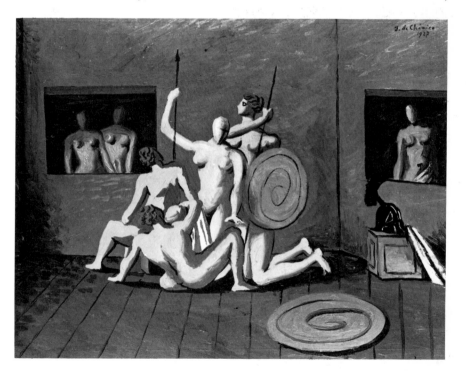

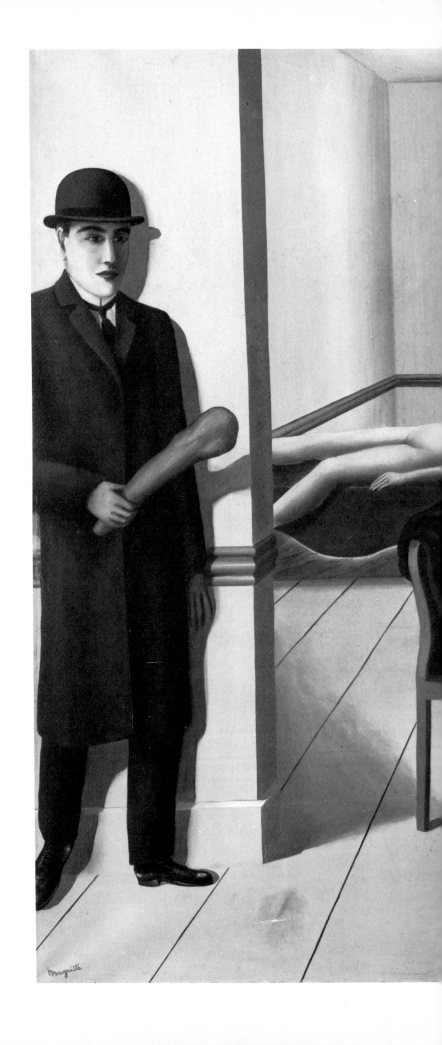

René Magritte: *The Menaced Assassin*, 1926
(Museum of Modern Art, New York, Kay Sage
Tanguy Fund).

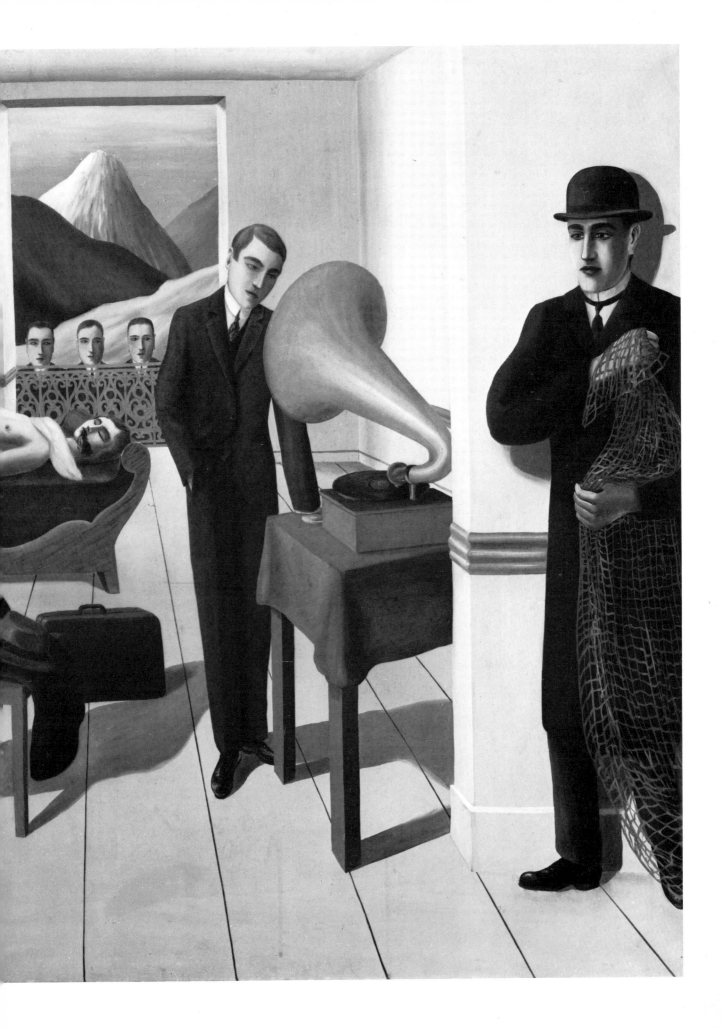

OPPOSITE Décor by Max Ernst for Diaghilev's production of *Romeo and Juliet*, 1926 (Wadsworth Atheneum, Hartford, Conn.).

not far removed from the stage decorations of, for instance, Jean Hugo and Christian Bérard. Both these artists had made their reputations with scenery for Cocteau productions, and predictably it was Jean Cocteau who leapt to the defence of the enfeebled de Chirico. He wrote an essay on the artist entitled *Le Mystère Laïc* (The Secular Mystery), so being careful not to fulfil Breton's prophecy that 'some Abbé Brémond' would explain away the artist's power in terms of Christian mysticism. But Cocteau wanted to refute Breton completely and felt constrained to sneer at Freud and lavish praise on the patently second-rate paintings which de Chirico was then producing. He attacked earlier artists who had evoked the mysteries of the unconscious: he discarded Redon, and 'Victor Hugo was a madman who thought he was Victor Hugo'. It was a remark which sounded clever, like many of Cocteau's remarks. Anyway, it was an epigram to please his friends, Les Daudet. Jean Hugo, one of Victor Hugo's descendants, was a close friend of Cocteau's but at that time he was breaking from his wife Valentine Gross Hugo, an artist, and perhaps the only woman whose beauty and kindness had made Cocteau regret his homosexuality. It had been a marriage which had deprived Cocteau of his intimacy with Valentine and he might still have hoped to achieve some sort of union, at least spiritual, with his 'sister'. But Valentine had been disgusted by Cocteau's conversion, by his opium-smoking and by his recurring cures, paid for by Coco Chanel, the first of which had been conducted almost under Valentine's nose in a clinic across the street from the Hugo home. Valentine was seen less and less at her husband's side in the fashionable world. For Cocteau, the greater horror was that she had now drawn close to the Surrealists and was often in Paul Eluard's company.

Through the jungle of fashionable cliques and factions the Surrealists tried to hack an uncompromising path. They had to maintain constant vigilance in order to avoid the snares and clinging tendrils of snobbism. The financial sacrifice was hard to make, particularly for the successful artists. In 1926 Max Ernst and Joan Miró succumbed to offers from Serge Diaghilev and agreed to design the scenery and costumes for the ballet of *Romeo and Juliet* by Constant Lambert. The opening on 4 May was disrupted by the Surrealists and a 'Protestation' by Breton and Aragon was published in *La Révolution Surréaliste*. The painters were soon forgiven, but the Surrealists' hostility towards Diaghilev would remain implacable; when he died in Venice three years later Eluard would record the Surrealists' gratification at the deaths within a few months of not only the Russian impresario but also the monumental sculptor 'W.C.'Bourdelle, the 'fat and stupid' Souday, a critic who had reviled Baudelaire's work, and of 'the cow' Foch.

At the end of 1926, two Surrealists were expelled. Soupault and Artaud had both shown that their artistic enterprise was incompatible with the ethics of the movement. Soupault could not be forgiven for the succession of novels which flowed from his pen, nor for the items of gossip about the Surrealists which he supplied to the press. Breton accused him of having publicized the story that he (Breton) mishandled the accounts of the Galerie Surréaliste. The rumour was that Breton had used the gallery's cash to buy beauty-treatments for the very delectable blonde working there. Her name was Youki and she had been living with Foujita in Rue Massenet; later she would marry Robert Desnos. Artaud's offence was his theatrical ambition which forced him into the company of not only Robert Aron and Roger Vitrac but also the Allendy couple. Dr René

Allendy was a fashionable psychologist who provided a shoulder on which wept many of the Parisian avant-garde as well as several socialites. His wife Yvonne conducted a progressive salon where the latest developments in art and science were earnestly discussed. They put up the money for the Théâtre Alfred Jarry, the enterprise of Aron, Artaud and Vitrac. The few productions which were undertaken included important milestones in the development of twentieth-century drama but they had little to do with Surrealism and involved what Breton considered humiliating compromises. Towards the end of 1926 extracts from the manifesto of the Théâtre Alfred Jarry were published in *La Nouvelle Revue Française* and the Surrealists particularly took exception to a passage in which Artaud suggested the dramatic potential of a police raid on a brothel. He showed no inclination to become involved in the Surrealists' political activities and was in contact with Jacques Maritain. His acting in films was another grievance they had against him, especially when he drew critical attention and praise for his role as a priest in Carl Dreyer's *Joan of Arc*, a film which the Surrealists predictably abominated. But Artaud's manic revolt against life continued to win sympathy from the group and sometimes contributions from him were printed in *La Révolution Surréaliste*. The skirmishing continued: in 1927 Artaud published *A la Grande Nuit ou Le Bluff Surréaliste* which ridiculed Breton's and the others' profession of faith in the *PCF*, made in the pamphlet *Au Grand Jour*; the next year he produced Strindberg's *Dream Play* with the financial assistance of the Swedish government. At the première insults were hurled across the footlights between Artaud and the Surrealists, and the Swedish diplomats walked out.

The problem of discipline within the Surrealist ranks grew as young revolutionaries were attracted to the movement in increasing numbers. The difficulty was that each writer, artist or political dissident at the threshold of his adult life sought within Surrealism the security of a group, but as he established himself in the world he found that some aspect of the movement's doctrine inhibited his development. Breton attached importance to taking intellectual risks. Every conviction was questioned or rejected in the process of his shifting attitudes. As one Surrealist who joined the movement at about this time described it, Breton was always picking up the cards, shuffling the pack and re-dealing. Several later recruits to Surrealism lived in Montparnasse, which they saw as the cultural focus of Paris at that time, and their attendance at the Cyrano gatherings used to be very irregular. Soon they lost touch with the mercurial views of the movement's leadership. At 54 Rue du Château in Montparnasse there developed a new base where a succession of the younger Surrealists lived, where many others dropped in and where the atmosphere of discussion was less rare than on Rue Fontaine. Marcel Duhamel had rented the house, which had been a sort of pavilion in the days when Montparnasse had been a rural retreat. He had lived there with Jacques Prévert and Yves Tanguy and they had made contact with Breton in 1925. When they moved out of No. 54 other young Surrealists moved in. Georges Sadoul took over the lease from Duhamel, and he was joined by André Thirion. The house was no museum, but a bohemian dwelling, 1920s style. Tanguy had decorated the interior, painting the communal rooms green. There was a huge, tapering mirror, inspired by the distorted world of Dr Caligari: a gramophone emitted American jazz; the curtains had Cubist designs by Jean Lurçat; notices stated: 'Every Saturday, wild fowl', 'Nomads not allowed to park here'.

Among the new Surrealists was a group of young men who produced a review called *Grand Jeu*. They had developed ideas similar to Surrealism and Breton at first welcomed them to the movement. But they frequently missed the finer points of Surrealist doctrine. They glorified Landru, the bluebeard who had murdered a succession of solitary ladies having possessed himself of their financial assets. Landru's crimes had been those of a small businessman; they seemed mean and petty-minded beside Germaine Berton's mad gesture of desperation. One of the Grand Jeu group, Roger Gilbert-Lecomte, had been given a petition against military service signed by eighty-three students at the Ecole Normale Supérieure. When disciplinary action was threatened most of the petitioners had revoked, and Gilbert-Lecomte, at their request, had handed back the inflammatory document. Aragon had assured the editors of the *Grand Jeu* that the petition would be published in *La Révolution Surréaliste*, and now the opportunity not only to enrage the authorities, but also to expose the bad faith of the timorous protesters had been lost. Breton was furious: it seemed incredible that Gilbert-Lecomte had not thought of having the petition copied before he returned it. All the group seemed to be half-hearted in their commitment to revolution. Another member, Roger Vailland, was editing the newspaper *Paris-Midi*. In its columns had appeared articles in praise of Jean Chiappe, the capital's vigilant chief of police, who made no secret of his reactionary views and was relentless in his persecution of Communists. A song which had been composed by the conductor of the police band, extolling his commanding officer's virtues, was warmly greeted by *Paris-Midi*'s correspondent. It was intolerable that men associated with such journalism should be known as Surrealists.

Early in 1929, Breton composed a letter, some copies of which were sent out to Surrealists, their friends and sympathizers. Breton asked whether individual or collective action was favoured; if the latter, with whom, Breton asked, would co-operation be contemplated? He wanted names. It was an attempt to force the group itself to condemn its untrustworthy elements. Some members refused to be trapped and replied to the effect that they could see no moral necessity requiring them to submit to such interrogation. They could no longer be counted among the Surrealists. The others were summoned to a meeting in March at the Bar du Château, down the road from 54 Rue du Château. The Grand Jeu group expected that they were going to be heavily outnumbered by Surrealists who endorsed the movement's political commitment. Cleverly they attempted to split the Communists ranged against them by proposing that the agenda should include a discussion of the treatment which Leon Trotsky had recently suffered at the hands of the Moscow authorities. Dismissed from any official position, expelled from the Party, sent to Alma Ata in remotest Russia, Trotsky had finally been exiled altogether from his homeland. In February a Russian ship deposited him and his family at Constantinople. Sadoul, Thirion and others, the inmates of 54 Rue du Château, were active members of the *PCF* and could not have debated Trotsky's fate, let alone shared the opinion of Breton, Fourrier and others. In the event, however, the Grand Jeu tactic failed. At the meeting in the Bar du Château, on 11 March, the replies to Breton's letter were read out. Then Breton and Raymond Queneau made speeches regretting that there were those present who favoured individual action; Queneau warned them that literature lies in ambush at the crossroads of scepticism and poetry. Only collective action can correct individual deviations.

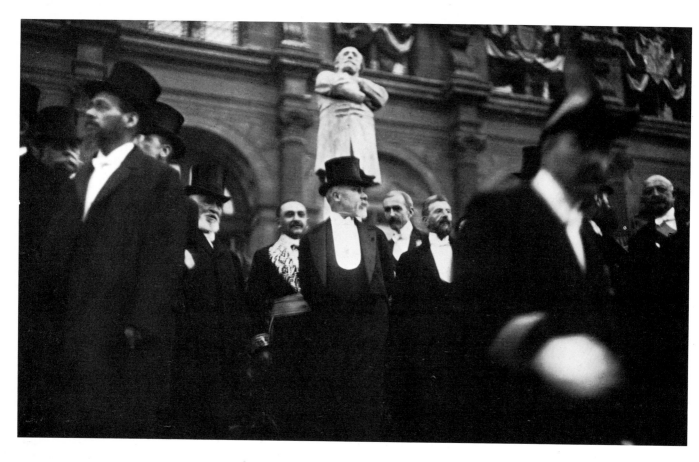

Raymond Poincaré (centre, in front of statue), who became Premier of France in 1926.

Before any debate on Trotsky, the Grand Jeu group was asked to explain its attitudes and behaviour. Vailland was forced to agree that he would publish in *Grand Jeu* a letter condemning the article in *Paris-Midi* and disclaiming its views. The meeting broke up in a crossfire of insults and recriminations. The matter of Trotsky was never aired, and those who had not realized that its inclusion on the agenda had been merely a Grand Jeu manoeuvre felt that Breton attached more importance to petty retribution than to burning issues. The episode thinned the ranks of the Surrealist movement, some driven away because they would not meet the demands made of them, others leaving because they abhorred Breton's inquisitorial methods.

The climate of political opinion in Paris at the time was not of a sort to induce conciliations or concessions among the Surrealist revolutionaries. Since Poincaré had established the franc in 1926, the economic fortunes of France had soared. The forces of reaction were cocksure and arrogant. Poincaré was not an attractive man, but he had won the veneration of the bourgeoisie. It was the opinion of a writer in *Le Temps* that 'one would have to go back to St Louis to find such popular enthusiasm for a sovereign'. Eluard, in *La Révolution Surréaliste*, called him 'our Mussolini'. He was also known as 'the enemy of the proletariat' and when the conservatives established an unassailable pre-dominance in the Chamber after the elections of 1928, he went to work with a will on the suppression of Communism. Jean Chiappe and the special brigade were his weapons; André Tardieu at the Ministry of the Interior was his tactician. The previous autumn, when Sacco and Vanzetti had been executed in America, a large mob of Communist demonstrators, Isadora Duncan

172

prominent among their leaders, had sacked the cafés in Montparnasse where the Americans on remittance used to pass the hours, and then tried to reach the American embassy. Tardieu was not going to let there be any recurrence of such disorderliness. When workers clashed with police at Ivry in 1928, thirteen hundred arrests resulted, and Tardieu banned all street demonstrations.

The *PCF* had won only fourteen seats in the Chamber of Deputies at the 1928 elections, less than half the number it had held after the elections in 1924. This was only to a mild degree due to the nation's affluence, the benefits of which barely reached the workers. The orders from Moscow, since the overthrow of Trotsky, had been to harry the Socialists, the 'social-traitors', and it had been mainly they who had pressed for the *scrutin d'arrondissement*, a procedural device at the elections which ensured the defeat of many *PCF* candidates. What had been a three to one majority of Communists over Socialists at the Congress of Tours in 1920, had by 1928 become an approximate equivalence. The *PFC* had lost members in droves as a result of the strict Party discipline maintained by its leaders Barbé and Celor, a scourge which many, including the Surrealists, found more stinging than police aggression.

'If you're a Marxist you have no need to be a Surrealist.' Breton reported that the *PCF* official, Michel Marty, had 'bawled' this opinion at one of the group, and it epitomized the attitude of the Party leadership. At the same time, Henri Barbusse made any intellectual contribution from the Surrealists impossible. Having in 1927 illogically appealed to writers to lead the Communist movement to a new art of the people which would emerge when the masses were liberated, he started the following year to publish a review called *Monde*. He was the only Communist on its editorial board, and the sort of 'proletarian' culture which it favoured was a learned exegesis on the popular inspiration of Dürer's art. Most *PCF* members still retained the moral outlook of their parents and were shocked by the Surrealist attitudes to love and sex. In a manifesto entitled *Hands Off Love*, published in *La Revue Surréaliste* in October 1927, the Surrealists deplored the way that Charlie Chaplin, who had decided to live with another woman, was being harassed by his wife and her lawyers. It seemed grossly unjust that 'Charlot', as he was called in France, would not be allowed to enjoy the moral liberation which so many had been comforted to glimpse in his films. In the next issue of *La Révolution Surréaliste* was published an account of a debate on sexuality which had been held in January 1928 at 42 Rue Fontaine. The Surrealists had expressed their opinions very freely on such matters as female orgasm, *libertinage* and a wide range of perversions. It was not the kind of reading which any but the most progressive working-class Marxist would have enjoyed.

In the late 1920s sexuality was only just becoming a topic of frank discussion; Christian morality and social taboo generally still restricted observations on the subject to the ground cleared by Balzac's novels or the less pornographic sections of the Bible. When Edward Titus, an American who ran the Black Mountain Press in Paris, tried to publish *Lady Chatterley's Lover* by D.H.Lawrence, Sisley Huddleston of *The Times* let him know discreetly that diplomatic pressure was being brought to bear, through Her Britannic Majesty's ambassador, on the French authorities to suppress the book. Titus asked Aragon, who was known to have influence in high places, if he could help. Aragon satisfactorily arranged the matter, probably through his friend Gaston Bergery, a Radical deputy who was the only politician to frequent the bars of

Henri Barbusse, writer. He edited *L'Humanité*, the official Communist Party newspaper.

Montparnasse. There were also more advanced, more profound views on sexuality being expressed at that time. Wilhelm Reich's *The Function of the Orgasm* had been published at Vienna in 1927 but the Surrealists would hardly have known about it. They would, however, have heard of the well-publicized International Congress for Sexual Research organized by Alfred Moll which took place towards the end of 1926 in Berlin. There the biology, psychology, sociology, and criminology of sex were discussed. Freud was hostile to Moll's theories; neither he nor his disciples accepted invitations to attend the congress. That circumstance may have inspired Breton to arrange his own contribution to sexual research. But he had more personal motives. He was over thirty, and his marriage had broken up.

Towards the end of 1926 Breton had met a girl near Rue Lafayette and started following her. She led him into a strange, frightening adventure which obsessed Breton over the next few months and contributed largely to the deterioration of relations between him and Simone. He gave an account of the affair in *Nadja*, in which he wrote of the girl's psychic awareness, the series of coincidences which dictated the development of his infatuation, her insanity and finally her suicide. Breton claimed he was presenting a factual record, not a romantic fantasy which would have been a contradiction of every judgement he had delivered against the novel. On the other hand he always maintained that there was a point where dream merged with reality. Whether *Nadja* was a waking experience or the author's dream or both, the events recorded could not have been suffered by Breton without great anxiety. At about the same time Simone left him, and the break, unpleasant enough, became sordid when disputes arose about property. Breton looked for distractions. There had been Youki; for some time he was Lise Deharme's close friend. She was a writer, 'a very attractive sorceress' as Thirion described her, 'with the lascivious and seductive eyes of the Queen of Sheba'. But it was not an enduring relationship. Soon Breton was sharing his apartment with a girl called Suzanne. Neither was that an affair which threatened to last.

None of the Surrealists, Breton least of them, set much store by promiscuity, either in practice or in principle. Love to them was elective and passionate, not simply carnal. They saw woman as a key to the great problem, to resolve which they thought should be the principal aim of their lives: the contradiction between the conscious and the unconscious. 'The problem of woman', Breton wrote in 1929, 'is the most marvellous and disturbing problem there is in the world.' The intensity of feeling without which they were not inclined to have a relationship with the opposite sex sometimes induced an emotional equilibrium where rapture and responsibility were balanced. But sometimes the Surrealists arrived at such a point only after plumbing the depths of disappointment, which was the risk implicit in the quest. Louis Aragon was one who suffered. In 1928 his *Treatise on Style* was published. The witty, swingeing attack on contemporary French literature brought him notoriety almost overnight. The book immediately established him as one of the most brilliant writers of his generation and won him a host of admirers. One of them was Nancy Cunard.

Lord and Lady Cunard's daughter, whose name had become associated with that of Sir Thomas Beecham, was well-known in Paris and most of the European capitals and resorts where the rich and cultured gathered in the twenties. She spoke almost immaculate French but her beauty was

OPPOSITE Salvador Dali: *Seize Titols, c. 1930* (Private Collection). This photo-montage records one of Dali's obsessions.

174

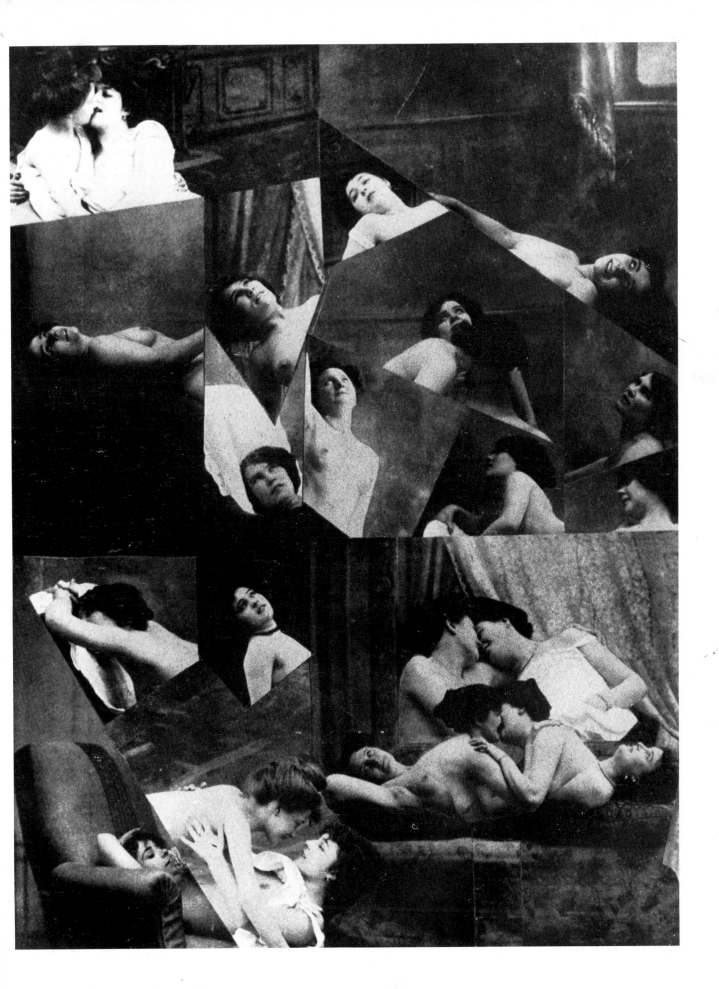

OPPOSITE Nancy Cunard, photographed by
Cecil Beaton.

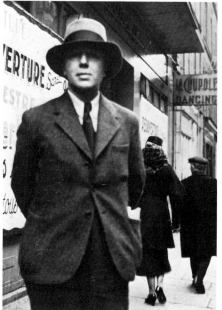

ABOVE André Breton, about 1930, on one of his
rare visits to Montparnasse.
RIGHT An illustration from *Nadja*, André
Breton's anti-novel.

distinctively English. She was slender, freckled, and her hair was the colour of
walnuts. In Paris, she took over the Hours Press from William Bird and moved
in literary circles. She had houses in Périgord and at Chapelle-Réauville near
Vernon and Aragon was soon invited to visit them. He fell in love with her and
in her company found himself leading an even more itinerant existence than he
always had, and living in a far denser haze of alcohol. Aragon bought her ivory
bracelets in which she sheathed her forearms from wrist to elbow, protection
that she was apt to use rather as an aggressive weapon. Physical cruelty was one
of the many aristocratic traits on which Nancy Cunard had not been sold short
at birth. Towards the end of 1928 the couple visited Venice. Already the
relationship had reached the stage of blood-letting when Henry Crowder
hove into sight. He was the pianist in the Plantation jazz-band which was

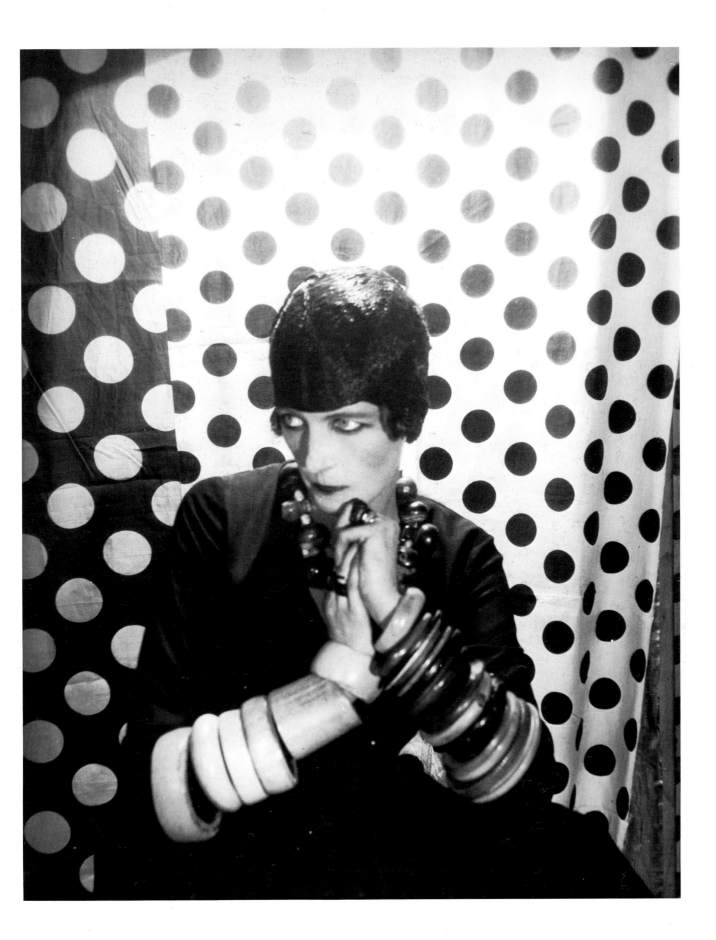

touring Europe with the Blackbird Troupe. Another trait among well-born, well-heeled English females, the need to offend the phlegmatic worthiness of Anglo-Saxon society, rapidly overtook Nancy Cunard who decided to possess the black musician. Aragon was devastated, suddenly and bitterly alone in a foreign city. He was short of money; the proceeds from the sale of a painting, negotiated before he had left Paris, had not yet reached him on his travels. In his hotel he took an overdose of drugs and was hardly alive when an English friend discovered him. Aragon recovered and returned to Paris, but he had not recovered from Nancy Cunard.

Back in Paris, Aragon went to live at 54 Rue du Château where Sadoul and Thirion nursed him through his emotional convalescence. He read them out loud Apollinaire's pornographic novels, pacing the room and breaking off to inspect his effect in the Caligari-mirror. More therapeutic was his meeting with Lena Amsel, a Viennese dancer who had acted in films and was engaged to an American but was happy to aid in Aragon's recuperation. At this era, Aragon often used to meet and talk with Ilya Ehrenburg in Montparnasse and one day there was a young Russian woman in his company who was eager to be introduced to Aragon. She was married to a Frenchman, André Triolet, whom she had met in Moscow during the revoluton and whom she had accompanied when he fled across Siberia, a few versts ahead of the Czechoslovakian forces fighting for the Tsar. Via Japan they had reached America and had been married in San Francisco. Eventually they had returned to France when Triolet had decided he had devoted himself too long to one woman and had found a mistress, the first of a succession. But Elsa was happy in Paris. She had mingled with the artistic avant-garde in Moscow. Her sister, Lili, had been and still was adored by Mayakovsky. Elsa soon belonged to the group round Ehrenburg. She was not a beauty but was intelligent and determined, so determined that at first Aragon was afraid she might be a police spy. When Mayakovsky visited Paris early in 1929, Aragon and all the other Surrealists were anxious to meet him and this provided Elsa with an opportunity. A party was given for the Russian poet at 54 Rue du Château and there began the romance which has, through Aragon's poetry, become one of the best-known love-affairs of the twentieth century.

But Aragon was far from redeemed. Nancy Cunard and Lena Amsel still commanded areas of his affection and he found himself as perplexed and anxious as Breton was feeling at the same time. When both were suffering the torments of rejection the two friends turned to each other. Together they planned *The Treasure of the Jesuits*, a spectacle that would be staged at the Théâtre Apollo on 1 December 1928. It was a series of satirical sketches, far below the standards, ethical or literary, which might have been expected from the authors of *Nadja* and the *Treatise on Style*. The production was part of a celebration staged by Musidora in memory of René Cresté, an actor who had played in Feuillade's *Judex* and *The Vampires*. It was an opportunity for Musidora, now fifty years old, to put on her black tights once again, but Aragon and Breton might have had the sense not to indulge themselves in nostalgia. One of their sketches alluded to the unexplained murder of de Pérédès, the treasurer-general to the Catholic Missions, earlier in the year, and another satirized the financial policies of the current administration, but what prevailed were references to the wartime era when *The Vampires* had epitomized for the two young medical students the fascination of hidden and irrational fantasies.

OPPOSITE Paul Eluard: *L'Amour, c.* 1936 (Private Collection). Photo-montage.

OPPOSITE Paul and Nusch Eluard, a photograph taken by Man Ray about 1935.

It was the first time that the leaders of Surrealism had looked back and it reflected their crises, emotional and intellectual. *The Treasure of the Jesuits* was feeble, an ill-conceived attempt to flee a world where the real phantoms stalked: Nancy Cunard and Simone, Vailland and Gilbert-Lecomte. The performance at the Théâtre Apollo, if it had been put on by Artaud or Soupault, would have been interrupted by a Surrealist protest led, no doubt, by Breton and Aragon.

Eluard, too, was wandering through a romantic purgatory. Although Gala's relationship with Ernst had ended and the German painter had met Marie-Berthe Aurenche, his first wife, nevertheless the Eluards' marriage was defunct. Paul was still in love with Gala and still travelling abroad extensively in order to forget her. In 1928 a recurrence of his childhood ailment took him to a sanatorium in Switzerland. Gala went with him but a reprise of the magic which had happened fifteen years before induced only nostalgia. In Paris Eluard was flattered for a time by Valentine Hugo's attentions, then he lingered with Frau Apfel whom he nicknamed 'La Pomme', but the profound love which his poetry makes clear he always needed to feel was frustrated until he met Nusch. Her real name was Maria Bentz, and she was from Alsace. One day

RIGHT Salvador Dali and Gala posing for Cecil Beaton with *Man with His Head Full of Clouds* (see page 155) and *Woman with Her Head Full of Clouds*.

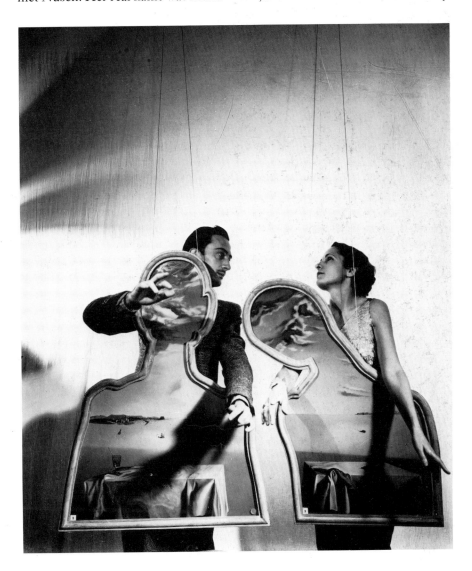

From the film *Un Chien Andalou*.
Luis Buñuel used the carcase of a cow
to obtain this horrific effect.

he was wandering near the Galeries La Fayette with René Char, a new Surrealist luminary who had been drawn to the movement by Eluard's poetry. They saw a young woman, quite lost in the capital, not very beautiful, wearing a ridiculous hat which was small *à la mode* but adorned by a long, coloured feather. She was looking at a painting by Miró in the window of a gallery; Eluard spoke to her and hailed a taxi which took them off together on a journey which did not end until the poet died in 1952.

Eluard knew he had finally lost Gala during the summer of 1929 when they stayed with Salvador Dali at the young Spanish painter's home in Cadaqués on the coast of northern Catalonia, not far from the French frontier. There Gala had found another unruly genius, like Eluard, like Ernst, whom she needed to nurture and train. Dali had been introduced to the Surrealists in 1928 by Joan Miró whom he had contacted on his arrival in Paris. He had come there with a reputation for rebellion. At the Escuela de Bellas Artes in Madrid he had led a group of 'ultraists' which included Federico Garcia Lorca, the poet, and Luis Buñuel the *cinéaste*. They had consistently done the opposite to whatever had been suggested by the staff or the other students. Dali was expelled and for a short time jailed when he protested against the appointment of a professor. In Paris he had renewed his friendship with Luis Buñuel who had been there three years. Buñuel had assisted Jean Epstein on two films and had written to his mother asking for money to make a film of his own. Dali collaborated with him and they made *Un Chien Andalou*. 'It is a two-reel short in which there are neither dogs nor Andalusians', wrote Buñuel. Shooting in Paris and Le Havre, the film was made in the spring of 1929 and shown in June to a small, invited audience at the Studio Ursulines. It was immediately hailed by Breton and his

RIGHT Luis Buñuel, as he appeared in *Un Chien Andalou*, which he financed out of money borrowed from his mother.

OPPOSITE Luis Buñuel brought to Surrealism a Spanish sense of the macabre. This still is also from *Un Chien Andalou*.

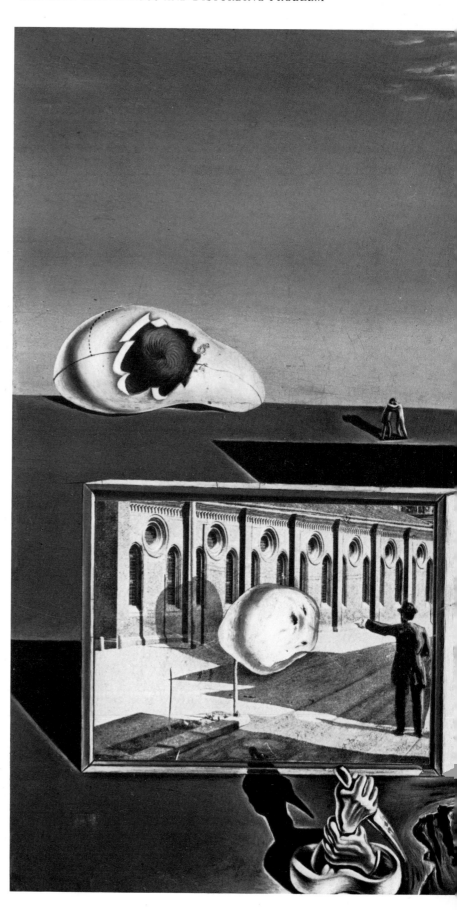

Salvador Dali: *Illumined Pleasures*, 1929
(Museum of Modern Art, New York, Sidney
and Harriet Janis Collection). In this, one of
Dali's first Surrealist works, the artist has used
elements of collage.

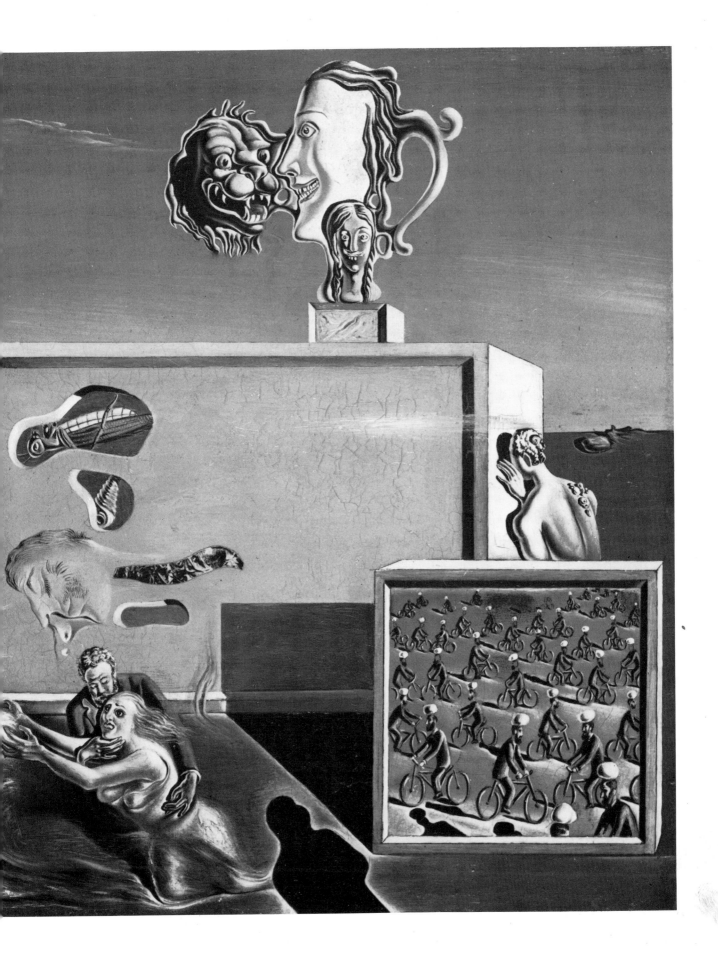

friends as a Surrealist masterpiece. Its imagery is sometimes savage, sometimes Freudian. A young girl's eye is slit in half with a razor in the opening sequence. It was actually the eye of a slaughtered cow which Buñuel sliced, and doing it made him feel sick. At Cadaqués that summer Dali began painting his first consciously Surrealist work which Eluard christened *The Lugubrious Game*. Camille Goemans, a Belgian Surrealist who had opened an art gallery in Paris was also staying at Cadaqués, and later in the year he put on an exhibition of Dali's paintings.

Breton welcomed such explosive new talents as Dali, Buñuel and Char who took up Surrealism at a time when the group suffered from internal dissensions and was beset by the hosts of snobs and speculators from whom its revolutionary purity was, as ever, in the greatest danger. Another figure who added verve to the movement in 1929 could hardly have been counted as a newcomer: Tristan Tzara made his peace with the Surrealists, contributed to their review and was active in their councils. He had recognized the necessity of political commitment and was moving towards Communism, aware, like Breton, that to have remained aloof from politics was too great a concession to sworn enemies. In October 1929 the stock market in Wall Street crashed and although the effect of the financial disaster did not reach France until two years later, it was a time to take sides. Capitalism suddenly seemed to be doomed and men either snatched up picks to undermine the toppling edifice or obediently mixed cement to fill the spreading cracks.

It was a changing world in 1929 and Breton wanted to reorganize Surrealism, to affirm new principles, to dismiss old friends whose means or motives he suspected. As in 1924 when the group had come close to losing not only its cohesion but its title Breton had drafted the first manifesto, so five years on, when disintegration threatened, he composed a second. It was published in the autumn and the text was reprinted in the twelfth and, as it happened, last number of *La Révolution Surréaliste*. Breton wrote spitefully about the members of the group who had deserted or been expelled, regretfully about the treatment the Surrealists had suffered at the hands of the *PCF*. He proclaimed the fundamental principles of Surrealism, not now in terms of psychic automatism but of revolutionary necessity. 'Everything remains to be done, every means must be worth trying, to lay waste the concepts of *family, nation, religion*.... We combat, in whatever form they may appear, poetic indifference, the distraction of art, scholarly research, pure speculation.' The victims of Breton's latest purge were mostly the younger Surrealists who did not feel the anger which had fermented amid the horrors of the First World War. Nor had they seen how Breton had saved Surrealism from the purely artistic nihilism of Dada. They were apparently capable of consecrating themselves to art or journalism, or compromising with the snobs. 'The approval of the public', wrote Breton in the Second Manifesto, 'is to be avoided like the plague.' Their alliance with Communism had failed to put the Surrealists beyond the pale. There were always the *bolchévisants*, as they were called, whose attitude had been exemplified by Cocteau's spurious admiration for the Russian revolution. 'It is therefore possible today', said Breton, 'with the help of M. Rappoport, to misuse Marx's name in France without anyone so much as raising an eyebrow.' If the snobs would follow them into Communism, the Surrealists would escape in another direction. Breton called for the 'occultization' of Surrealism, and cited Nicholas Flamel, the fourteenth-century alchemist. Flamel had dreamt of

a strange manuscript which he subsequently discovered on a second-hand bookstall; at the beginning of the work had been written the curse-word '*maranatha*', a warning to the reader not to go any further unless dedicated to the mysteries. 'It is necessary', wrote Breton, 'to make the point once more, and to maintain here the "*Maranatha*" of the alchemists. . . .'

Next year, twelve dissident Surrealists, victims of Breton's latest purge, published the pamphlet *Un Cadavre*, another corpse, but this time the body was not yet dead; it was Breton's. They called him 'cop', '*curé*', 'hypocrite' and 'barnyard aesthete'. When Breton published another edition of the manifesto in the summer he did not try to refute their charges, even the more reasoned ones. He quoted alongside the abuse tributes made by the same authors before their expulsion. The effectiveness of 'Before and After', as Breton's reply was entitled, was the contrast not so much in sentiment between the two quotations from each author, but in style. Whereas the tributes were considered and generous, the abuse was mean and crude. *Un Cadavre* was clearly the killing of a father by his jealous sons, and it indicated that a stage in the development of Surrealism had been reached. But neither the movement nor its principals were yet prepared to settle down to comfortable middle age.

Salvador Dali: Study for *The Lugubrious Game*, 1929 (Private Collection). When the Surrealists saw the painting for which this drawing was made they accepted Dali among their ranks.

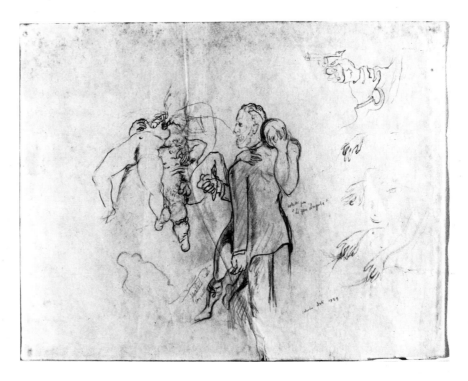

7 'Your Place is No Longer With Us'

OPPOSITE René Magritte: *The Principle of Pleasure*, 1937 (Collection E. F. W. James Esq.).

On 11 May 1930 Luis Buñuel wrote to a friend: 'I don't know if you've heard that Noailles has given me a million francs to make a talking picture, with complete spiritual freedom which I hope, in consequence, will make all who see it blush with shame.' The Vicomte Charles de Noailles was a distant relative of the Comtesse Anna de Noailles whose poetry Paul Eluard had satirized. In 1923 the Vicomte had married the heiress Marie-Laure Bischoffsheim, the granddaughter of Laure de Sade, who became an enthusiastic patroness of the arts. The Noailles had invited Man Ray to their villa at Grasse in 1929 to make a film and the American had shot *Le Mystère du Château de Dés* (*The Mystery of the Castle of Dice*), a fantasy played by the Noailles' guests with stockings pulled over their heads. Dali collaborated on Buñuel's script, but they argued about it and the film was almost entirely Buñuel's creation. He thought of calling it *Down with the Constitution*; then, borrowing a phrase from Karl Marx, he thought of giving it the title *In the Icy Waters of Egoist Calculation*. Finally it was screened as *L'Age d'Or*.

The film is about love which defies all the institutions of society, religion and the state. Breton called it 'a unique exaltation of total love'. Most of it was filmed at the Billancourt studios near Paris, and short sequences were shot on

Marie-Laure, Vicomtesse de Noailles, photographed by Man Ray in 1936.

location in the suburbs and at Cadaqués. Lya Lys and Gaston Modot played the leading roles and the cast included Max Ernst as the bandit-chief, Ernst's wife Marie-Berthe, Valentine Hugo, and Paul Eluard; Llorens Artigas, a studio-potter friend of Miró's, had a part.

The film also featured Caridad de Labaerdesque, 'the most picturesque woman at the Coupole', as André Thirion described her, 'an ugly well-built dancer who was temperamental, intelligent, lazy and a drug addict'. Caridad was high in the Surrealists' esteem at the time. In February 1930 they had stormed a nightclub in Montparnasse which had been impiously named 'Maldoror'. They had marched in and Breton had shouted: 'We are the guests of the Comte de Lautréamont!' In the ensuing mayhem considerable damage had been done and René Char had been stabbed in the thigh. The police had been called but had decided to wait outside and Caridad had aided one Surrealist who had failed to extricate himself from the angry guests.

The Noailles had wanted Stravinsky to write the score for Buñuel's film, but Buñuel firmly resisted the idea because the composer had worked with Cocteau. Instead, Buñuel used excerpts from works by Mozart, Beethoven, Mendelssohn, Debussy and Wagner. Each piece was chosen to contrast in feeling with the sequence which it accompanied, an effect which had been suggested by Sergei Eisenstein, V. I. Pudovkin and Alexandrov in their

Gaston Modot and cow in a scene from
Buñuel's *L'Age d'Or*.

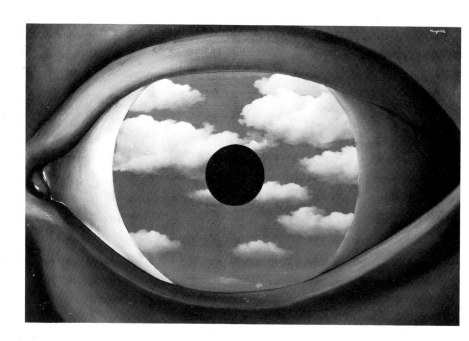

René Magritte: *The False Mirror*, 1928
(Museum of Modern Art, New York).

The unashamed eroticism of *L'Age d'Or*
caused a furore when the film was first shown
in Paris. Lya Lys played the female lead.

Manifesto on Cinema Sound of 1928. All the techniques of Eisenstein's cinematography had been an inspiration to Buñuel, and had been admired by the Surrealists who had seen the affinity between his montage and collage paintings. *Potemkin*, Eisenstein's record of the naval mutiny at Odessa in 1905, had been shown in Paris in 1926 when the Surrealists' alliance with the Communists was maturing. When Eisenstein himself had been in Paris, not long before Buñuel had started shooting *L'Age d'Or*, the Surrealists had hailed him. He had presented his film *The General Line* and had given a lecture at the Sorbonne. *Potemkin* was to have been shown that evening but the police had been worried by threats from right-wing students and had forbidden the screening. While Eisenstein had extemporized, keeping his audience interested and amused for two to three hours, brigade cars had been stationed round the corner in Rue St Jacques.

When Eisenstein had been sent two tickets for a preview of Cocteau's *La Voix Humaine* at the Comédie Française in February, Paul Eluard accompanied him. Throughout Cocteau's play a woman, on stage alone, speaks on the telephone with her lover; the audience hears only her part of their intense dialogue. The emotional attitudes which she expresses sometimes suggest the author's homosexuality. Hardly had the play started when Berthe Bovy, playing the role of the woman, dressed in a nightdress and négligée designed by Christian Bérard, was interrupted by Eluard. From Eisenstein's box he waved a newspaper and called out: 'Obscene! Enough! Enough! It's Desbordes on the other end of the line!' Jean Desbordes was Cocteau's current lover. Cocteau's *claque* had assaulted Eluard, one of them burning him on the neck with a cigarette. Eluard had been ejected but had waited until the performance ended. Then, in the theatre-manager's office, he had exchanged words with Cocteau, words which Eluard would have recounted later, no doubt, to Valentine Hugo.

The next month Louis Aragon had been involved in another scuffle. When Mayakovsky committed suicide in Moscow, the Capitalist press in the West had seized on the event which had apparently testified to the Soviet

government's persecution of progressive artists. Probably Mayakovsky had been the victim of both official displeasure and his unrequited love for Lily Brik. But the Surrealists had taken the view that his death was no reflection on the Soviet authorities, but only the desperate act of a man whose heart had been broken. They had deplored the alternative explanation, especially when it was offered with smug satisfaction by André Nevinson, a Russian *émigré*, in the pages of *Nouvelles Littéraires*. Aragon had gone to Nevinson's home in an angry mood. The Russian had said he could not defend himself, having recently broken his arm. Aragon had thrown some crockery through the window and Madame Nevinson had fetched the police. On their arrival, Aragon had punched Nevinson in the face and had been escorted away.

Mayakovsky's honour was vindicated by the Surrealists in their new review, called *Le Surréalisme au Service de la Révolution*, the first number of which appeared in July 1930. It was not very different in format to *La Révolution Surréaliste* but the accounts of dreams and automatic texts which had filled many pages of the earlier review gave way to doctrinaire articles expressing the Surrealists' intractable resistance not only to bourgeois society but also to the critics of the Left who, demanding a proletarian literature, had in fact ascribed Mayakovsky's suicide to his inability to remove himself or his work from his bourgeois origins. But, as the change of title suggested, the Surrealists now accepted that the intellectual independence, which they would defend against every enemy, could not itself effect the revolution. On the opening page of the new review the Surrealists published a telegram from the International Bureau of Revolutionary Literature in Moscow which required an answer to the question 'what will be your position if imperialism declares war on the Soviets?' Beneath appeared the Surrealists' reply:

Comrades, if imperialism declares war on Soviets our position will be, in conformity to the directives of the Third International, position of members French Communist Party.

Should you in such circumstances think of a better employment within our capacities we are at your disposal for precise mission requiring any other service from us as far as we are intellectuals. To submit suggestions to you would be to presume indeed on our role and on circumstances.

In actual situation of unarmed conflict we believe it useless waiting to exploit in the service of the revolution any means which are not specifically ours.

That was as far as the Surrealists would go in sacrificing their intellectual ideals to a political objective, and it was not as far as some Communists would have wished.

In the pages of the new review there were attacks on most of the movement's traditional enemies, and some new ones. There was a report on a postcard which Sadoul and Caupenne had sent to Keller, a cadet at the military college of St Cyr. For his insults to the army, Sadoul would face prosecution. Other articles attacked the Church and French colonialism. Aragon treated Desnos' latest publication to the withering scrutiny of which he was the master, and, in a review of Claudel's opera *Christopher Columbus*, he managed to condemn not only Claudel but also Milhaud the composer and Barbusse's review *Monde*. One of that review's regular writers, Emmanuel Berl, was picked on by both Aragon and Crevel. Berl had recently published a pamphlet called *Death of Bourgeois Thinking* but its tone seemed nostalgic. 'At the burial of bourgeois

Paris 28 Jan 1933

Mon très cher

Eluard, Tu as bien tort de ne pas croire en ma... Je ne mérite pas ce reproche... heureux sur que tu n'en pense... pas un mot. Écris moi souvent car ton absence est dure pour moi

Soignes toi bien

Pardonne moi cette stupide façon de t'écrire.

je n'ai pas de nouvelles importantes à t'annoncer, mais Breton doit certainement te tenir au courant de ... Moi je ne puis que te redire notre très grande affection et notre très grande admiration

N'oublie pas que je suis à ta disposition si tu as ... chez Cor ... quelques courses à faire à Paris, Snégaroff demande à qui ... porté le ... à ce sujet Je pense à Crevel envoyer Je pense à toi et peut aller comme toi Musch la facture qu'il ... vas Mes amis ... Yves et je t'embrasse Jeannette

RIGHT Vladimir Mayakovsky, photographed in Moscow shortly before he committed suicide.

OPPOSITE Yves Tanguy: *Letter to Paul Eluard*, 1933 (Museum of Modern Art Library, New York, Eluard and Dausse Collection).

thinking', wrote Crevel, 'M. Berl was prominent among the family mourners. Sincere condolences.' To Berl's greater discredit, he had come between Breton and Suzanne. She had left 42 Rue Fontaine to live with Lise Deharme at Saint-Brice where she had been joined by Berl, her former lover. Lise thought it had only been Berl's bad manners which had driven Suzanne temporarily to Breton's side. Now Breton had been abandoned and found the house of one of his closest friends harbouring his enemies. To make matters worse Suzanne taunted Breton, who had not given up all hope of winning her back, with accounts of how Barbusse and Berl conspired against him. A new number of *Le Surréalisme au Service de la Révolution* appeared in October. It opened with a collage of press-cuttings arranged in the form of a hammer and sickle entitled 'A story of fellow-travellers, from Barbusse to Coty, the wartime press re-awakes.' Coty, the perfume-king who owned *Le Figaro* and other newspapers,

RIGHT André Breton: *La Nourrice des Etoiles*,
c. 1934 (Collection Dominique Eluard).
A collage portrait of Paul Eluard.

OPPOSITE An untitled collage by Paul Eluard,
1935 (Private Collection).

held views which were almost Fascist. J. Frois-Wittmann reviewed Freud's
book on slips of the tongue and Breton attacked psychological medicine in
France. Maurice Heine wrote on de Sade and Aragon on *Maldoror*. André
Thirion, this time, abused the unfortunate Berl.

Throughout 1930, the Surrealists produced a succession of important
works. Breton went on a holiday in Vaucluse with René Char and Paul Eluard
whose travelling had been restricted to his homeland when the police deprived
him of his passport. There Breton and Eluard collaborated on *The Immaculate
Conception*, an investigation into the creative potential to be exploited at the
level of madness. All three of them jointly composed the poem *Slowing Down
Work*. Max Ernst's *The Dream of a Little Girl Who Wanted to Enter the
Carmelite Order* and Salvador Dali's *The Visible Woman*, both published in
1930, were substantial additions to Surrealist art. Luis Buñuel made *L'Age*

RIGHT Max Ernst: *Quiétude*, 1929. A plate from *La Femme 100 Têtes*.

OPPOSITE *Cadavre exquis* composed by Nusch Eluard, Valentine Hugo, André Breton and Yves Tanguy in 1935.

d'Or. Only Aragon, among the leading Surrealists, was yet to make his contribution to the year's crop. There were difficulties. How could he follow *Treatise on Style* in which he had apparently doubted the existence of any worthwhile literary project? He started writing the libretto for *The Third Faust*, an opera on which Breton was to work with him; Georges Antheil was to compose the score. But Breton's enthusiasm waned and his relations with Aragon had noticeably cooled. Elsa did not help matters. She now lived with Aragon in a studio on Rue Campagne-Première. Her need to possess Aragon made it important for her to undermine his oldest friendship. She said Breton was a domineering bore, and Breton in his turn distrusted her. The couple were short of money and Elsa made jewellery which Aragon, always charming and credible, sold to the buyers from Chanel, Molyneux and Schiaparelli. But that meant an early start each morning and left him little time or energy for more appropriate pursuits. It was hardly the *modus vivendi* which he could have imagined, or desired, would last forever. In the autumn, when Elsa suggested

OPPOSITE André Breton: *The Serpent*, 1932 (Private Collection). Photo-montage.

that they should visit Moscow and meet her friends and relations, Aragon welcomed the plan.

Early in October they arrived in Moscow and while there they lived in the apartment which had been Mayakovsky's home. They were soon joined by Sadoul who faced imprisonment if he remained in France and had to answer the charges arising from his postcard to the St Cyr cadet. Aragon wrote to Breton assuring him that he was meeting the right people and could clear up the Soviet intellectuals' misconceptions about Surrealism. Then it was decided that he and Sadoul should attend the Second Congress of the International of Revolutionary Literature at Kharkov. On 17 November Breton received a wire from Aragon at Kharkov: 'Here complete success.' Largely at his instigation the Congress had passed one resolution condemning *Monde* and another which admitted the revolutionary value of Surrealism. But if Aragon could negotiate successfully with the buyers from the fashion houses, he was a novice at treating with Russian bureaucrats. The Congress might convict *Monde* of promoting 'ideologies hostile to the proletariat' but Barbusse's election to the Presidium of the International was not challenged. Not only was he respected by the leaders of the *PCF* but he was also of quantifiable value to the Comintern, particularly as an influential voice for pacifism. It had been Soviet policy since the Treaty of Locarno to encourage disarmament among the Western powers. The editorial policy of *Monde* promoted international understanding and helped to inspire a feeling of security as well as sympathy with Russian Communism. Surrealism, on the other hand, had a negligible influence on intellectual opinion and had constantly displayed an independence of mind which made the adherence of the movement to Communism a mixed blessing. The *PCF* and the Comintern insisted that Aragon and Sadoul should not return to Paris without their achievement at Kharkov seriously debilitated.

A trap was ingeniously laid for the two unwitting Surrealists. From Kharkov, treated with immense official decorum which seemed to endorse their newly won prestige, they were taken to the Ukraine and at Dnieprostroi shown the site where a new dam was being built. Fired with enthusiasm for Stalin's industrialized Russia, and only a few hours before their departure from Moscow, they were presented with a letter which they were urged to sign. It was a confession and, like most proselytes, they were ready to purify themselves. They were guilty of having undertaken literary activity without Party supervision, of having attacked Barbusse outside the organs of the Party, of having criticized the Party press in Surrealist reviews, of having used a facetious tone in the postcard written to the St Cyr cadet; they should reject all idealistic thought, especially Freudianism, they should commit themselves to struggle against counter-revolutionary Trotskyism, they should abjure Breton's Second Manifesto, and they should submit all their literary production to Party supervision. They signed. The victory of Surrealism at Kharkov had been transformed into a crushing humiliation.

Breton was dumbstruck. Aragon had put his signature to what was nothing less than a betrayal. The language of the text was imprecise but for that very reason was more odious since it could be interpreted to the satisfaction of every enemy. To have had to submit their writing to the Party for its approval would place the Surrealists on the same level as journalists working for *L'Humanité*, many of whom were probably not subject to such discipline. It was difficult to

RIGHT Hans Arp: *Bell and Navels*, 1931
(Museum of Modern Art, New York, Kay Sage
Tanguy Fund).
BELOW Alberto Giacometti: *The Palace at
4 a.m.*, 1932–3 (Museum of Modern Art, New
York). Giacometti's constructions in wood,
glass, wire and string stimulated other
Surrealists to make objects charged with
unconscious significance.

believe that the Party censorship would let through more than a small fraction of what appeared in the Surrealist review. Freud's psychoanalysis was as indispensable to the Surrealists as Marx's philosophy was to the Communists; the Russians, however, were no longer willing to acknowledge the psycho-analyst's work. Yuri V. Kannabikh's *History of Psychiatry*, published in 1929, was the last statement in favour of Freud to appear in Russia. Now his name and his work were ignored. The omission was symptomatic of the way in which science in Russia would be re-drafted by Lysenko during the thirties according to 'the Party line'. To accept such propaganda was a dishonourable suspension of the intelligence. At Rue Fontaine the full weight of what Aragon had done was brought home to him immediately on his return from Russia and early in December he and Sadoul produced the pamphlet *Aux Intellectuels Révolutionnaires* in which they recanted most of what their Moscow letter contained. But Breton was irked by Aragon's need to justify himself; he came back from Russia a compromised Surrealist, part of whose mind still lingered by the Dnieprostroi dam.

'Never before in the cinema', said Léon Moussinac writing about *L'Age d'Or* in *L'Humanité* of 7 December, 'or with such vigour, such scorn of the "conventions" and of bourgeois society and its appurtenances – the police, religion, the army, morality, the family, the state itself – had one been so assailed by blows from head to foot.' Moussinac's glowing review of Buñuel's film was probably conceived in knowledge of the letter which Aragon and Sadoul had signed in Moscow; but he would have been unaware of their recantation which only appeared a few days after the review had been printed in *L'Humanité*. From 28 November the film was shown at Studio 28 in Rue Tholozé and the Surrealists had made the occasion into a demonstration of the movement's strength. Surrealist books and paintings were exhibited in the foyer and a pamphlet had been issued hailing the film. Such a self-congratulatory stance, however, provoked the forces of reaction. Léon Daudet launched an assault on *L'Age d'Or* in the columns of *L'Action Française*. On 3 December youths of the Patriots' League and the Anti-Jewish League attacked the cinema during a performance. The screen was slashed and the paintings and books on display in the foyer were damaged or stolen. Projection of the film continued for a few days in the shattered cinema and then Chiappe ordered its confiscation on the grounds that it was an incitement to riot. The Radical deputy Gaston Bergery, Aragon's friend, appealed in the Chamber on behalf of the film but to no avail. The Vicomte de Noailles was aghast at the reception accorded *L'Age d'Or*. Apparently there was a threat of excommunication which he barely managed to avert by appealing to influential friends. Etienne de Beaumont rebuked him for sponsoring such blatant atheism, but perhaps the hardest retribution to bear was his expulsion from the Jockey Club. A licence was not granted for the exhibition of another film financed by the Noailles, Jean Cocteau's *The Blood of a Poet* which would not be seen by the public for over a year.

Against a background of tumescent Fascism in France as well as in Germany, the Surrealists saw with dismay the mounting opposition to themselves within the ranks of Communism. The prospect of any revolution, political or intellectual, was rapidly receding. During 1931 the rumblings which had started at Kharkov went on as, from month to month, Aragon tried to re-establish himself with the *PCF* on the one hand and Breton on the other.

BELOW Gaston Bergery, the Radical-Socialist deputy who was a friend of Aragon's.

Thanks to his obeisance in Moscow he was re-admitted to the Party, but the Surrealists waited in vain for any clear signal of his wholehearted support for the movement. It came as a relief when the opportunity occurred for direct co-operation between the Surrealists and the *PCF*. In May 1931 the Exposition Coloniale was opened. Temples and pagodas rose like mushrooms in the Bois de Vincennes. There were pavilions representing the Imperialist powers who were eager to show off the blessings of their paternal rule on the hundreds of millions of their happy subjects. With apparent pride they displayed the products manufactured from raw materials stolen from the indigenous peoples. Music, dancing, fireworks and exotic spectacles were provided to lull the consciences of the less sceptical. Antonin Artaud was shamelessly thrilled by a performance of Balinese dancing on the terrace of the Dutch pavilion, but the Surrealists were disgusted by the whole event. In *Le Surréalisme au Service de la Révolution*, a speech made by Marshal Lyautey at the close of the exhibition was quoted. The former governor of Morocco spoke of the destructiveness of European wars; in contrast, colonial wars were 'constructive, pacifying and civilizing'.

There was an Anti-Imperialist League sponsored by the *PCF* and it was suggested that the Surrealists should combine with it in preparing another 'Colonial Exhibition'. The *PCF* put at their disposal the Russian pavilion from the 1925 Exhibition of Decorative Arts. A wooden building, designed in the Constructivist style by the Vesnin brothers, it had been moved to a site belonging to the Association of Trade Unions of the Seine on Avenue Mathurin-Moreau. 'The Truth About the Colonies', as the exhibition was called, opened its doors three months after the Vincennes show had ended. The primitive art of the colonies was contrasted with Western culture. From Breton's and Eluard's collections there was a display of Oceanic, American Indian and African art. In the same area, designed by Tanguy, the 'fetish objects' of the Imperial powers were shown; Eluard and Aragon had gone to Rue Saint-Sulpice and bought a collection of mass-produced devotional ornaments. Aragon had also scoured Paris for records of Polynesian and Indian music which were played over loudspeakers alternately with the most banal rumba melodies.

In December a new number of *Le Surréalisme au Service de la Révolution* appeared. Eluard provided his usual commentary on current events, describing among other idiocies an evening at the Casino de Paris where Paul Doumer, the President of the Republic, and a bevy of politicians, generals and other worthies including Madame Chiappe had attended a gala performance of the revue *Paris which Glitters*. When Mistinguett dedicated a song to the prefect's wife, the theatre resounded to thunderous applause. Eluard regretted that so much talent and labour should be employed to satisfy 'the lovers of beauty, the collectors of vignettes from the Bank of France'. He went on: 'M. Doumer smiled at the Casino de Paris as Poincaré-the-War laughed in the cemeteries.... While millions of workers suffer from hunger, while those who defend them are in prison, while the armies of the Republic massacre the colonial peoples, the masters *are amused*.' Another society event which enraged the Surrealists was the première of René Clair's film *A Nous la Liberté*. One of their own number, Albert Valentin, had assisted in its production and privately admitted that the film was counter-revolutionary, but he could not be persuaded to disavow it in public. It is the story of the owner of a gramophone

OPPOSITE Salvador Dali: *Soft Construction with Boiled Beans: Premonition of Civil War*, 1936 (Philadelphia Museum of Art, Louise and Walter Arensberg Collection).

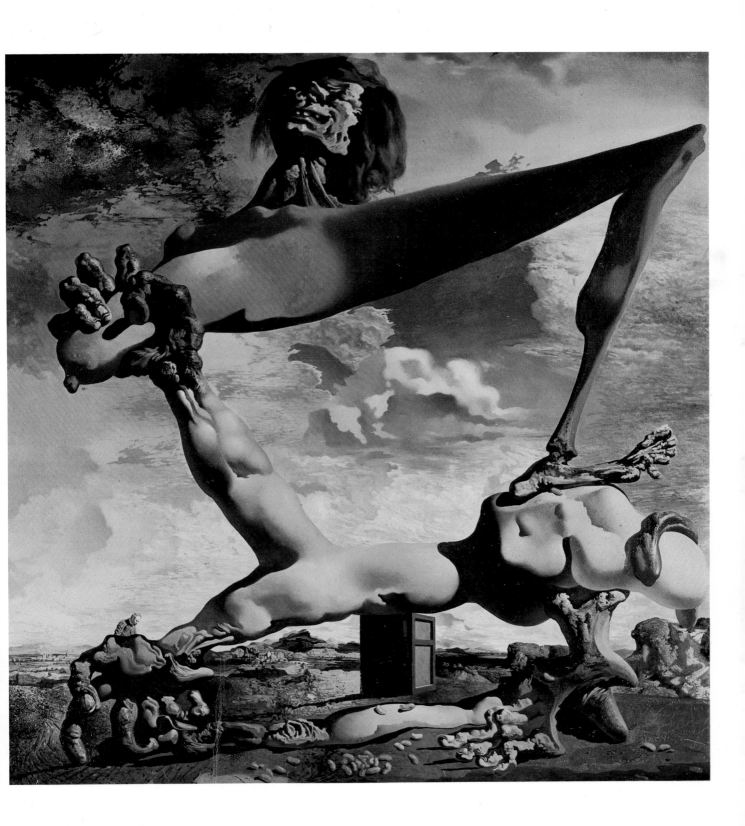

Valentine Hugo, photographed by Man Ray.

factory, who decides to escape for a while, leaving the plant in the hands of his employees. Anarchy reigns: the workers spend the time fishing, the office-girls go dancing. Nevertheless, the unattended factory goes on churning out gramophones. The point of the film is misty beyond an element of whimsical satire, but the piece might have seemed callously superficial at a time when mass-unemployment was spreading through the industrialized world. Crevel and Eluard lamented its friendly cops and office-girls turned out *à la mode*. Their article in *Le Surréalisme au Service de la Révolution* was entitled 'A Commercial Film'. They regretted that its première was given at The Mirácles cinema which was managed by the board of the 'fascist' journal *L'Intransigeant* and they quoted a newspaper report to the effect that the affair was attended by 'several princesses, various generals and ambassadors, M. Becq de Fouquières, Mme Chiappe, M. Rappoport, etc, etc.'

In January 1931 Cocteau's film *The Blood of a Poet* was shown at the Théâtre du Vieux-Colombier. The Surrealists found in this film as much to deplore as they had in Clair's satire. The plagiarism of Buñuel was self-evident and the whole film was larded with pseudo-Surrealist gimmicks. It was, as might be expected from Cocteau, frivolous. The treatment of themes such as love and death was outworn and the novelty of the technical means at Cocteau's disposal was largely lost on him. Cocteau at the time had become a greater annoyance than ever to André Breton. Valentine Hugo, who was living alone at 9 Rue Vignon, had become Breton's mistress the year before and now Cocteau took a flat on a lower floor in the same house. Breton had to pass his door on the way up to see Valentine. Considering the attachment Valentine still felt for Cocteau, who had been such an inspiration to her when she had first entered the Parisian world of art, the proximity of their apartments must have injured her relationship with Breton. First Berl, then Cocteau: Breton perhaps regretted that being the leader of Surrealism brought such a host of foes. Any emotional satisfaction, apparently, would be crushed in the coils of serpentine intrigue and calumny. Eluard, however, was now deeply attached to Nusch, and Aragon, who was the only friend of Breton's who might have been able to console him, was kept hidden away by Elsa. His article on Lewis Carroll in *Le Surréalisme au Service de la Révolution* written at this time took, to some extent, the part of an exorcism. It had been Nancy Cunard who had inspired his enthusiasm for the creator of Alice, and the Hours Press which had printed and published his translation of *The Hunting of the Snark*.

In November 1931 a very different work from the hand of Aragon had been published in the review *La Littérature de la Révolution Mondiale*. The long poem *Front Rouge* was a gauge of the depth to which Aragon had been impressed by his experiences in the Soviet Union. It describes a proletarian rising in Paris and is interspersed with references to actual political events, such as the Allies' intervention in the Russian civil war, which appear like news flashes on the fabric of the poem. The technique had been used by Mayakovsky, whose poetry the Surrealists had admired for its revolutionary ardour rather than its literary adroitness. *Front Rouge* was a revolutionary act itself: 'Kill the cops! Kill the cops!', cried the poet and he called on Communists to shoot contemporary politicians, naming Blum, Boncour, Frossart and Déat. In January he was indicted and charged with 'demoralization of the army and of the nation'. So began 'the Aragon affair' which had hung like a stormcloud on the horizon since his return from Russia.

Between allegiance to his friend and allegiance to the Communists Breton did not take a moment to decide. He immediately started collecting signatures to a petition in which he denied the authorities any right to prosecute a poet on the basis of lines of verse taken out of their context. In effect he was denying that the poem was a direct incitement to revolt. But that was exactly how the *PCF* wanted Aragon to have intended it because he would thus have written a piece of purely circumstantial literature, in breach of elementary Surrealist ethics.

Aragon himself must have been divided in his mind. He cannot have cared very much for Breton's approval because he would have known that it was precluded by the nature of the poem. Elsa's strength not only gave him the courage to defy Surrealism but also probably bred in him a devotion to the memory of Mayakovsky, who had killed himself for the love of Elsa's sister,

FOLLOWING PAGES
LEFT René Magritte: *The Therapeutist*, 1937 (Urvater Collection, Belgium).
RIGHT Salvador Dali: *Metamorphosis of Narcissus*, 1937 (Edward James Foundation).

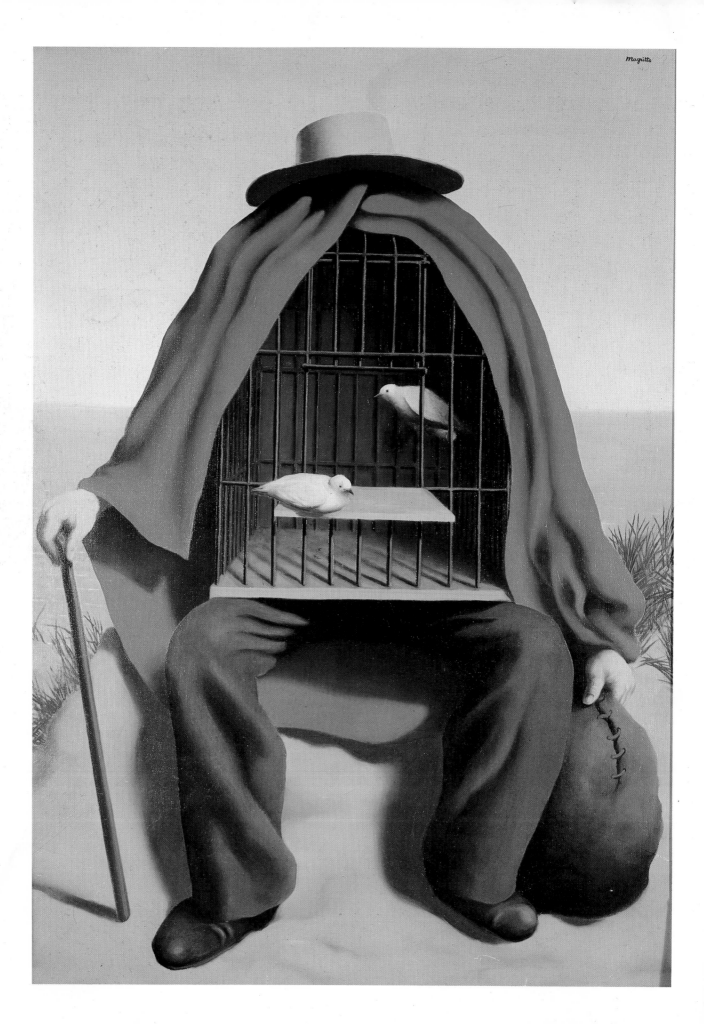

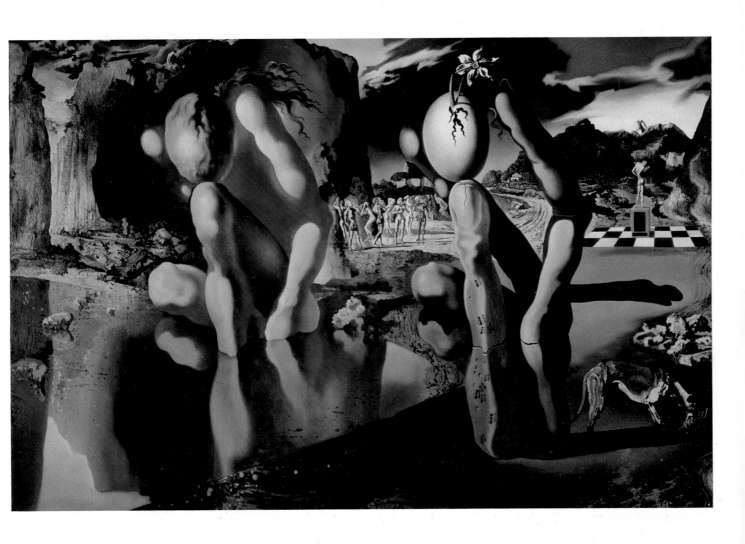

and whose personality had, anyway, made a deep impression on Aragon. On the other hand he cannot have anticipated legal proceedings and the possibility of five years in prison, the maximum sentence for his offence, with anything approaching equanimity; nor would he have found it in his heart to repudiate his old friend's efforts to save him from such a fate.

Within a few days Breton had collected over three hundred signatures to his petition on Aragon's behalf. 'We protest', ran the words of this document, 'against this attempt to interpret a poetic text for judiciary ends, and demand the immediate cessation to the prosecution.' Picasso, Braque, Léger, Matisse, Le Corbusier, Brecht, Thomas Mann and Federico Garcia Lorca all signed the petition, but many would not. Those who refused generally thought that Aragon should accept responsibility for a poem which was evidently an act of faith, or they resented his attack on 'social traitors' and his demand for the assassination of Léon Blum. Men like Gide and Romain Rolland, of a generation which remembered the Socialists as the party of the extreme Left and Jaurès' name at the head of *L'Humanité*, were not inclined to support a Comintern hardliner in peril. But Signac did offer to harbour Aragon at his house in Brittany or even, if necessary, to take him across the Channel on his own yacht.

Neither Gaston Bergery nor any other of Aragon's friends were able to use political influence to have the charges dropped. On the other hand it was palpably a prosecution the embarrassment of which the authorities would be happy to forego. It became clear that the Aragon affair's greater significance lay in its bearing on the old struggle between Surrealists and the *PCF*. Breton felt that it was important to express more clearly his opinion on the matter and he issued the pamphlet *La Misère de la Poésie* (The Aragon Affair before Public Opinion). Here he strongly put forward the argument that the Surrealist writing poetry followed the prompting of his unconscious and was not therefore responsible for the sentiments or instructions which might appear in his text. He had to admit, however, that *Front Rouge* was not entirely a Surrealist poem. Its circumstantial reference, its political didacticism hardly liberated it from the literary chains which Surrealism was supposed to have shattered. In this pamphlet Breton, perhaps from grief over Aragon's departure from the group which he was beginning to feel was inevitable, turned on those who had plagued the movement for so long, those who had been unable to accept the support of Surrealism without demanding a total commitment – the Communists. In *La Misère de la Poésie*, Breton mercilessly exposed the intellectual buffoonery which characterized the hacks of *L'Humanité*. Breton had been particularly incensed by an article which had appeared in that newspaper on 9 February:

We cannot approve of the stand of those intellectuals who fail to stir when suppression strikes the workers and who move heaven and earth when it skims their precious persons.... The Surrealist position is a let-down pure and simple. Instead of defending the poem's content, they beat a retreat all along their 'Red Front'. Their revolution is only verbal.... The bourgeoisie, in its suppression of the revolutionary proletariat, sometimes strikes those who are clinging by chance to the working-class movement. Such is the significance of the Aragon affair.

The Communists were determined that no kudos should be attached to Surrealism in the pillory of judicial censorship. They were also anxious to

establish their own right to censor Surrealist texts. In the current issue of *Le Surréalisme au Service de la Révolution* there appeared a 'Rêverie' written by Salvador Dali in which he recounted in graphic detail a masturbatory daydream the object of which was Dulita, an eleven-year-old girl. Aragon, Sadoul, Unik and Alexandre, the Surrealists most involved in *PCF* affairs, were summoned before the literary arbiters of the party and asked why such decadent pornography was allowed to appear in their review. When Breton heard about this inquisition his anger, so long restrained, erupted in *La Misère de la Poésie*.

Aragon could sit on the fence no longer, and Elsa was already on the opposite side to Breton and Surrealism. On 10 March Breton read with consternation in his *L'Humanité*: 'Our comrade Aragon has informed us that he had nothing to do with the publication of a pamphlet entitled *La Misère de la Poésie* signed by André Breton. He wishes to make it very clear that he disapproves of the entire pamphlet and the clamour that it sets up over his name. And he condemns as incompatible with the class struggle and as therefore objectively counter-revolutionary, the attacks that are contained in it.' Maxime Alexandre has described how he went at apéritif time to the Cyrano that day and was surprised to see so many of the Surrealists there. Only Aragon, Sadoul and Unik were missing. He was handed a text affirming exclusive submission to the discipline of the Surrealist movement. Would he sign? No, he would not. 'Your place is no longer with us', Breton declared.

In March another pamphlet was issued from 42 Rue Fontaine. Breton's sadness could be read between the lines of *Weathervane! The End of the Aragon Affair*, lines which set Aragon outside the Surrealist movement. Aragon, Sadoul, Alexandre, Unik, and Buñuel now dedicated their talents to Communism. They would have backward glances towards Surrealism which remained the major cultural influence on much of their work, but they had forever alienated themselves from the movement which Breton refused to sacrifice to ideological dogma. Despite harsh words written on both sides the uneasy alliance between Surrealists and Communists continued. They shared an inveterate loathing of the bourgeois state and its institutions, church, army and high finance. Aragon became editor of a review called *The Anti-Religious Struggle*, while Eluard and Crevel continued to make their scathing comments on the latest follies of the national hierarchy. A project, which had been growing in Breton's mind, of a union of revolutionary artists was developed by the French Communists. In January 1932 *L'Humanité* announced the formation of the Association des Ecrivains et Artistes Révolutionnaires (*AEAR*) and when the dust of the Aragon affair had settled the Surrealists were admitted to membership. In Russia Stalin had dissolved the Association of Proletarian Writers and it became permissible, until a new orthodoxy was introduced, to acknowledge the presence, even the value, of heretics. Breton and the other Surrealists found themselves writing political tracts and judging workers' poetry competitions.

The *PCF* had continued to decline in strength and, despite the poor economic situation, won only ten seats in the Chamber at the 1932 elections. The effects of world recession had only begun to pinch the Frenchman in 1931, partly because the harvest had been so bad the year before. But gradually foreign investment had dwindled and the commodity surpluses from which America, Britain and Germany had been suffering for years were experienced

FOLLOWING PAGES
LEFT Yves Tanguy: *Days of Delay*, 1937 (Museum of Modern Art, Paris).
RIGHT Paul Delvaux: *Phases of the Moon*, 1939 (Museum of Modern Art, New York).

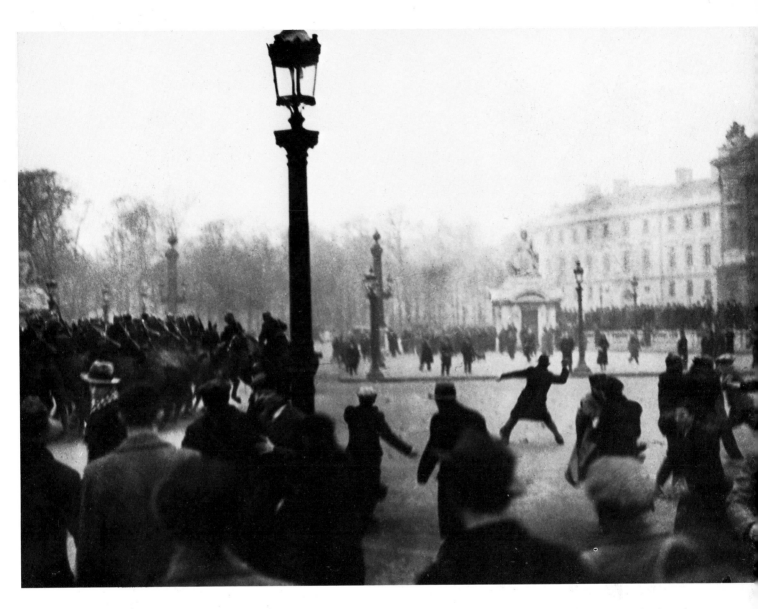

ABOVE Demonstrators clash with mounted
gendarmes in the Place de la Concorde, 1934.

OPPOSITE The Stavisky affair. A cartoon by
J. Sennep from *Le Rire*, 1934.

FOLLOWING PAGES
LEFT Salvador Dali: *Lobster Telephone*, 1936
(Collection E.F.W. James Esq.).
RIGHT René Magritte: *The Good Adventure*,
1939 (Edward James Foundation).

by the French. They brought unemployment and destitution. The agricultural
vote, still so massive in France, went to the Radicals and Socialists. Herriot was
Premier again but, as had happened in 1924, he found it impossible to manage
the deputies on whose support he relied. He had to resign and was followed by
a succession of Radical and Socialist Premiers, none of whom succeeded in
either arresting the economic decline or winning public approval. With the
right-wing leaders, not only Maurras and Daudet but also younger men who
noted with admiration and approval the emergence of Nazi Germany in 1933,
baying for a more authoritarian form of government, the situation became
inflammable. At the beginning of 1934 it burst into flames and Serge Stavisky
was the spark.

Stavisky was a swindler who had several times been in the custody of the
police but who had never been charged, a fact which, when his career
culminated in a national scandal, raised an unpleasant smell of complicity. In
1933 he opened a number of pawnshops in the vicinity of casinos, a legal if
cynical enterprise which, Stavisky being Stavisky, was only the pretext for a

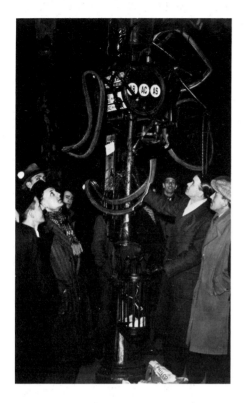

ABOVE A bus-stop decorated with policemen's bicycles in the Place de la Madeleine during the strikes of early 1934.

OPPOSITE Three days after the right-wing demonstrations of 6 February 1934 the workers marched in protest. '200 criminals' refers to the Regents of the Bank of France.

RIGHT The Jeunesses Patriotes demonstrating in Paris, February 1934.

BELOW Jean Chiappe (left), Prefect of Paris police, and Edouard Renard, Prefect of the Seine. A photograph from *L'Illustration*, 10 February 1934, captioned 'Two Great Paris Prefects'.

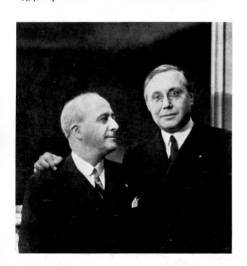

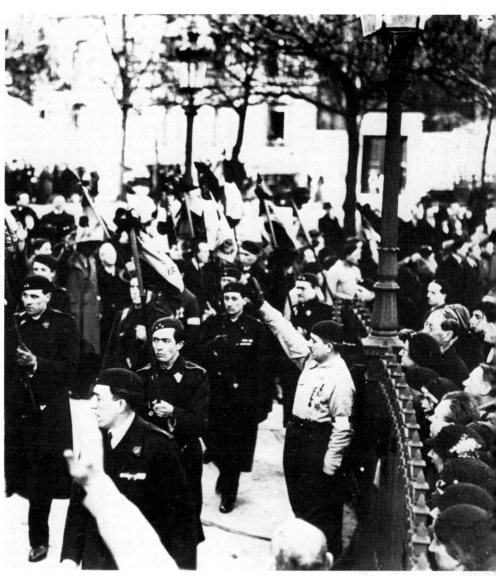

highly illegal issue of an enormous number of shares in the business. It was so outrageous a fraud that the police, however unwillingly, had to act. In December a warrant for his arrest was issued. The wanted man was tracked down to a lair in the French Alps where he shot himself. It was suggested that he had been murdered by the police to avoid an investigation which would have been embarrassing to them and to several ministers. Under pressure from deputies of the extreme right who hated the Jews, and Catholics among the Moderates who suspected freemasonry, the Premier Chautemps resigned. Daladier took his place. Then Prince, the police official who had been put in charge of an investigation into Stavisky's affairs, was found dead beside a railway line. He had been poisoned and tied up. According to the right-wing press, a conspiracy involving the Radicals and the Sûreté began to emerge. Chiappe, who as head of the Paris Préfecture was the traditional enemy of the Sûreté and whose reactionary politics made him no friend to Radicals, was suspected of organizing street demonstrations against the government. Daladier dismissed him. The fulminations from the Right were stunning, but

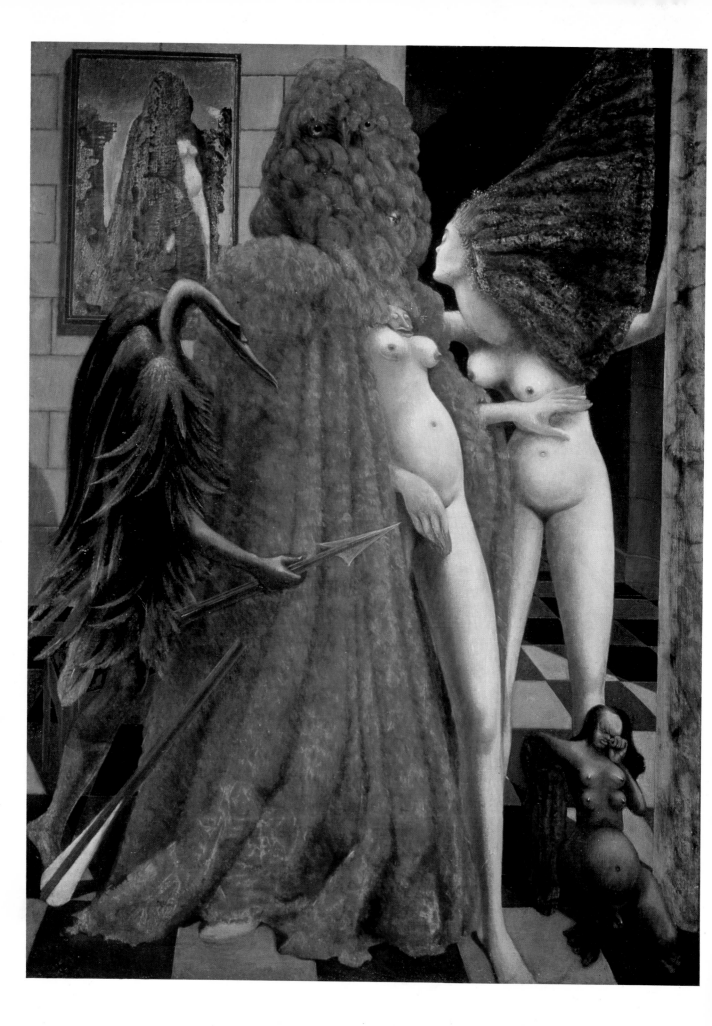

OPPOSITE Max Ernst: *The Robing of the Bride*, 1939 (Solomon R. Guggenheim Museum, New York).

RIGHT Pickets relishing their role during the general strike of February 1934.

rose yet higher when Daladier compounded his errors by also dismissing the director of the Comédie Française, apparently because he had just staged *Coriolanus*, a drama which implicitly menaced the democratic institutions of the Third Republic. Daladier, short on tact, appointed in his place the head of the Sûreté. A level of comedy had been reached at which tragedy had to ensue. On 6 February a *coup d'état* was attempted.

A parliamentary committee set up in 1947 to investigate the events of 6 February 1934 reported that 'it was not a question of a spontaneous demonstration but of a genuine insurrection, minutely prepared'. There were a number of Fascist groups in France during the early 1930s who had the power to organize the putsch. Action Française had been weakened by the Papal interdict of 1926 and anyway many of its adherents had joined the more avowedly Hitlerian movements. There was the League of Patriots who had sacked the Studio 28 cinema when *L'Age d'Or* was being shown; there were the Jeunesses Patriotes in their blue berets and blue macintoshes, financed by the champagne millionaire Pierre Taittinger; there were the Francistes, led by Marcel Bucard, strongly anti-semitic and drawing their strength from the working-class districts of Paris. François Coty had founded the Solidarité Française and Maurice Déat, a Socialist whose execution Aragon had demanded in *Front Rouge*, had called for a revolution to overthrow the existing plutocracy, even if it inaugurated Fascist rule in France. Among the veterans' organizations, particularly Colonel de la Rocque's Croix de Feu, were many whose conservatism was tinged with support for aspects of a Fascist programme.

Veterans comprised the majority of the huge crowd which gathered in the Place de la Concorde on the evening of 6 February. There they were hemmed in by mounted police. Across the Seine a phalanx of the Croix de Feu approached the Chamber from the rear, but these too found their way blocked by the police. The Communist veterans' organization marched up the Champs Elysées. The mob in the Place de la Concorde attempted to sack the Ministry of Marine. Then they stormed the bridge. The police repulsed them, but they came on again. There were shots. Night fell and the battle of the Pont de la

RIGHT *Cadavre exquis* composed by André Masson and Yves Tanguy in 1925 (Private Collection).

BELOW Salvador Dali: *Fantastic Beach Scene*, 1936 (Edward James Foundation).

OPPOSITE Max Ernst: *The Blind Swimmer*, 1934 (Museum of Modern Art, New York, Gift of Mrs Pierre Matisse and Helena Rubenstein Fund).

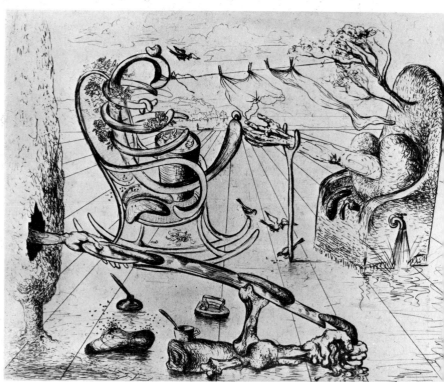

226

Concorde continued. Within the Chamber, the deputies of the Right howled and the Communists sang 'La Marseillaise'. A division was called; the government won. Frightened deputies slipped away into the darkened streets. The mob made one or two more assaults but gradually the strains of 'La Marseillaise' weakened and the rioters went home to bed. There had been fifteen deaths, over a thousand injuries, and the forelegs of several police mounts had been shredded by razor-blades.

If it had been an organized rebellion, it had been badly organized, and had evidently lacked the co-operation of Chiappe who could easily have undermined the resistance of the police. Nevertheless, it brought home to intelligent men the fragility of their freedom, and within a week the pamphlet *Appel à Lutte* (Appeal to Struggle) appeared bearing the Surrealists' signatures among others. The 'appeal' was to intellectuals to form a united front and maintain constant vigilance against Fascism. Breton and his friends found their names alongside those of old friends like Henry Jeanson as well as old enemies like Marcel Martinet. But if the attempted putsch had drawn the Surrealists closer to their comrades of the *PCF* the chasm between them was soon seen again to be gaping as widely as ever. In April the government refused Trotsky a permit to live in France and inevitably Breton wrote a protest, *The Planet*

Book-burning in Nazi Germany, 1933.

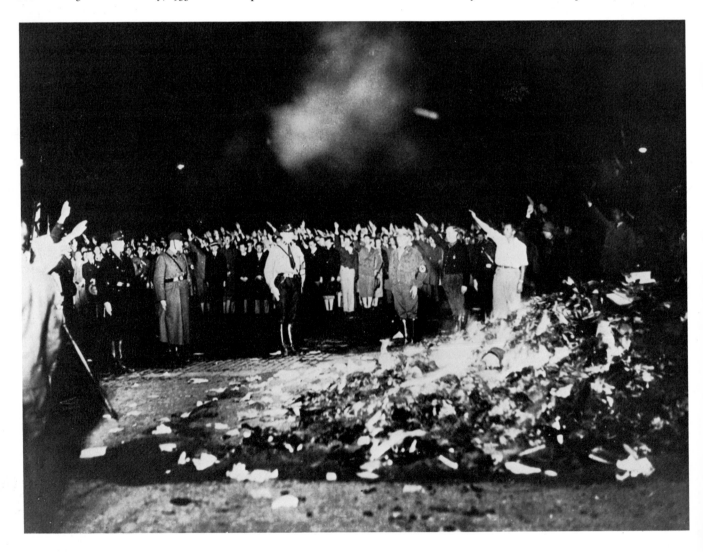

ABOVE A photograph of M. Parain, the
journalist, reproduced in *Le Surréalisme au
Service de la Révolution*.

BELOW Paul Eluard gathered a large collection
of postcards: this erotic lampoon was
reproduced in *Minotaure* no. 3–4, 1934.

without Visas. The *PCF* could hardly have endorsed the opinion that Trotsky
had formulated 'a permanent reason for us to live and to act'. Events of the
previous year had exacerbated fundamental differences of opinion. In *Le
Surréalisme au Service de la Révolution* a letter from Fernand Alquié, who was
not a Surrealist, had been published criticizing the Soviet film *The Road of Life*
for its call to hard work and conformist morals. Angrily the *PCF* watchdogs
had demanded the editor's disavowal, which Breton had refused. He had
no intention of suspending his or anybody else's intellectual faculties in the
interests of party discipline. It had been only a month after the Nazis' book-
burning that Alquié's letter had appeared and Breton had long known the
importance of maintaining intellectual debate, allowing criticism and not
seeking to suppress ideas. He had known it when he had recognized in Dada a
mirror image of Mussolini's anti-intellectual tyranny; then he had denounced
Dada. He had known it when the *PCF* had reprimanded the Surrealists for the
publication of Dali's 'Rêverie'. He would not have contemplated submission to
the Party whose intellectual validity was becoming more and more suspect. In
1930 the Surrealists had reported with dismay the appointment of M. Parain, a
former editor of *Détective*, to take charge of the book page in *L'Humanité*.
Détective had first appeared in 1928, directed by George Kessel, whose brother
Joseph Kessel had run a literary journal with Horace de Carbuccia, Chiappe's
brother-in-law; subsequently Carbuccia had become editor of *Gringoire*, a
journal which expressed the most virulent Fascist opinion. That a book
reviewer on the staff of *L'Humanité* had formerly been associated with this
network of Fascist hacks had appalled Breton and his friends.

A new review sponsored by the *AEAR* appeared the same month, June
1933, that the Surrealists were expelled from the association for their defiance
over Alquié's letter. *Commune* was edited by Barbusse, Gide and Rolland and it
is a measure of Aragon's apostasy that he was working on the review as
secrétaire de rédaction. But as Aragon was immersing himself ever deeper in the
literature of the Party, so the Surrealists at the same time were abándoning
altogether the forum of political literature. *Le Surréalisme au Service de la
Révolution* had made its last appearance a month earlier. The financial crisis
had already accounted for several organs of the European avant-garde:
Adrienne Monnier's *Commerce*, Kurt Schwitters' *Merz*, Theo van Does-
burg's *De Stijl*, Herwarth Walden's *Der Sturm*. The sumptuous *Minotaure*,
however, directed by Edouard Tériade and published by Albert Skira, began
publication at the same time and soon the Surrealists were contributing
to it in force. It was of a very different format to the Surrealists' reviews, and
comprised articles on literature, art, psychology and anthropology and repro-
duced the work of a wide range of Ecole de Paris artists. Of politics or current
events there was hardly a whisper among its pages.

In *Minotaure*, Surrealism flourished. Freed from the exigencies of political
commitment it was self-indulgent, wallowing in its dearest obsessions. Michel
Leiris wrote on Dogon funeral dances. Breton described the recent work of
Picasso, Eluard discussed the poetry of Baudelaire. In the fifth issue, which was
published in May 1934, there was a long review by Jean Levy of *King Kong*, a
film which was hailed as a Surrealist masterpiece. With the advent of sound,
the cinema lost much of its attraction for the Surrealists. Besides *King Kong*
and *L'Age d'Or* their enthusiasm was limited to the films of Marlene Dietrich
and Henry Hathaway's *Peter Ibbetson*, based on George du Maurier's story of a

The Surrealists acclaimed *King Kong*, a film which seemed to express the most primitive sexual desires.

The Papin sisters, before and after the ordeal of their servitude. Photographs reproduced in *Le Surréalisme au Service de la Révolution*.

convict whose dreams of his loved one mysteriously merge with reality. Dali developed his 'paranoia-criticism' in *Minotaure* with a Rabelaisian analysis of Millet's *Angelus*, and he contributed a piece on Art Nouveau architecture, with illustrations of Gaudi's confections in Barcelona and Guimard's exotic Métro stations. Dr Jacques Lacan wrote an article describing 'the psychiatric concept of the paranoiac forms of experience' and another on 'motives for paranoiac crime' in which he analyzed the Papin sisters. The two servant-girls had brutally murdered their employers who had consistently persecuted them. Their crime had already been condoned by the Surrealists in the pages of *Le Surréalisme au Service de la Révolution*; photographs of them before and after the murder clearly illustrated the paranoiac state to which their cruel treatment had reduced them. The Surrealists also justified the crime of Violette Nazière. She had been raped by her father when she was fifteen; she became a prostitute, in the hands of a pimp who was a supporter of Action Française; she contracted syphilis which she passed to her father and he in turn passed it on to her mother. She killed her father with an overdose of the medicine they were all taking for their condition. The Surrealists composed a pamphlet denouncing her long prison sentence; it had to be published in Belgium. Dali's contribution to it was a 'paranoiac portrait of Violette Nazière'. Dali's ambivalent attitude to Nazism and his erotic dreams about Hitler began to rile the Surrealists.

In August 1934 André Breton married Jacqueline Lamba and for ten years or so, until her habit of leaving taps running began to strain his nerves, he would enjoy emotional serenity. Even the sworn enemy of family life would have the pleasures of parenthood to compensate for the aches and anxieties of middle age. The same month the Bretons' wedding was celebrated, the *mésalliance* between Surrealism and Communism came a step nearer to total rupture. At the First Congress of Soviet Writers, Andrei Zdahnov promulgated the decree of social realism, a philosophy which cut the Gordian

knot of art *vis à vis* politics with the crude assertion that art's only value was as political propaganda. It was an aesthetic as totalitarian as, though quite opposite to, the classical-cum-Teutonic idealism of Hitler's Germany. In December, Breton's article 'The Great Poetic News' was published in *Minotaure*. There he discussed the conflict between poetry and utility and stressed the poet's duty to reveal every nuance of social and psychological life. He still favoured, he said, automatism, which gave the poet's voice the inflections of authentic experience, and he presented as an example a story and some poems by the fourteen-year-old Gisèle Prassinos who wrote unconsciously.

Not only had the Communists abdicated any title to intellectual credibility, they were also in the process of relinquishing their revolutionary authority. Following directives from Moscow they began paying court to the Socialists. Stalin was aware that Nazi Germany posed a real threat to Russian security and the line given the *PCF* to follow was one of reconciliation with the Socialists and the establishment of a left-wing power bloc which would work for rearmament and détente with the Soviet Union. Even Jacques Doriot, one of the leaders of the *PCF*, could not accept such a travesty of the revolution and left the Party. 'The great Marxist dream', he said, 'is bankrupt in Russia and elsewhere.' He founded the Partie Populaire Française (*PPF*) which was

BELOW In 1934, André Breton married Jacqueline Lamba, who appears BELOW RIGHT as the knave of hearts, photographed by Man Ray.

Pablo Picasso: *Two Figures on a Beach*, 1933
(Museum of Modern Art, New York).
Picasso's art comes close to Surrealism during
the early thirties, when he also wrote automatic
poetry.

'both national and social'. Drieu la Rochelle was one of the first to join it. In 1933 Breton had written: 'If you want peace, prepare for civil war.' The Communists on the contrary were making it their business to make France another armed camp. In May 1935, a Franco-Russian treaty was signed and the *PCF* rallied to the support of French foreign policy. The next month the Congress of Writers in Defence of Culture was held in the Palais de la Mutualité. It was not sponsored by the Communists but it was organized by a committee whose members had always sympathized with the Russian revolution. Among them were Barbusse, Gide, Heinrich Mann, Bertholt Brecht, Aldous Huxley, Louis Aragon and Sinclair Lewis. While the Congress was in session Italy was preparing to invade Abyssinia and fifteen thousand French Fascists marched through Algiers while aeroplanes circled overhead saluting them. 'I swear that within a month', their leader was reported to have said, 'we shall seize power in France.' Breton asked to be allowed to speak at the Congress, but the request was refused. Not long before Breton, meeting Ilya Ehrenburg in the street, had struck him in the face. The *Izvestia* correspondent had written an article in which he described Surrealism as 'pederasty'. There was no reason why the vaguely liberal Ehrenburg should be allowed to insult the movement any more than the vaguely conservative Claudel. René Crevel appealed to the committee on Breton's behalf but to no avail; even among idealists censorship prevailed. Crevel went home disheartened. In his kitchen he turned on the gas stove without lighting it and laid down beside it. His body was found the next morning.

The Congress proceeded. Aragon read the text of Crevel's speech. Other speakers poured out a torrent of liberal platitudes. Not all confessed as frankly as E. M. Forster how ineffective they felt: 'If there is another war, writers of the individualistic and liberalizing type, like myself and Mr Aldous Huxley, will be

swept away. . . . We have just to go on tinkering as well as we can with our old tools until the crash comes.' In view of Crevel's suicide a concession was made by the organizing committee and Paul Eluard was allowed to read Breton's speech. His message was a warning against the dangers of the Franco-Russian pact: 'It is our responsibility to keep very close watch on the *modalities* of this *rapprochement.*' He expressed his disappointment with the *PCF* who had apparently forgotten their revolutionary function: 'For our part, we refuse to reflect in literature any more than in art the ideological *volte-face* recently expressed in today's revolutionary camp by the abandonment of the watchword "transformation" of imperialist war into civil war.' He was optimistic about Germany and would not be a party to any intellectual suppression: 'We will not work for the asphyxiation of German thought . . . so active yesterday, and from which the revolutionary German thought of tomorrow cannot fail to come.'

The heroic period of Surrealism could be said to have started with Vaché's suicide and ended with Crevel's. Vaché's sheer desperation of finding any meaning to humanity had inaugurated the Surrealists' attempts to transform the world by invoking powers which had been atrophied through centuries of Greek logic and Christian morality. Crevel's suicide was a final curtain falling on the drama of the movement's effort to bring about a revolution by working with the Communists at the level of materialism. When it had become plain that the First World War had changed nothing, Vaché had killed himself; Crevel saw no reason to go on living when there appeared to be no way of marshalling effective opinion against a Second World War.

Salvador Dali: *Paranoiac-Critical Solitude*, 1935 (Collection E. F. W. James Esq.).

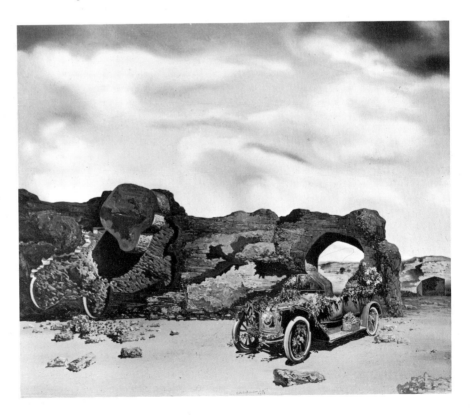

233

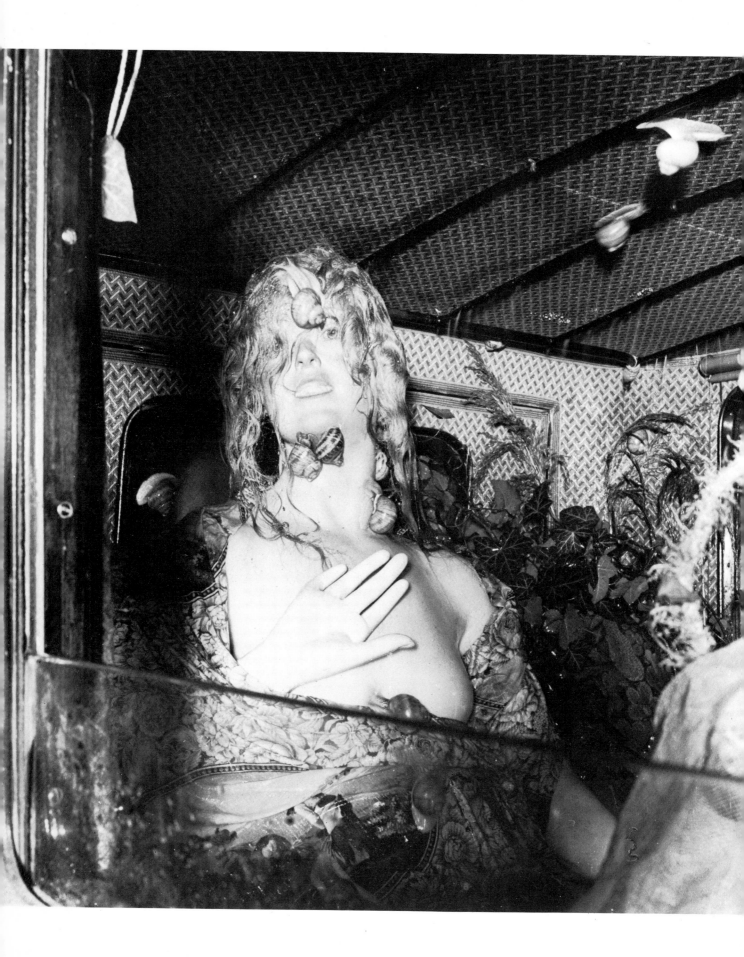

8 Shocking

About the period from 1935 until the outbreak of the Second World War there is an eerie gloom. It is not a depressive gloom because Europe and America, despite economic trouble and the imminence of war, continued to glitter. The bourgeoisie was losing its servants, but not its chic. In every intelligence there was concealed the certainty of the approaching disaster and more effort was expended in making a better job of concealment than in trying to avert the catastrophe. It is difficult to say when the Second World War became virtually inevitable, and harder to know for certain who could have done what to have prevented it. As far as people entertained the notion of its necessity and left the politicians and the generals to do whatever could be done about it, to such an extent Surrealism as an intellectual movement had patently failed. Conceived as an insurrection against a society which accepted, if it did not celebrate, nationalism and militarism, the Surrealist movement had sprung from the forehead of one war and now would be trodden beneath the heel of another.

Surrealism would not end at the outbreak of the Second World War. André Thirion, in his autobiography, pointed out that the students who protested in Paris during May 1968 against the repressive administration of General de Gaulle daubed the walls of the Latin Quarter with more quotations from the writings of André Breton than from Marx or Lenin. During the war some leading Surrealists, Breton among them, took refuge in the USA, and the movement has profoundly affected post-war American culture. In France itself, Sartre and Camus presented, after 1945, a view of revolution which does not accord on all points with Surrealism, but which nevertheless cannot conceal glances, often oblique, in the direction of Surrealist ideas. Much of post-war French literature and painting owes a large debt to Surrealism, as does the modern French cinema. During the sixties and seventies artists throughout the world have acknowledged the influence of the movement. Somehow the material substance of a geometrical abstract painting is beginning to lose the power it used to have over the intellect. 'Psychological' novels, though they are still widely read, are no longer accepted as the most trenchant literature of modern life. The treatment of criminals and the insane is a problem to which, specialists have now realized, the solutions lie many years ahead. Even as science reveals more and more the nature of the universe and of life itself, the conviction gathers strength that science can never restore to man those powers which the shaman and the mage once possessed. To whatever extent the movement has been an influence, it cannot be gainsaid that Surrealism in the twenties and thirties was a portent, and Surrealism today remains an effective cultural force. That the political morality of the movement remains a lesson unlearnt is amply demonstrated by events of the last twenty

ABOVE A procession of Syndicalists marching through Paris in May 1937.
BELOW Léon Blum, leader of the French Socialists, became Premier after the elections of 1936.

years – Suez, Hungary, Prague, Chile. But the intellectual and moral precepts which Breton and the Surrealists formulated have perhaps had something to do with the fact that today voices are raised in protest with greater strength and surer conviction.

The Congress of Writers in Defence of Culture had been the defeat of the Surrealists' hopes of forming an effective intellectual opposition to the political process which would culminate in the Second World War. Within little more than a year of the Congress, Italy invaded and conquered Ethiopia, Germany occupied the Rhineland and the Spanish Civil War started. When Mussolini declared war on Ethiopia in October 1935 over eight hundred and fifty French intellectuals signed a manifesto of solidarity with Italy. A few days later the manifesto of *Contre-attaque*, 'the Battle Union of revolutionary intellectuals', appeared, which was composed by Breton and signed by the Surrealists and some sympathizers, among them Georges Bataille. *Contre-attaque* was a formation which urged the necessity of a proletarian revolution to stem the advancing tide of Fascism, but it was probably not read by a single French worker and the movement was defunct within a few months. In March 1936 Germany occupied the Rhineland, Hitler choosing a moment not long before a general election in France when he calculated the Radical administration was unlikely to take chances by offering military resistance. The elections were won by the

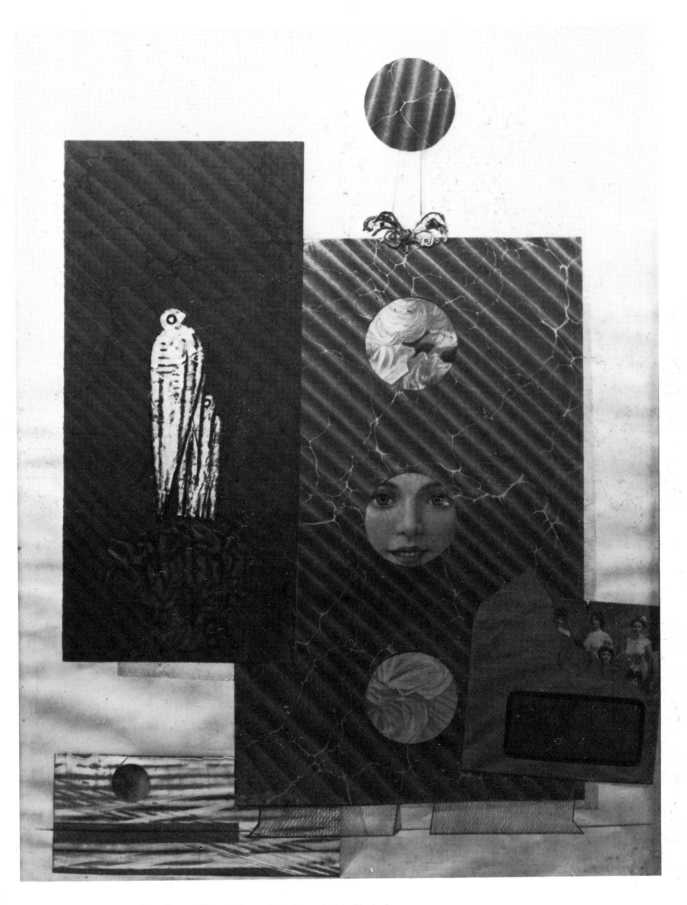

Max Ernst: *The Postman Cheval*, 1932 (Peggy Guggenheim Foundation, Venice).
Ernst created this collage in homage to a Surrealist hero. With obsessive persistence,
over a period of many years, Cheval built his own fantastic palace.

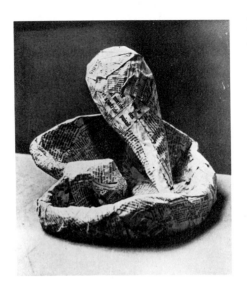

Hans Arp: *Mutilé et Apatride*. An object
reproduced in *Minotaure* no. 8, 1936.

Popular Front, the Socialist-*PCF* alliance, and Léon Blum headed the new
administration. In May and June, immediately after the elections, there was a
wave of strikes which began in the aircraft factories around Paris and spread
through several industries. The strikes were spontaneous. Even the unions
were unaware of them until officials heard on the telephone that the workers
were occupying their factories. The strikers were showing that the left-wing
government for which they had voted must quickly offer them some redress for
low pay and bad conditions. Their leaders were summoned to the Hôtel
Matignon, the Premier's official residence, where Blum negotiated with them.
Shorter hours, better pay and paid holidays were agreed. In the summer of
1937 the bourgeoisie would bewail the mass invasion of their favourite resorts
by the workers and their families; but they knew that the Matignon settlement
had been necessary to ensure that the nation was united, and that the machines
in the armament factories were humming, when another, far more horrible
invasion came across the French frontier. Paid holidays now, not Catholicism,
was the opium of the masses.

At the Galerie Ratton in May 1936 there was an exhibition of Surrealist
objects and in June and July an international exhibition of Surrealist painting
took place in London. From the start internationalism had been one of the
movement's principal aims. It was largely in the sphere of painting, where
there are no language barriers, that Surrealism had gained adherents from
outside France. Max Ernst, a German, had been the first foreign artist to be
closely involved with the group. From Spain, Joan Miró had joined the
Parisian Surrealists, and he had soon been followed by Luis Buñuel and
Salvador Dali. In Belgium, Surrealism had taken root during the twenties and
that country had given René Magritte to the movement. Now, during the years

Joan Miró: *Woman's Head*, 1938 (Pierre
Matisse Gallery, New York).

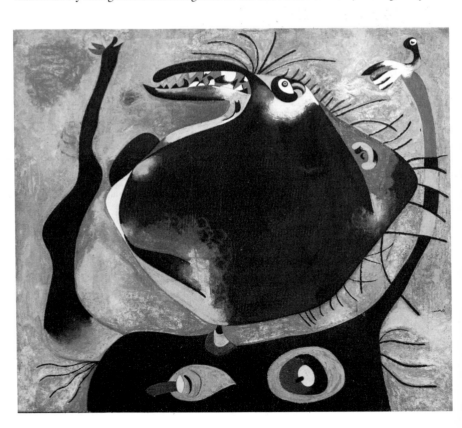

An illustration by Max Ernst for the
complete works of the Comte de Lautréamont,
published in 1938.

ABOVE Max Ernst: *Wednesday, Blood –
Oedipus*, 1934. A plate from *Une Semaine de
Bonté ou Les 7 Eléments Capitaux*.
RIGHT An illustration by Salvador Dali for an
edition of the Comte de Lautréamont's *Les
Chants de Maldoror*, published in 1934.

RIGHT Victor Brauner: *Man in an Interior*, 1937 (Private Collection).

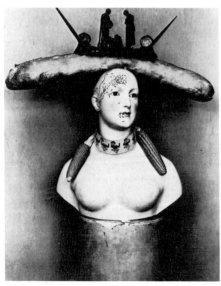

A composition by Salvador Dali, photographed by Man Ray.

leading up to the Second World War, when political action by the Surrealists seemed to have failed, the artistic side of the movement flourished and spread throughout the world. Roland Penrose and David Gascoyne were the first English artists to be in touch with Surrealism and they had formed the nucleus of a group which developed in London during the 1930s. It included Edward Burra the painter, Humphrey Jennings the writer and film-maker, and Edward James who began to form one of the best collections of Surrealist paintings outside France. In 1933 a Czechoslovakian group had been founded and in 1935 an international exhibition had been held in Prague, with Breton and Eluard in attendance. There were also Surrealists in Hungary, Romania, Switzerland and Japan. In 1931, at the Wadsworth Atheneum in Hartford, Connecticut, had been organized the first exhibition of Surrealist paintings in America. The traffic went both ways. Artists came from abroad, perhaps having been fired by the illustrations in *Minotaure*, to work in Paris alongside the French Surrealists. From the Canary Islands came Oscar Dominguez, who in 1935 developed *decalcomanias* which he produced by placing a sheet of paper over another which had been covered in gouache; the colours pressed between the two sheets formed mysterious, chance images. The same year he organized an exhibition of Surrealist paintings in Tenerife, which Breton and Péret

RIGHT A general view of the International Exhibition of Surrealism at the Galerie des Beaux-Arts, 1938. The exhibition was designed by Marcel Duchamp.

BELOW Victor Brauner: *Self-Portrait*, 1931 (Private Collection).

attended. From Austria came Wolfgang Paalen, who introduced *fumage*, the creation of images from the markings of candle smoke on the paper. Hans Bellmer was an artist working in Berlin who first made contact with the Surrealists in Paris during 1936. When his wife died a few months later, he decided to settle in Paris. He brought with him a book of photographs showing dolls which he had made and posed, their limbs and expressions evoking an obsessive eroticism reminiscent of dreams.

In 1933 Victor Brauner, who was born in Bucharest, shared a house in Montrouge with Yves Tanguy and Alberto Giacometti. He asked to be introduced to the Surrealists, and when he had his first exhibition at the Galerie Pierre in 1933 Breton wrote the foreword to the catalogue. His paintings are clearly influenced by de Chirico's, but are invested with a menace and mystery which speak for his Romanian background. Between 1935 and 1938 Brauner was back in Bucharest where he collected a Surrealist group round him. In August 1938, in Paris again, he was the victim of a cruel accident. Two of his friends were arguing; one angrily hurled a glass which by chance struck Brauner in the face, irreparably damaging his left eye. Curiously, he had painted a self-portrait seven years earlier, showing himself with an injured right eye, which would have been the left one as he looked in a mirror.

Salvador Dali admires his creations at the International Exhibition of Surrealism.

A stool by Kurt Seligmann, exhibited at the International Exhibition of Surrealism. It was entitled 'Ultra-furniture'.

In July 1936 the Spanish Civil War started. On 11 August Benjamin Péret wrote to Breton: 'If you could see Barcelona as she is today, dotted with barricades, decorated with burnt out churches only their four walls standing, you would be exultant like me.' But the mood changed. Péret had joined the Anarchists in Barcelona and fought in the Durruti division on the Aragon front. Germany and Italy rallied to support Franco, but the Republicans were practically left to fend for themselves. The trickle of arms and men which arrived from Russia were directed against the Anarchists rather than the Whites, the Communists apparently preferring to gain control of their own side before disposing of the enemy. The convolutions of Soviet foreign policy at this time twisted in every direction except confrontation with Fascism; like France and Britain, Russia would later pay dearly for her lack of resolution. To the Anarchists, on whom had fallen the main brunt of fighting Franco, the Communists' wilful neglect of the Republican army for the sake of controlling the government in Barcelona seemed bad strategy if not outright perfidy. When Ehrenburg visited the front and talked to Durruti, the latter pulled out a revolver to shoot the Russian. Ehrenburg saved his skin only by appealing to the Spanish notion of hospitality. By September Péret was complaining in his letters to Breton that in Barcelona bourgeois order had been restored under the Communist government of Largo Caballero and that 'the whole of Madrid looks like Passy, a Passy where the marquises have stopped wearing hats and their husbands have abandoned their ties and bowlers!' He asked Breton for a copy of his declaration against the Moscow purge trials; Kamenev and Zinoviev had been sentenced to death in August. In October, Péret was glad to hear that Breton had not signed the manifesto congratulating the Soviet Union on its support of the Spanish Republic: 'That would have meant', Péret wrote, 'endorsing all the bluffing, intrigue-ridden, cowardly politics of the Communist International.' The next spring Nazi dive-bombers attacked Guernica; Picasso in a painting and Eluard in a poem deplored an event that now, looking back across a flattened Hamburg and a flattened Hiroshima, seems trivial, but was still then a vicious assault on what little moral dignity was left in the world.

In 1938 Breton, who was still financially impoverished, accepted a job managing the Galerie Gradiva. Marcel Duchamp painted the doors. But the era was over when 'Cubist and other queer painting' sold as fast as it was produced, and the gallery named after one of Freud's essays struggled. In October, Eluard and Breton lectured at the Comédie Française on the future of poetry and black humour respectively. Was it a compromise to have presented Surrealist ideas in a state-owned theatre? Not as great as the compromises with the commercial world of which other Surrealists would soon be guilty. In 1937 Paris was decked for the International Exhibition. It was 1925 all over again. Strange pavilions arose and the strains of music came from barges on the Seine. Schiaparelli caused a sensation by piling flowers on the plaster dummy with which she was supplied by the Syndicat de la Couture and hanging the garments on a clothes-line. These were the years of Schiaparelli's success. The young woman's imagination fascinated le Tout Paris and drew the Honourable Mrs Reginald Fellowes, Marlene Dietrich and the entire world of fashion to her Boutique Fantasque in Place Vendôme. Through Aragon, the Surrealists had for many years had a connection with the Italian fashion-queen. One of her closest assistants was Bettina Jones, an American woman

André Masson: *Never Satisfied*, 1937 (Galerie Louise Leiris, Paris). Masson's comment on the Spanish Civil War.

who became Mme Gaston Bergery. She had helped Aragon sell Elsa's jewellery and now she introduced other Surrealists to 'Schiap'. Schiaparelli chose pink and pink became the colour of everything, but Schiaparelli called it 'shocking'. Dali had made drawers in the chest of a stuffed grizzly bear which Edward James had given him; he had it dyed pink and it stood in Schiaparelli's boutique. He designed a hat in the form of an upturned shoe for her, another like a leg of mutton complete with its white paper frill. Some Schiaparelli gowns were printed with designs by Dali, others with designs by Christian Bérard. When Mae West sent a plaster cast of her body to Schiaparelli, who had been asked to supply the costumes for *Sapphire Sal*, Dali took the opportunity to model a sofa from the contours of her lips. Léonore Fini did slick Surrealist drawings for the fashion magazines, painted articles of furniture and designed the Schiaparelli scent-bottle. Lisa Deharme wrote an article describing Schiaparelli's house in Rue de Berri. She called it 'the house *du coup de foudre*'. The blossoming of Surrealist art in the latter half of the thirties had the disadvantage that it was quickly adopted as a fashionable style of interior decoration, a fate which can hardly have been cherished by Breton and his friends who had worked so hard to avoid and deride '*snobbismes*'. Carlos de Bestigui, a leading patron of the applied arts, had already had his penthouse apartment overlooking the Etoile decorated in an outlandish taste, with a roof

L'écriture automatique

ABOVE Salvador Dali, inspired by the sex
appeal of Mae West, created a sofa, 1936–7
(Edward James Foundation).

OPPOSITE André Breton: *Self-Portrait*, 1938
(Private Collection). Photo-montage.

garden 'room' where the 'carpet' was a lawn and a circular 'painting' above the
fireplace was a real view of the Arc de Triomphe. A note of irony was struck by
the fact that this 'Surrealist' folly adorned a plain, geometrical structure
designed by Le Corbusier. In 1939 the Galerie Drouin opened next door to
Schiaparelli's boutique in Place Vendôme. There Léonore Fini's painted
panels and Eugene Berman's *trompe l'oeil* furniture was on sale, but not for
long.

At the International Exhibition of Surrealism which opened at the Galerie
des Beaux-Arts in January 1938, the Surrealists arranged an alley of plaster
dummies, each one decorated by a different artist. They were there to surprise
the spectator, to disorientate him. This was the aim of the show, which was
organized by Breton and arranged by Duchamp. Everything was done to make
the visitor uneasy, and to alert his senses and to provoke his repressed desires.
Sacks of coal hung from the ceiling; the floor was uneven and covered in
twigs. At each corner of the main room were large beds covered in stained
and rumpled sheets. In one of them writhed the actress Hélène Vanel, her
nightgown torn. Sometimes she leapt from the bed and splashed in a pool

247

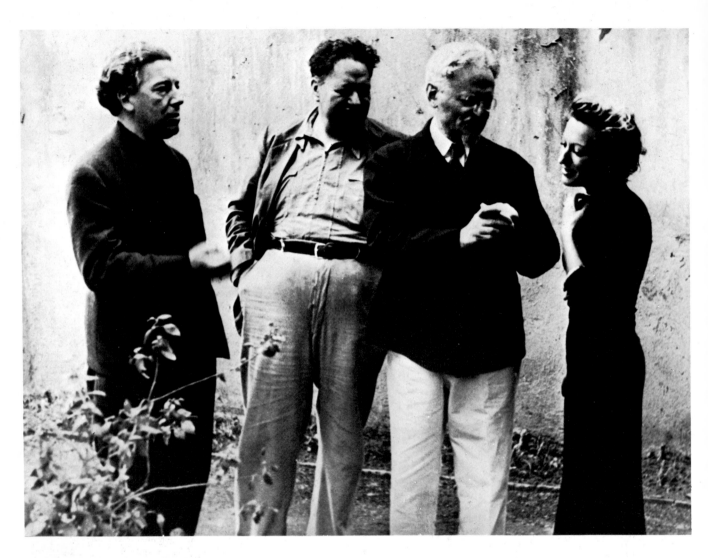

BELOW In 1938 André Breton visited Leon Trotsky in Mexico. Together they composed the manifesto *Towards an Independent Revolutionary Art*, which was also signed by Diego Rivera, the Mexican artist (ABOVE, second from left). Jacqueline Breton is on the right of this photograph.

beside it. It was not the kind of exhibition which was usually held at the Galerie des Beaux-Arts. Georges Wildenstein, its owner, had asked Breton to organize the show, which came as the last in a series of exhibitions reviewing different trends in modern art, and it did include a number of Surrealist paintings. But it was not an exhibition so much as an environment and an experience.

But the critic of the *Nouvelle Revue Française*, reporting on the opening, was unhappy to see there 'the professional and traditional snobs, and professors of philosophy out on the spree, patrons of divine right in disgrace, civil servants in need of reform, critics on the rebound, nature lovers, true reactionaries and false revolutionaries, and all those who find themselves alarmed by the reality of 1938'. For Breton, the evening must have reminded him of the Dada years when 'the great enemy was the public' and all Tzara and his mob had been able to do was amuse it. History was repeating itself in other ways too as the war drew near. In 1937 Carbuccia's review *Gringoire* had mercilessly attacked Roger Salengro, the mayor of Lille and Blum's Minister of the Interior, who was supposed to have deserted during the First World War. The slander achieved his resignation in much the same way that Daudet had brought down Malvy in 1917. France was returning to the state of hysterical patriotism which Breton and his friends had so detested twenty years earlier. Again there was the

André Masson: *La Grande Dame*, 1937 (Galerie Louise Leiris, Paris). Although Masson had distanced himself
from the Surrealists during the early thirties, he returned to the movement later and to techniques
which he had developed under its aegis, using natural materials such as feathers and sand.

call to chauvinism in matters of art and in 1939 the theme of what was to prove the last of Etienne de Beaumont's costume-balls was 'At the court in the age of Racine'.

In 1938 Breton went on a government mission to Mexico to lecture about art and literature. He was in contact with the Mexican painter Diego Rivera who arranged for him to meet Leon Trotsky. Breton stayed at Trotsky's home, the Blue House in Coyoacan, during February and after many hours of conversation the manifesto *Towards an Independent Revolutionary Art* emerged. It was largely written by Trotsky and appeared over his, Breton's and Rivera's signature. Its opening words were: 'We can say without exaggeration that never has civilization been menaced so seriously as today.' It goes on to affirm: 'It is our deliberate will to keep to the formula: *any license in art* . . . in defending freedom of creation we intend in no way to justify political indifference. . . . We believe that the supreme task of art in our age is to take part actively and consciously in the preparation of the revolution.' The manifesto was published in July and a Federation of Independent Revolutionary Art was established. The French section produced a review, *Clé*, which appeared in January 1939. But even at this eleventh hour the Trotskyite Marcel Martinet objected to the Surrealist domination of the group. It seemed that co-operation was never to be achieved.

While he was still in Mexico, Breton heard that Eluard had contributed poems to the review *Commune* which was sponsored by the *PCF*. On his return to Paris in the middle of August, he reproved Eluard for supporting the Communists, and their friendship which had survived so many years of conflict and confusion gave way at this moment when all they had done together to

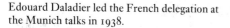

Edouard Daladier led the French delegation at the Munich talks in 1938.

Paul Eluard, photographed by Man Ray in 1937.

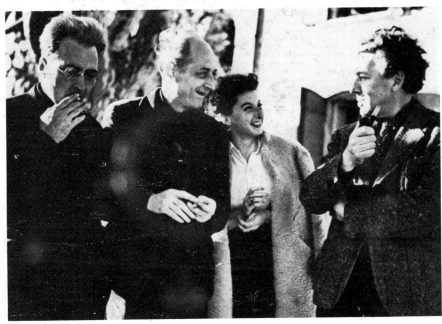

LEFT From the left: Victor Serge, Benjamin Péret and his wife, and André Breton at Marseilles, 1939.

ABOVE The anguish of a Czechoslovakian woman 'greeting' the invading *Wehrmacht* in 1938.

RIGHT SS guards drilling outside the Reichs Chancellery, Berlin. In 1939 Hitler and the Nazis brought to an end a period of intense intellectual and artistic activity. But Surrealism has remained a vital movement and has never abandoned the cause of freedom.

provide an alternative to hatred and militarism seemed to be doomed. Soon Eluard officially broke with the Surrealists and joined the *PCF*, and in September appeared the tract 'Neither your war, nor your peace', signed 'the Surrealist group', which attacked both Fascists and Communists. Three days after it was published, the Munich Agreement was signed. Hitler, having tested the nerves of the French and British statesmen, ordered his armies into Czechoslovakia. In August 1939 the non-aggression pact between Russia and Germany was made public. It was the saddest vindication of Breton's political stance, for it revealed the cynicism of both governments. The pact mocked the memory of Brest-Litovsk twenty-one years earlier, when Lenin had sued for peace on any terms so that the revolution could be preserved. Now Hitler and Stalin agreed that their nations should not fight each other because both wanted to wage their own imperialist wars.

During that summer Schiaparelli's window in Place Vendôme displayed a large globe of the world with a dove sitting on it, an olive branch in its beak. But it was a season of eagles, not doves. On 1 September Germany invaded Poland and France mobilized. Soon Breton, Aragon, Eluard and Péret were once more in uniform. Ernst was interned as an enemy alien. The *PCF* was made illegal. On 23 September Sigmund Freud died in London. An era was over which the world has reason to regret and reason to remember.

Chronology

1917

In the First World War, the Allies gain limited and very costly successes at Passchendaele, Vimy Ridge and on the Aisne; the Italians are defeated at Caporetto. The October Revolution, in which the Bolsheviks seize power in Petrograd, paralyzes the Russian war effort. Clemenceau is appointed Premier of France (November). Sigmund Freud, *Introductory Lectures on Psychoanalysis*, is published in Vienna; Léon Daudet, *L'Hérédo*, is published in Paris.

André Breton, Philippe Soupault and Louis Aragon meet each other in Paris; they contribute to the reviews *Sic* and *Nord-Sud* and frequent the circle of Guillaume Apollinaire, who uses the term *'sur-réalisme'* in a preview of the ballet *Parade*, written by Jean Cocteau, designed by Pablo Picasso and scored by Erik Satie; it is presented by Serge Diaghilev at the Théâtre Châtelet (May). *Les Mamelles de Tirésias*, a 'surrealist drama' by Apollinaire, is performed in Paris (June); during the intermission Jacques Vaché, a friend of Breton's, brandishes a revolver. Apollinaire lectures on 'The New Spirit and the Poets' at the Théâtre du Vieux-Colombier (November).

1918

The Ludendorff offensive fails; the German army retreats across France. Kaiser Wilhelm II abdicates. The Armistice agreement is signed (11 November). Amédée Ozenfant and Le Corbusier, *After Cubism*, is published.

Breton is put in contact with Paul Eluard by Jean Paulhan; all three are experimenting with poetic language. Breton starts to correspond with Giorgio de Chirico in Italy. Aragon contributes to the review *Le Film*. Apollinaire publishes *Caligrammes* and dies on 9 November.

1919

The Treaty of Versailles between the Allies and Germany is signed (July). Gabriele D'Annunzio seizes Fiume in defiance of the treaty terms. A Communist uprising in Berlin is crushed. Elections in France result in a landslide victory for the conservative Bloc National. The Clarté group of intellectuals, with Bolshevik sympathies, is founded by Henri Barbusse.

Jacques Vaché dies in Nantes from an overdose of drugs (January). The review *Littérature*, edited by Breton, Soupault and Aragon, begins publication in Paris (March). Breton is corresponding with Tristan Tzara in Zurich. Marcel Duchamp and Francis Picabia return to Paris. Breton and Soupault compose *Les Champs Magnétiques*, the first instance of automatic writing among the emerging group (July).

1920

In France, an attempt to call a general strike fails (June). General Weygand organizes Polish resistance to the Soviet army, which is defeated at Warsaw. Joan of Arc is canonized by Pope Benedict XV. At the Congress of Tours, the French Communist Party (*PCF*) is founded (December).

Tzara's arrival in Paris (January) heralds a series of Dada demonstrations there; Breton, Soupault, Aragon, Eluard and Picabia are among those who take part. Benjamin Péret joins the *Littérature* group. Breton, writing about Dada in the *Nouvelle Revue Française*, first uses the term 'surrealist'. Twenty-three Dada manifestoes are published in *Littérature*. Breton and Aragon contribute to *Die Schammade*, a Dada review edited by Max Ernst and Johannes Baargeld in Cologne. Ernst and Baargeld organize a Dada exhibition; Eluard visits Cologne and meets Ernst.

Surrealist publications:
André Breton and Philippe Soupault, *Les Champs Magnétiques* (automatic texts).

1921

Fascists are elected to the Italian parliament. The NKVD is established in Russia.

The Dadaists demonstrate against F. T. Marinetti when he lectures in Paris (January). Breton leads a Dada excursion to the abandoned church of St-Julien-le-Pauvre. The 'Grand Dada Season' (May–June) includes the first exhibition in Paris of work by Ernst; the mock trial of the Nationalist writer Maurice Barrès, over which Breton presides; and the Salon Dada which is organized by Tzara and virtually ignored by Breton. Aragon, Soupault, Eluard and Péret all take part in these activities, but Picabia abandons Dada at the time of the Barrès trial; Duchamp refuses an invitation to exhibit at the Salon Dada. The last number of *Littérature* (first series) appears in August. Breton marries Simone Kahn (July) and in September they visit the Tyrol where they join Ernst, Arp and Tzara. Breton goes on to Vienna to see Freud (October). The first exhibition in Paris of work by Man Ray is held at Soupault's bookshop, Librairie Six (December).

Surrealist publications:
Paul Eluard, *Les, Nécessités de la Vie et les Conséquences des Rêves.*
Louis Aragon, *Anicet.*
Benjamin Péret, *Le Passager du Transatlantique.*

1922

The civil war in Russia ends. Joseph Stalin is made general secretary of the Russian Communist Party. The *Fasci* march on Rome, and Benito Mussolini is invited to form a government (October). André Gide's novel of homosexuality, *Corydon* (written in 1911), is published and acclaimed. Charlie Chaplin makes *The Kid*. The piano-bar Le Boeuf sur le Toit opens in Paris.

Breton moves to 42 Rue Fontaine, Montmartre. He tries to organize the Congress of Paris, hoping to broaden the debate

about avant-garde literature and painting, but Tzara is hostile to the idea; the projected Congress fails to take place when the Dadaists dissociate themselves from it: Breton is condemned by Tzara and the Dadaists at a hearing held in the Closerie des Lilas (February). A new series of *Littérature* begins publication in March with a cover designed by Man Ray; Breton and Soupault are the editors. In the second issue is printed Breton's 'Leave Everything', in which he finally disavows Dada. Ernst comes to live in Paris. Breton becomes sole editor of *Littérature* (September), which henceforth appears with covers designed by Picabia. Among new adherents to Breton's group is René Crevel, who introduces them to the techniques of the trance; seances continue through the winter. An exhibition of work by Picabia is held in Barcelona (November) and the artist invites Breton to give a lecture there on the modern movement.

Surrealist publications:
Paul Eluard, *Répétitions* and *Les Malheurs des Immortelles* (collections of poetry illustrated by Max Ernst).

1923

French forces occupy the Ruhr when Germany fails to pay reparations. Adolf Hitler's Nazi *putsch* in Munich fails (November). General Primo de Rivera becomes dictator of Spain. Sun Yat Sen establishes the Chinese Nationalist government in Canton and, with Russian advice, reorganizes the Kuomintang.

Aragon, Breton, Crevel and Robert Desnos start contributing to *Paris-Journal*. Breton and his group break up the *Soirée du Coeur à Barbe* (July), an entertainment through which Tzara attempts to re-establish his leadership of the Parisian avant-garde. Eluard is sued for the cost of repairs to the theatre and goes to Italy where he visits Giorgio de Chirico in Rome.

Surrealist publications:
Louis Aragon, *Plaisirs de la Capitale*.
Benjamin Péret, *Au 125 du Boulevard Saint-Germain*.
André Breton, *Clair de Terre*.

1924

Lenin dies (January). Matiotti, the dissident politician, is murdered in Rome on the orders of Mussolini. Elections in France are won by the Cartel des Gauches, an alliance of Radicals and Socialists.

André Masson is given his first one-man exhibition in Paris; he comes into contact with Breton's group and introduces to them Joan Miró (who has a studio in the same house as Masson's, 45 Rue Blomet) and Antonin Artaud. The last number of

DICTIONNAIRE ABRÉGÉ DU SURRÉALISME

Littérature appears (June). Eluard makes a journey to the Far East. In the autumn number of a new literary review, *Commerce*, Aragon's '*Une Vague des Rêves*' is published. Yvan Goll and Paul Dermée start another new review called *Surréalisme*, but only one number appears (October). Breton's Manifesto of Surrealism is published (October). Anatole France dies and the Surrealists issue the pamphlet *Un Cadavre*, reviling his memory. In it Aragon refers to 'feeble-minded Moscow' and is censured in the Communist review *Clarté*. The Bureau of Surrealist Research is opened (December) and the review *La Révolution Surréaliste*, edited by Pierre Naville and Benjamin Péret, begins publication.

Surrealist publications:
André Breton, *Les Pas Perdus*.
Louis Aragon, *Le Libertinage*.
Benjamin Péret, *Immortelle Maladie*.
Paul Eluard, *Mourir de ne pas Mourir*.
Robert Desnos, *Deuil pour Deuil*.
René Crevel, *Détours*.
Pierre Naville, *Les Reines de la Main Gauche*.
Antonin Artaud, *L'Ombilie des Limbes*.

1925

The Treaties of Locarno secure European frontiers. The Syrians revolt against French rule, and the Riff tribesmen, led by Abd El Krim, invade French Morocco. The Nazi Party is reconstituted in Germany, and publication of Adolf Hitler's *Mein Kampf* begins. The Exposition des Arts Décoratifs is held in Paris. Sergei Eisenstein makes the film *Potemkin*.

Joan Miró's Surrealist paintings are exhibited at the Galerie Pierre; Péret writes the preface to the catalogue (June). Breton becomes sole editor of *La Révolution Surréaliste* (July). The Surrealists riot at a banquet given in honour of the Symbolist poet Saint-Pol-Roux at the Closerie des Lilas (July). Breton meets Marcel Fourrier, an editor of the review *Clarté*, and an alliance between Surrealists and Communists begins to emerge; it culminates in the manifesto *La Révolution d'Abord et Toujours*, printed in *La Révolution Surréaliste* (October). There is a wave of conversions to Catholicism among French intellectuals; Jean Cocteau is the best-known of the converts. Abbé Ernest Gengenbach, a defrocked Jesuit priest, writes to *La Révolution Surréaliste* and becomes a member of the group. Yves Tanguy and Jacques Prévert join the movement at about this time and their house in Rue du Château becomes a centre of Surrealist activities.

Surrealist publications:
Paul Eluard and Benjamin Péret, *152 Proverbes Mis au Goût du Jour*.
Benjamin Péret, *Il Etait une Boulangère*.

1926

In France, the Radical-Socialist administration fails and the conservative Raymond Poincaré is appointed Premier. Jean Cocteau's *Lettre à Jacques Maritain*, his public profession of the Catholic faith, is published in Paris.

The Galerie Surréaliste in Rue Jacques-Callot opens with an exhibition of work by Man Ray. Exhibitions of work by Masson and Arp follow. Publication of *Surrealism and Painting* by Breton begins in *La Révolution Surréaliste*. Ernst and Miró are reprimanded by Breton and Eluard because the artists had accepted commissions from Diaghilev to design scenery and costumes for *Romeo and Juliet*; the ballet's first performance is made the occasion for a Surrealist protest. Naville criticizes the Surrealists' revolutionary role and Breton replies with *Legitimate Defence* (September), which states the Surrealists' dissatisfaction with the Communists' literary attitudes as expressed in *L'Humanité*, the Party newspaper. Extracts from Artaud's manifesto of the Théâtre Alfred Jarry are published in the *Nouvelle Revue Française* (November); the Surrealists are perturbed. Artaud and Soupault, who has increasingly dissociated himself from Surrealism and writes novels, are expelled from the movement.

Surrealist publications:
Louis Aragon, *Le Mouvement Perpetuel*, and *Paysan de Paris*.

1927

Sacco and Vanzetti are executed in America (August). Trotsky and Zinoviev are expelled from the Russian Communist Party (November). Abbé Bremond's *Prayer and Poetry*, Jacques Maritain's *Primacy of the Spiritual*, and André Gide's *Le Journal des Faux-Monnayeurs* are published in Paris. The last number of *Clarté* appears (December).

Breton, Aragon, Eluard, Péret and Pierre Unik join the French Communist Party (January); Breton writes *Au Grand Jour* to explain their motivation. Yves Tanguy is given his first one-man exhibition at the Galerie Surréaliste (May–June); the preface to the catalogue is written by Breton. *Cadavres exquis* make their first appearance in *La Révolution Surréaliste* (October). René Magritte comes to live at Perreux-sur-Marne, near Paris, and enters Surrealist circles. Some of the Surrealists leave the Communist Party at the end of the year.

Surrealist publications:
René Crevel, *L'Esprit Contre la Raison*.

1928

The elections in France are won by the conservatives. André Tardieu at the Ministry of the Interior and Jean Chiappe, Prefect of police in Paris, inaugurate the persecution of Communists. Thirteen hundred workers are arrested when police clash with demonstrators at Ivry.

At 42 Rue Fontaine, the Surrealist group hold extensive debates on sexuality (January). In protest against Giorgio de Chirico's latest paintings, exhibited at Léonce Rosenberg's gallery, the Surrealists show his earlier canvasses at the Galerie Surréaliste. The Surrealists interrupt Artaud's production of Strindberg's *Dream Play*, financed by the Swedish government (June). Aragon meets Nancy Cunard and accompanies her to Venice where he attempts suicide (September). Two months later he is introduced to Elsa Triolet. On visits to Paris from Spain, Salvador Dali is introduced to the Surrealists by Miró.

Surrealist publications:
André Breton, *Le Surréalisme et la Peinture*, and *Nadja*.
Louis Aragon, *Traité du Style*.
Paul Eluard, *Défense de Savoir*.
Benjamin Péret, *Et les Seins Mouraient*, and *Le Grand Jeu*.

1929

In New York, the Wall Street stock market crashes (October).

The Surrealists hold a party at 53 Rue du Château for Mayakovsky, who visits Paris early in the year. At a meeting of the Surrealists at the Bar du Château corporate action is preferred to individual action, and the editors of the review *Grand Jeu* are reprimanded for the ambivalence of their political stance. Buñuel and Dali make the film *Un Chien Andalou*, which is shown privately to Breton and others at the Studio Ursulines; they hail it as a Surrealist masterpiece. Eluard and Gala stay with Dali at Cadaqués during the summer; there Dali paints *The Lugubrious Game*. Later in the year Dali's Surrealist paintings are exhibited at the Galerie Goemans in Paris; Breton writes the preface to the catalogue. Breton also writes the Second Manifesto of Surrealism, in which he calls for the 'occultization' of the movement. The manifesto is reprinted in the final issue of *La Révolution Surréaliste*, which appears in December.

Surrealist publications:
Paul Eluard, *L'Amour la Poésie*.
René Crevel, *Etes-Vous Fous?*
Louis Aragon, *La Grande Gaieté*.
Max Ernst, *La Femme 100 Têtes*.

1930

Mayakovsky commits suicide in Moscow (April). One hundred and seven Nazi candidates are elected to the Reichstag in Berlin. Josef von Sternberg makes *The Blue Angel*, starring Marlene Dietrich.

Twelve dissident Surrealists attack Breton in the pamphlet *Un Cadavre*. Luis Buñuel makes the film *L'Age d'Or*. Eisenstein, visiting Paris, is in contact with some of the Surrealists. Georges Sadoul and Jean Caupenne compose and send an abusive postcard to a cadet at the St Cyr military academy; Sadoul is charged, tried and sentenced to three months' imprisonment (June). Aragon, Elsa and Sadoul visit Russia (October); Aragon and Sadoul attend the Second Congress of the International of Revolutionary Literature at Kharkov. Before they leave Russia, Aragon and Sadoul sign a letter denouncing Freud, Trotsky and the Second Manifesto of Surrealism 'to the extent that it contradicts the teachings of dialectical materialism'; on their return to France they retract these views in the pamphlet *Aux Intellectuels Révolutionnaires*. The cinema where *L'Age d'Or* is first shown to the public is sacked by extreme right-wing youths objecting to the film, which is banned by the police in the interest of public order (December).

Surrealist publications:
André Breton and Paul Eluard, *L'Immaculée Conception*.
Max Ernst, *Rêve d'une Petite Fille qui Voulut Entrer au Carmel*.
Salvador Dali, *La Femme Visible*.

1931

Alfonso XIII leaves Spain and the republic is proclaimed.

In collaboration with the French Communist Party the Surrealists mount an exhibition called 'The Truth about the Colonies'. It is their riposte to the Exposition Coloniale held at Vincennes earlier in the year. Aragon's *Front Rouge*, an outspoken revolutionary poem, is published in *La Littérature de la Révolution Mondiale*, copies of which, as a result, are seized by the police (November). Hans Arp and Alberto Giacometti are in close contact with the Surrealists at this time, and Dali contributes the essay *Objets à Funtionnement Symbolique* to *Le Surréalisme au Service de la Révolution* (December).

Surrealist publications:
Tristan Tzara, *L'Homme Approximatif*.
Louis Aragon, *Persécuté Persécuteur*.
Salvador Dali, *L'Amour et la Mémoire*.

1932

The effects of the international economic recession begin to be felt in France. In the elections, the *PCF* win only ten seats in the Chamber of Deputies. Two hundred and thirty Nazis are elected to the Reichstag in Berlin; they have become the largest single party in Germany. Mussolini, *La Dottrina del Fascismo*, is published.

Aragon is indicted for his poem *Front Rouge* and charged with 'demoralization of the army and nation'. Breton organizes a protest, collecting over three hundred signatures, and writes *La Misère de la Poésie*, in which he demands immunity from prosecution arising from anything which the poet might write; in the same pamphlet he attacks the literary attitudes of *L'Humanité*, in which Aragon's disapproval of Breton's arguments is published a few days later. Aragon breaks with Surrealism. Giacometti's first one-man exhibition is held at the Galerie Pierre Colle.

Surrealist publications:
René Crevel, *Le Clavecin de Diderot*.
André Breton, *Le Revolver à Chevaux Blancs*, and *Les Vases Communicants*.
Paul Eluard, *La Vie Immédiate*.
Tristan Tzara, *Où Boivent les Loups*.

1933

Hitler is appointed Chancellor of Germany (January); book-burning day in Germany (10 May); Germany leaves the League of Nations (October). In Spain, the Falange (Fascist Party) is founded. The Third International is dissolved. In France, a warrant is issued for the arrest of Stavisky (December). André Malraux, *La Condition Humaine*, and Federico Garcia Lorca, *Boda de Sangre*, are published.

Having attacked Ehrenburg and *L'Humanité* in February, Breton is expelled from the Communist-sponsored Association des Ecrivains et Artistes Révolutionnaires when he refuses to disavow a letter published in *Le Surréalisme au Service de la Révolution* (no. 5, 15 May), criticizing the moral attitudes of Soviet life as portrayed in the film *The Road to Life*. Publication of *Le Surréalisme au Service de la Révolution* ends; the Surrealists contribute to the new review *Minotaure*. An exhibition of Surrealist painting at the Galerie Pierre Colle includes work by Arp, Breton, Dali, Duchamp, Eluard, Ernst, Giacometti, Maurice Henry, Marcel Jean, Magritte, Miró, Picasso, May Ray and Tanguy (June). Victor Brauner is introduced to the Surrealists by Tanguy. Masson, who is estranged from the Surrealist group, paints décor for *Les Presages*, a Ballets Russes de Monte Carlo production. Aragon founds the Maison de la Culture and works on the staff of the new review *Commune*, edited by Barbusse, Gide and Romain Rolland. The Surrealists publish the pamphlet *Violette Nazière*, protesting against the conviction of a young murderess (December).

Surrealist publications:
Tristan Tzara, *L'Antitête*, and *Monsieur Aa l'Antiphilosophe*.
René Crevel, *Les Pieds dans le Plat*.

1934

The Stavisky affair in France involves prominent politicians and government officials; extreme right-wing groups riot in Paris, threatening to overthrow the Third Republic (6 February); strikes and demonstrations follow. In Germany, Hitler becomes Reichsführer on the death of President Hindenburg. Andrei Zdahnov promulgates the aesthetic of social realism at the First Congress of Soviet Writers.

Dali is censured by the Surrealists for his ambivalent attitude towards Hitler (January). The Surrealists sign the pamphlet *Appel à Lutte*, calling for a united front of intellectuals against Fascism (February); but in April the Surrealist pamphlet *La Planète sans Visas*, condemning Trotsky's expulsion from France, again alienates the group from the Communists. Tzara and Crevel join the Maison de la Culture. Breton marries Jacqueline Lamba (August). The film *King Kong* is acclaimed by the Surrealists. An exhibition of paintings by Victor Brauner is held at the Galerie Pierre; Breton writes the preface to the catalogue. Dali visits New York for an exhibition of his paintings at the Julien Levy Gallery. Oscar Dominguez joins the Surrealists and Breton introduces the fourteen-year-old Gisèle Prassinos, whose automatic poetry and drawings appear in *Minotaure*.

Surrealist publications:
André Breton, *Point du Jour*.
Paul Eluard, *La Rose Publique*.
Max Ernst, *Une Semaine de Bonté*.
Benjamin Péret, *De Derrière les Fagots*.

1935

The Franco–Russian mutual aid treaty is signed (May). Italy invades Abyssinia (October); the Hoare–Laval pact (Britain and France) gives Italy a free hand.

Breton and Eluard visit Prague for an international exhibition of Surrealism (March–April). Breton, Péret and others go to Tenerife in the Canary Islands for a Surrealist exhibition organized by Oscar Dominguez (May). Breton is refused permission to speak at the Congress of Writers in Defence of Culture (June); Crevel, having appealed in vain to the committee to reverse this decision, commits suicide. The Surrealists publish the manifesto *Du Temps que les Surréalistes Avaient Raison* (August), justifying their political position. Picasso writes automatic poetry. The Surrealists admire Henry Hathaway's film *Peter Ibbetson*.

Surrealist publications:
André Breton, *Position Politique du Surréalisme*.
Tristan Tzara, *Grains et Issues*.
Salvador Dali, *La Conquête de l'Irrational*.

1936

Germany occupies the Rhineland (March). The French general elections are won by the Popular Front; widespread strikes follow the elections; Premier Léon Blum makes concessions to the workers (June). The Spanish Civil War starts (July). The first Soviet purge trials open in Moscow (August).

The Surrealist Exhibition of Objects is held at the Galerie Charles Ratton (May). Breton, Eluard and Péret visit London for the International Exhibition of Surrealism (June–July). In August, Péret arrives in Barcelona; from there he goes to the Aragon front where he fights with the Anarchist Durruti division. Breton condemns the Soviet purge trials.

Surrealist publications:
Benjamin Péret, *Je ne Mange pas de ce Pain-là*, and *Je Sublime*.
Paul Eluard, *Les Yeux Fertiles*.

1937

The Rome–Berlin Axis is formed. German planes bomb Guernica during the Spanish Civil War (April). In France, the Blum ministry falls (June).

Masson is reconciled with the Surrealists. Breton accepts a post running the Galerie Gradiva. Picasso begins painting *Guernica* and Eluard writes a long poem in reaction to the atrocity. Eluard lectures on 'The Future of Poetry', and Breton on 'Black Humour', at the Comédie Française (October).

Surrealist publications:
Paul Eluard, *Les Mains Libres*, and *Quelques-uns des Mots qui, jusqu'ici, m'Etaient Mystérieusement Interdits*.
André Breton, *L'Amour Fou*, and *De l'Humour Noir*.
André Breton and Paul Eluard, *Dictionnaire Abrégé du Surréalisme*.
Salvador Dali, *Métamorphoses de Narcisse*.

1938

The *Anschluss* takes place, by which Germany annexes Austria (March). The Munich Pact is signed; the European powers agree to Hitler's seizure of the Sudetenland (30 September). Antonin Artaud, *Le Théâtre et Son Double*, and Jean-Paul Sartre, *La Nausée*, are published in Paris. Charlie Chaplin makes the film *Modern Times*.

An international exhibition of Surrealism is held at the Galerie des Beaux-Arts in Paris (January); it is organized by Breton and Eluard, and designed by Marcel Duchamp. Breton visits Mexico on a government mission to deliver a series of lectures (April); while there he meets Leon Trotsky and together they compose the manifesto *Pour un Art Révolutionnaire Indépendant* (July). Eluard contributes poems to the Communist-sponsored review *Commune*, and on Breton's return to France the two friends quarrel; Eluard abandons Surrealism and Ernst follows him out of the movement. The pamphlet *Ni de Votre Guerre, Ni de Votre Paix!*, signed 'le groupe surréaliste', condemns both protagonists in the political crisis (27 September). Hans Bellmer arrives in Paris and is on friendly terms with Tanguy and Eluard.

Surrealist publications:
André Breton, *Trajectoire de Rêve*.
Paul Eluard, *Cours naturel*.
Tristan Tzara, *La Deuxième Aventure Celeste de M. Antipyrine*.

1939

The Spanish Civil War ends in victory for Franco and the Nationalists. Czechoslovakia is invaded by Germany. The Russo–German non-aggression pact is made public (24 August). Poland is invaded by Germany (1 September). France mobilizes. The French Communist Party is dissolved for supporting the Russo–German pact. France and Britain declare war on Germany. Freud dies in London (23 September).

On the outbreak of war Breton, Eluard, Aragon, Péret and Tanguy are called up. Ernst is interned as an enemy alien.

Select Bibliography

Below are listed some of the books I have found useful. The Surrealists' own writings, particularly the periodicals *La Révolution Surréaliste* and *Le Surréalisme au Service de la Révolution*, provide the most vivid history of the movement. *A Bibliography of the Surrealist Revolution in France*, compiled by Herbert S. Gershman, was published by the University of Michigan Press in 1969.

ALEXANDRE, Maxime, *Mémoires d'un surréaliste* (La Jeune Parque, 1968).
ALEXANDRIAN, Sarane, *L'Art surréaliste* (Fernand Hazan, 1969). Translated as *Surrealist Art* (Thames and Hudson, 1970).
BALAKIAN, Anna, *Surrealism: the Road to the Absolute* (revised and enlarged edition, Dutton, 1970).
BONNET, Marguérite, *André Breton et la naissance de l'aventure surréaliste* (Corti, 1975).
BROGAN, D. W., *The Development of Modern France (1870–1939)* (Hamish Hamilton, 1940).

CARDINAL, Roger and SHORT, Robert Stuart, *Surrealism: Permanent Revelation* (Studio Vista, 1970).
CAUTE, David, *Communism and the French Intellectuals 1914–1960* (André Deutsch, 1964).
CAWS, Mary Ann, *The Poetry of Dada and Surrealism* (Princeton, 1970).
COWLEY, Malcolm, *Exile's Return* (Cape, 1934).
DUNLOP, Ian, *The Shock of the New* (Weidenfeld and Nicolson, 1972).
EHRENBURG, Ilya, *Men, Years – Life* (MacGibbon and Kee, 1963).
ESSLIN, Martin, *Artaud* (Collins, 1976).
GERSHMAN, Herbert S., *The Surrealist Revolution in France* (University of Michigan Press, 1974).
HUDDLESTON, Sisley, *Bohemian Literary and Social Life in Paris* (Harrap, 1928).
JEAN, Marcel, *Histoire de la peinture surréaliste* (Editions du Seuil, 1959). Translated as *The History of Surrealist Painting* (Weidenfeld and Nicolson, 1960).

JOLL, James, *Europe since 1870* (Weidenfeld and Nicolson, 1973).
MATTHEWS, J. H., *Surrealism and Film* (University of Michigan Press, 1971).
MONNIER, Adrienne, *Rue de l'Odéon* (Albin Michel, 1960).
NADEAU, Maurice, *Histoire du surréalisme* (Editions du Seuil, 1945). Translated as *The History of Surrealism* (Macmillan, 1965).
POUPARD-LIEUSSON, Y. and SANOUILLET, M., *Documents Dada* (Weber, 1974).
SACHS, Maurice, *Au temps du Boeuf sur le Toit* (NRF, 1939).
SANDROW, Nahma, *Surrealism, Theater, Arts, Ideas* (Harper and Row, 1972).
SCHIAPARELLI, Elsa, *Shocking Life* (Dent, 1954).
STEEGMULLER, Francis, *Cocteau: a Biography* (Macmillan, 1970).
THIRION, André, *Révolutionnaires sans révolution* (Editions Robert Laffont, 1972). Translated as *Revolutionaries without Revolution* (Cassell, 1976).

Acknowledgements

The author and publisher would like to thank the following museums, collections and private individuals by whose kind permission the illustrations are reproduced. Sources without parentheses indicate the owners of paintings and photographs; those within parentheses refer to illustration sources only.

3 Photograph by Man Ray: *Eye with Tear*, 1934. (Weidenfeld and Nicolson Archive, London), © ADAGP Paris 1978.
4 Ernst: *R. Desnos 'A Present'*, 1921. Private Collection (Arturo Schwarz, Milan), © SPADEM Paris 1978.
7 Ernst: *Changement de Viande Rejouit le Cochon*, 1921. Private Collection (Arturo Schwarz, Milan), © SPADEM Paris 1978.
9 General Foch. Mansell Collection, London.
11 Apollinaire. Archives Editions du Seuil, Paris (Snark International, Paris).
12 French soldiers near Décauville. Roger-Viollet, Paris.
13 Dead Germans in Soissons. Mansell Collection, London.
14 Magazine illustration of French omnibus. Mansell Collection, London.
15 Breton. Elisa Breton Collection (Snark International, Paris).
16 Picasso. René Jacques Collection (from J. Crespelle, *Montmartre Vivant*, Hachette).
17 de Chirico: *The Uncertainty of the Poet*. Sir Roland Penrose Collection, London (Snark International, Paris), © SPADEM Paris 1978.
19 Adrienne Monnier. Saillet Collection (Snark International, Paris).
20–1 Ernst: *The Meeting of Friends*. Lydia Bau Collection, Hamburg (Snark International, Paris), © SPADEM Paris 1978.
22–3 Breton at St Dizier. Snark International, Paris.
24 above de Chirico: *The Dream of Tobias*. Edward James Foundation, © SPADEM Paris 1978.
24 below Duchamp: *Apolinère Enameled*. Philadelphia Museum of Art, © ADAGP Paris 1978.
26 left Aragon. Archives Editions du Seuil, Paris (Snark International, Paris).
26 above right Breton and Fraenkel. Archives Editions du Seuil (Snark International, Paris).
26 below right Vaché: *Drawing*. (From Willy Verkauf, *Dada*, Academy Editions.)
27 above Picasso: Drawing of *Cocteau*. Private Collection (Snark International, Paris), © SPADEM Paris 1978.
27 below Picasso: Drawing of *Satie*. Private Collection (Snark International, Paris), © SPADEM
Paris 1978.
28 above Freud. (Mansell Collection, London.)
28 below Charcot. Centre Photographique de l'A.P., Paris (Snark International, Paris).
29 Demonstration outside Winter Palace. (Popperfoto, London.)
30 left de Chirico: *The Nostalgia of the Infinite*. Museum of Modern Art, New York, © SPADEM Paris 1978.
30 right de Chirico: *The Dream of the Poet*. Peggy Guggenheim Foundation, Venice, © SPADEM Paris 1978.
31 Léon Daudet. B. Moraugres Collection (Snark International, Paris).
32–3 Place de la Concorde. Roger-Viollet, Paris.
34 Cocteau: *Portrait of Guillaume Apollinaire*. Private Collection (Arturo Schwarz, Milan), © SPADEM Paris 1978.

35 Fraenkel: *Collage 'Tommy'*. (Arturo Schwarz, Milan.)

36 Duchamp. (Arturo Schwarz, Milan.)

39 Tzara. Madame Arp Collection (Weidenfeld and Nicolson Archive, London).

40 Cover of *Dada* no. 3. Fischer Fine Art Ltd, London.

41 Vaché. Perrin Collection (Snark International, Paris).

42 Pearl White. (Mansell Collection, London.)

43 Cocteau. Bibliothèque Nationale Estampes, Paris (Snark International, Paris).

44 Buster Keaton in *Go West*. (Radio Times Hulton Picture Library, London.)

45 Charlie Chaplin in *Sunny Side*. (Weidenfeld and Nicolson Archive, London.)

47 above Clemenceau, Wilson and Lloyd-George. Mansell Collection, London.

47 below Hall of Mirrors, Versailles. Roger-Viollet, Paris.

48–9 Musidora in *Les Vampires*. (National Film Archive, London.)

49 Anti-Bolshevik poster. (Snark International, Paris.)

50 above Emile Henry. Mansell Collection, London.

50 below Bonnot's hideout. B. Moraugres Collection (Snark International, Paris).

51 Duchamp: *Bottle-Rack*. Museum of Modern Art, New York, James Thrall Soby Fund, © ADAGP Paris 1978.

52–3 Dust Elevation, photographed by Man Ray. (Arturo Schwarz, Milan), © ADAGP Paris 1978.

53 Duchamp: *The Bride Stripped Bare by Her Bachelors, Even*. Philadelphia Museum of Art, Katherine S. Dreier Bequest, © ADAGP Paris 1978.

54 Picabia: *Amorous Parade*. Private Collection (Snark International, Paris), © SPADEM and ADAGP Paris 1978.

55 Picabia: *Very Rare Picture on Earth*. Peggy Guggenheim Foundation, Venice, © SPADEM and ADAGP Paris 1978.

56 left Gala and Eluard. Musée Municipal de St-Denis (Weidenfeld and Nicolson Archive, London).

56 right Breton. Bibliothèque Doucet, Paris (Snark International, Paris).

57 Ernst: *Fantômes*. (Sotheby's, London), © SPADEM Paris 1978.

58 Group of Surrealists.

Bibliothèque Doucet, Paris (Snark International, Paris).

59 Tableau Dada. Bibliothèque Doucet, Paris (Snark International, Paris).

60 Ernst: *Men Shall Know Nothing of This*. Tate Gallery, London (Cooper-Bridgeman Library, London), © SPADEM Paris 1978.

61 Ernst: *Two Children Threatened by a Nightingale*. Museum of Modern Art, New York (Snark International, Paris), © SPADEM Paris 1978.

62 Passage de l'Opéra, Paris. Bibliothèque Nationale, Paris (Roger-Viollet, Paris).

63 Strikers' meeting. Snark International, Paris.

64 Miró: *Person Throwing a Stone at a Bird*. Museum of Modern Art, New York, © ADAGP Paris 1978.

65 Trotsky. Bibliothèque Lenine, Paris (Snark International, Paris).

66 Gide. Radio Times Hulton Picture Library, London.

69 Valéry. Radio Times Hulton Picture Library, London.

70 D'Annunzio. (Weidenfeld and Nicolson Archive, London.)

71 Ernst, Gala and Arp. Madame Arp Collection (Weidenfeld and Nicolson Archive, London).

72 above Fraenkel: *Dada Excursion to St-Julien-le-Pauvre*. Private Collection (Arturo Schwarz, Milan).

72 below Photograph of Dada excursion. (Victoria and Albert Museum, London.)

73 Ernst: Illustration to *Les Malheurs des Immortelles*. Victoria and Albert Museum, London, © SPADEM Paris 1978.

74 Maurice Barrès. Radio Times Hulton Picture Library, London.

75 Trial of Maurice Barrès. Marker Collection (Snark International, Paris).

76 Ernst: *Farewell, My Beautiful Land of Marie Laurencin, Help! Help!* Museum of Modern Art, New York, © SPADEM Paris 1978.

77 Ernst: *Celebes*. Tate Gallery, London, © SPADEM Paris 1978.

78 Fraenkel: *Artistic and Sentimental*. Private Collection (Arturo Schwarz, Milan).

79 above Picasso: *André Breton*. Private Collection (Arturo Schwarz, Milan), © SPADEM Paris 1978.

79 below left Rayograph by Man Ray. Peggy Guggenheim Foundation, Venice, © ADAGP

Paris 1978.

79 below right Rayograph by Man Ray. Peggy Guggenheim Foundation, Venice, © ADAGP Paris 1978.

80 Huidobro, Delaunay, Tzara and Arp. Madame Arp Collection (Weidenfeld and Nicolson Archive, London).

81 Miró: *Dog Barking at the Moon*. Philadelphia Museum of Art, A. E. Gallatin Collection, © ADAGP Paris 1978.

83 Delaunay: Study for *Portrait of Philippe Soupault*. Hirshhorn Museum, Washington DC, © ADAGP Paris 1978.

84 Ernst: *The Virgin Spanking the Infant Jesus Before Three Witnesses*. Madame Jean Krebs Collection, Brussels (Snark International, Paris), © SPADEM Paris 1978.

85 Magritte: *The Lovers*. Zeisler Collection, New York (Snark International, Paris), © ADAGP Paris 1978.

86 Cover of *Littérature* no. 3, by Man Ray. Bibliothèque Nationale, Paris (Taylor Institution Library, Oxford/ACRPP, Paris), © ADAGP Paris 1978.

87 Picabia, photographed by Man Ray. (Sotheby's Belgravia, London), © ADAGP Paris 1978.

88 Tanguy: *Outside*. Sir Roland Penrose Collection, London (Cooper-Bridgeman Library, London), © SPADEM Paris 1978.

89 Léger: Swedish Ballet programme cover. Private Collection (Snark International, Paris), © SPADEM Paris 1978.

90 Cover of *Littérature* no. 10, by Picabia. Bibliothèque Nationale, Paris (Taylor Institution Library, Oxford/ACRPP, Paris), © SPADEM and ADAGP Paris 1978.

91 Cover of *Littérature* no. 9, by Picabia. Bibliothèque Nationale, Paris (Taylor Institution Library, Oxford/ACRPP, Paris), © SPADEM and ADAGP Paris 1978.

92 Cover of *Littérature* no. 13, by Picabia. Bibliothèque Nationale, Paris (Taylor Institution Library, Oxford/ACRPP, Paris), © SPADEM and ADAGP Paris 1978.

93 left Mussolini. (Weidenfeld and Nicolson Archive, London.)

93 right Picabia and Tzara. Francis Bacon Foundation, California (Snark International, Paris).

94 Poster advertising La Coupole. (From J. Crespelle, *Montparnasse Vivant*, Hachette.)

98 above Desnos, photographed by Man Ray. Mayor Gallery, London, © ADAGP Paris 1978.

98 below Desnos: *Here Lies Eluard*. Galerie François Petit, Paris (Snark International, Paris).

100 *Midinettes* on strike. Radio Times Hulton Picture Library, London.

101 Josephine Baker. Roger-Viollet, Paris.

102–3 Kiki and negro mask, photographed by Man Ray. (Weidenfeld and Nicolson Archive, London), © ADAGP Paris 1978.

104 James Joyce, Sylvia Beach and Adrienne Monnier, photographed by Gisèle Freund. (John Hillelson Agency, London.)

105 Picasso: *Seated Bather*. Museum of Modern Art, New York, Mrs Simon Guggenheim Fund, © SPADEM Paris 1978.

106 Fournier: *La Rotonde*. (Weidenfeld and Nicolson Archive, London), © ADAGP Paris 1978.

107 above Le Dôme restaurant. Radio Times Hulton Picture Library, London.

107 below Raymond Duncan. Radio Times Hulton Picture Library, London.

108–9 Miró: *Swallow/Love*. Museum of Modern Art, New York, Gift of Nelson Rockefeller, © ADAGP Paris 1978.

110 Aleister Crowley. Radio Times Hulton Picture Library, London.

112 above Dali: *Evocation of the Apparition of Lenin*. Museum of Modern Art, Paris (Bulloz, Paris), © ADAGP Paris 1978.

112 below Magritte: *The Ladder of Fire*. Edward James Foundation, © ADAGP Paris 1978.

114 Breton. (Weidenfeld and Nicolson Archive, London.)

115 left Duchamp: *Nude Descending a Staircase*. Philadelphia Museum of Art, © ADAGP Paris 1978.

115 right Breton's studio. Simone Collinet Collection, Paris.

116 André and Simone Breton. Simone Collinet Collection, Paris.

117 Les Buttes Chaumont. Roger-Viollet, Paris.

118 Surrealist playing cards. Marker Collection (Snark International, Paris).

120 Anna de Noailles. Snark International, Paris.

121 Satie in *Entr'acte*. (National Film Archive, London.)

122 Title page of first issue of *La Révolution Surréaliste*. Bibliothèque Doucet, Paris (Snark International, Paris).

124 Anatole France. Bibliothèque Nationale, Paris (Snark International, Paris).

128 Cartoon of Léon Daudet, by Pavil. (From Sisley Huddleston, *Bohemian Literary and Social Life in Paris*, Harrap 1928), © SPADEM Paris 1978.

129 left Germaine Berton. (Mansell Collection, London.)

129 right Group of Surrealists. (Victoria and Albert Museum, London.)

130 above Desnos and Masson. (Snark International, Paris.)

130 below Artaud. Roger-Viollet, Paris.

131 Masson: *Automatic Drawing*. Private Collection (Snark International, Paris), © ADAGP Paris 1978.

132 Masson: *Automatic Drawing*. Private Collection (Arturo Schwarz, Milan), © ADAGP Paris 1978.

133 Claudel. Bibliothèque Nationale Estampes, Paris (Snark International, Paris).

135 above Marshal Lyautey. (Mansell Collection, London.)

135 below Abd El Krim. (Mansell Collection, London.)

136 Clara Zetkin. Popperfoto, London.

139 Briand. Mansell Collection, London.

140 Exposition des Arts Décoratifs, main entrance. Harlingue-Viollet, Paris.

141 Eiffel Tower illuminated. (Roger-Viollet, Paris.)

143 Cover of *La Révolution Surréaliste*. Bibliothèque Nationale, Paris (Taylor Institution Library, Oxford/ACRPP, Paris).

144 Ernst: *The Stallion and the Bride of the Wind*. Bibliothèque Nationale, Paris (Snark International, Paris), © SPADEM Paris 1978.

145 Dali: *The Birth of Liquid Desires*. Peggy Guggenheim Foundation, Venice (Weidenfeld and Nicolson Archive, London), © ADAGP Paris 1978.

146–7 Miró: *The Hunter (Catalan Landscape)*. Museum of Modern Art, New York, © ADAGP Paris 1978.

148 Picasso: Cover of *Minotaure*. Bibliothèque Nationale, Paris

(Snark International, Paris), © SPADEM Paris 1978.

149 Ernst: Cover of *Minotaure*. (Courtauld Institute, London), © SPADEM Paris 1978.

151 Letter from Abbé Gengenbach, from *La Révolution Surréaliste*, no. 5. Bibliothèque Nationale, Paris (Taylor Institution Library, Oxford/ACRPP, Paris).

152 Miró: *Object*. Museum of Modern Art, New York. Gift of Mr and Mrs Pierre Matisse, © ADAGP Paris 1978.

152–3 Dali: *Outskirts of Paranoiac-Critical Town*. Collection E. F. W. James Esq., © ADAGP Paris 1978.

154–5 Cabinet ministers' doodles, from *La Révolution Surréaliste*, no. 6. Bibliothèque Nationale, Paris (Taylor Institution Library, Oxford/ACRPP, Paris).

156 Dali: *Man with His Head Full of Clouds*. Edward James Foundation, © ADAGP Paris 1978.

157 Magritte: *Napoleon's Death Mask*. Collection E. F. W. James, Esq., © ADAGP Paris 1978.

159 Tanguy: *Fantômas*. Private Collection (Eric Pollitzer, New York), © SPADEM Paris 1978.

160 Magritte: *The Rape*. George Melly Collection, London (Snark International, Paris), © ADAGP Paris 1978.

162 Tanguy: *Girl with Red Hair*. Private Collection (Eric Pollitzer, New York), © SPADEM Paris 1978.

164 *Cadavre exquis*. Private Collection (Arturo Schwarz, Milan).

165 de Chirico: *Amazons*. Private Collection (Maître Binoche, Paris), © SPADEM Paris 1978.

166–7 Magritte: *The Menaced Assassin*. Museum of Modern Art, New York, Kay Sage Tanguy Fund, © SPADEM Paris 1978.

169 Ernst: Décor for *Romeo and Juliet*. Wadsworth Atheneum, Hartford, Conn., © SPADEM Paris 1978.

172 Poincaré. Snark International, Paris.

173 Barbusse. Radio Times Hulton Picture Library, London.

175 Dali: *Seize Titols*. Private Collection (Arturo Schwarz, Milan), © ADAGP Paris 1978.

176 left Breton. Elisa Breton Collection (Snark International, Paris).

176 right Illustration to *Nadja*. (From André Breton, *Nadja*, Gallimard.)

177 Nancy Cunard, photographed by Cecil Beaton. Sotheby's Belgravia, London.

179 Eluard: *L'Amour*. Private Collection (Arturo Schwarz, Milan).

180 Paul and Nusch Eluard, photographed by Man Ray. (Sotheby's Belgravia, London), © ADAGP Paris 1978.

181 Dali and Gala, photographed by Cecil Beaton. Sotheby's Belgravia, London.

182–3 Still from *Un Chien Andalou*. (Museum of Modern Art, New York, Film Stills Archive.)

184 Still from *Un Chien Andalou*. (Museum of Modern Art, New York, Film Stills Archive.)

185 Buñuel in *Un Chien Andalou*. (Archives J. Chevalier/Snark International, Paris.)

186–7 Dali: *Illumined Pleasures*. Museum of Modern Art, New York, Sidney and Harriet Janis Collection, © ADAGP Paris 1978.

189 Dali: Study for *The Lugubrious Game*. Private Collection (Arturo Schwarz, Milan), © ADAGP Paris 1978.

190 Magritte: *The Principle of Pleasure*. Collection E. F. W. James, Esq., © ADAGP Paris 1978.

193 Marie-Laure, Vicomtesse de Noailles, photographed by Man Ray. Mayor Gallery, London, © ADAGP Paris 1978.

194–5 Still from *L'Age d'Or*. (Weidenfeld and Nicolson Archive, London.)

196 above Magritte: *The False Mirror*. Museum of Modern Art, New York, © ADAGP Paris 1978.

196 below Still from *L'Age d'Or*. (Weidenfeld and Nicolson Archive, London.)

198 Tanguy: *Letter to Paul Eluard*. Museum of Modern Art Library, New York, Eluard and Dausse Collection, © SPADEM Paris 1978.

199 Mayakovsky. Private Collection (Snark International, Paris).

200 Breton: *La Nourrice des Etoiles*. Collection Dominique Eluard (Archives Editions du Seuil/Snark International, Paris).

201 Eluard: *Collage*. Private Collection (Galerie François Petit, Paris/Snark International, Paris).

202 Ernst: *Quiétude*. Victoria and

Albert Museum, London, © SPADEM Paris 1978.

203 *Cadavre exquis*. Private Collection (Arturo Schwarz, Milan).

204 Breton: *The Serpent*. Private Collection (Arturo Schwarz, Milan).

206 above Arp: *Bell and Navels*. Museum of Modern Art, New York, Kay Sage Tanguy Fund, © ADAGP Paris 1978.

206 below Giacometti: *The Palace at 4 a.m.* Museum of Modern Art, New York, © ADAGP Paris 1978.

207 Gaston Bergery. Popperfoto, London.

209 Dali: *Soft Construction with Boiled Beans: Premonition of Civil War*. Philadelphia Museum of Art, Louise and Walter Arensberg Collection, © ADAGP Paris 1978.

210 Valentine Hugo, photographed by Man Ray. (Sotheby's Belgravia, London), © ADAGP Paris 1978.

212 Magritte: *The Therapeutist*. Urvater Collection, Belgium (Snark International, Paris), © ADAGP Paris 1978.

213 Dali: *Metamorphosis of Narcissus*. Edward James Foundation, © ADAGP Paris 1978.

216 Tanguy: *Days of Delay*. Museum of Modern Art, Paris (Bulloz, Paris), © SPADEM Paris 1978.

217 Delvaux: *Phases of the Moon*. Museum of Modern Art, New York.

218 Sennep cartoon. Bibliothèque Nationale, Paris (Snark International, Paris), © SPADEM Paris 1978.

219 Place de la Concorde. Roger-Viollet, Paris.

220 Dali: *Lobster Telephone*. Collection E. F. W. James Esq., © ADAGP Paris 1978.

220–1 Magritte: *The Good Adventure*. Edward James Foundation, © ADAGP Paris 1978.

222 Workers' demonstration. Roger-Viollet, Paris.

223 left Place de la Madeleine. Snark International, Paris.

223 right Jeunesses Patriotes. Bibliothèque Nationale, Paris (Snark International, Paris).

223 below Chiappe and Renard. (Mansell Collection, London.)

224 Ernst: *The Robing of the Bride*. Solomon R. Guggenheim Museum, New York (Cooper-

Bridgeman Library, London), © SPADEM Paris 1978.
225 Pickets. Meurisse Collection, Paris (Snark International, Paris).
226 above Cadavre exquis. Private Collection (Arturo Schwarz, Milan).
226 below Dali: *Fantastic Beach Scene*. Edward James Foundation, © ADAGP Paris 1978.
227 Ernst: *The Blind Swimmer*. Museum of Modern Art, New York, Gift of Mrs Pierre Matisse and Helena Rubinstein Fund, © SPADEM Paris 1978.
228 Book-burning. Imperial War Museum, London.
229 above M. Parain. Bibliothèque Nationale, Paris (Taylor Institution Library, Oxford/ACRPP, Paris).
229 below Erotica from *Minotaure*. Courtauld Institute, London.
230 above Still from *King Kong*. (National Film Archive, London.)
230 below Papin sisters. Bibliothèque Nationale, Paris (Taylor Institution Library, Oxford/ACRPP, Paris).
231 left Jacqueline Lamba. Jacqueline Lamba Collection (Snark International, Paris).
231 right Jacqueline Breton, photographed by Man Ray. (Sotheby's Belgravia, London), © ADAGP Paris 1978.
232 Picasso: *Two Figures on a*

Beach. Museum of Modern Art, New York, © SPADEM Paris 1978.
233 Dali: *Paranoiac-Critical Solitude*. Collection E. F. W. James Esq., © ADAGP Paris 1978.
234 Dali: *Raining Taxi*. Images et Textes/Denise Bellon, Paris.
238 above Procession of Syndicalists. Popperfoto, London.
238 below Léon Blum. Radio Times Hulton Picture Library, London.
239 Ernst: *The Postman Cheval*. Peggy Guggenheim Foundation, Venice, © SPADEM Paris 1978.
240 above Arp: *Mutilé et Apatride*. Courtauld Institute, London, © ADAGP Paris 1978.
240 below Miró: *Woman's Head*. Pierre Matisse Gallery, New York (Weidenfeld and Nicolson Archive, London), © ADAGP Paris 1978.
241 above Ernst: Illustration to complete works of Lautréamont. Victoria and Albert Museum, London, © SPADEM Paris 1978.
241 below left Ernst: Illustration to *Une Semaine de Bonté*. Victoria and Albert Museum, London, © SPADEM Paris 1978.
241 below right Dali: Illustration to *Les Chants de Maldoror*. Victoria and Albert Museum, London, © ADAGP Paris 1978.
242 above Brauner: *Man in an*

Interior. Private Collection (Weidenfeld and Nicolson Archive, London).
242 below Dali composition, photographed by Man Ray. (Sotheby's Belgravia, London), © ADAGP Paris 1978.
243 above View of International Exhibition of Surrealism. Images et Textes/Denise Bellon, Paris.
243 below Brauner: *Self-Portrait*. Private Collection (Weidenfeld and Nicolson Archive, London).
244 above Dali and mannequin. Images et Textes/Denise Bellon, Paris.
244 below Seligmann's 'Ultra-furniture'. Images et Textes/Denise Bellon, Paris.
245 Masson: *Never Satisfied*. Galerie Louise Leiris, Paris, © ADAGP Paris 1978.
246 Breton: *Self-Portrait*. Private Collection (Arturo Schwarz, Milan).
247 above Schiaparelli, photographed by Cecil Beaton. Sotheby's Belgravia, London.
247 below Dali's Mae West lips sofa. Edward James Foundation, © ADAGP Paris 1978.
248 above Breton, Trotsky and others. Jacqueline Lamba Collection (Snark International, Paris).
248 below Breton and Trotsky. Elisa Breton Collection (Snark International, Paris).
249 Masson: *La Grande Dame*.

Galerie Louise Leiris, Paris, © ADAGP Paris 1978.
250 Daladier. Snark International, Paris.
251 above Eluard, photographed by Man Ray. Mayor Gallery, London, © ADAGP Paris 1978.
251 below Breton, Péret and others. Elisa Breton Collection (Snark International, Paris).
252 left Czech woman. Keystone Press Agency, London.
252 right SS guards in Berlin. National Archives, Washington DC (Weidenfeld and Nicolson Archive, London).
254 Tanguy: Cover of *Dictionnaire Abrégé du Surréalisme*. (Weidenfeld and Nicolson Archive, London), © SPADEM Paris 1978.
261 Magritte: Illustration to *Les Chants de Maldoror*. Bibliothèque Nationale, Paris (Snark International, Paris), © ADAGP Paris 1978.

The publisher has taken all possible care to trace and acknowledge the ownership of all the illustrations. If by chance we have made an incorrect attribution we apologise most sincerely and will be happy to correct the entry in any future reprint, provided that we receive notification.

Picture research by Belinda Greaves and Julia Brown.

Index